THE ART OF DARKWATCH

designstudio PRESS

HIGH MOON STUDIOS

DEDICATION

This book is dedicated to our families. None of us would be able to pursue our passions and professional goals without the love and unwavering support of our families.

SPECIAL THANKS

We would like to specifically thank John Rowe and Hajime Satomi for conceiving this uniquely creative environment that has become High Moon Studios.

Written by:

Farzad Varahramyan
Chris Ulm
Paul O'Connor
Aaron Habibipour
Rory McGuire
Francis Tsai
Chad Bishop
Rob Bacon

Edited By:

Aaron Habibipour
Erin Ward

Art Direction: Scott Robertson
Graphic Design: fancygraphics
http://www.fancygraphics.net
Text Editor: Anna Skinner

Published by Design Studio Press
8577 Higuera Street
Culver City, CA 90232
http://www.designstudiopress.com
E-mail: info@designstudiopress.com

Printed in China
First Edition, August 2005

Paperback ISBN 1-933492-01-5
Hardcover ISBN 1-933492-00-7
Library of Congress Control Number:
2005927186

10 9 8 7 6 5 4 3 2

contents

FOREWORD

All children like to make a mark. It is instantly satisfying visually and most kids eventually drift to other pursuits. Some kids stick with it, honing and refining their skills in order to more accurately depict their imaginative visions.

Today's entertainment audience has high expectations for being entertained, mesmerized, and captivated by what they see on the screen, be it a feature release, the latest video game or theatrical commercials on TV. The expanded technical capacities available for elaborate visualization demand a more exotic range of technique beyond a simplistic, predetermined view no matter how well executed. To be complete alternate realities must have story validity that supports coherent presentations that inventively present a believable 'there.' I've been creating alternate realities for over 40 years. That accumulation of experience demands that visualizing 'futures' demands skills sensitive to all of the basic disciplines of story telling; scenario invention and the careful crafting of the objects and scenic elements that combine to create a convincing 'alternate' reality.

The men and women at High Moon Studios are expert in the skills of visualizing alternate realities. Some of these take place in some hoary past such as Jericho Cross and Darkwatch, worlds that imaginatively exist before space ships, robotic and alien technology and before much of what we consider to be science-fiction had become the durable genre of today.

The artists who have created and visualized this world developed their imaginative creativity with such fertile cultural elements as *Star Wars, Blade Runner, Aliens, Tron,* and *The Terminator* to name but a few of individual inspirations. From the bucolic to the terrifying, these artists all share a common sense of exhilaration that is the signature characteristic of genuine creative facility.

I commend these vibrant talents and invite you to wonder and thrill to the images and wondrous worlds presented in this volume

Syd Mead
May 12, 2005 • Pasadena, California

INTRODUCTION

Making a video game is truly a collaborative effort between many people of varied and specialized skills. A large number of artists, game designers, programmers and producers have to work and come together artistically. Although this book focuses on the contributions of the concept artist, it is important to note the collective effort that went into creating an original IP (Intellectual Property) such as Darkwatch.

Visually creating a new world from scratch is not an easy task, and it requires not only imagination and artistic skills but also perseverance. We were fortunate to have a whole team of concept artists who could meet the demands of visualizing an original IP and supply the necessary quality and quantity of 2-D art, which formed the foundation for the visual development of Darkwatch.

When visualizing concepts for an interactive medium such as video games, the concept artist is trying to balance and harmonize many variables. Something may look good on paper, but in the game it may fall apart visually. The design may need to fulfill specific game mechanics, or be visible and recognizable from far away. Certain colors will blow out and not read well on a specific gaming platform, or perhaps a particular color and graphics language are needed to communicate hints to the player. We may want to create a dark, moody environment to match the story beat, but it is also necessary to give the environment depth and enough lighting in order to play the game.

Fundamentally, the concept artist becomes a problem solver, and we try to visually solve as many of these potential issues on paper before we get to the 3-D digital medium. Visual problem-solving takes perseverance, since we rarely hit the mark with the first few sketches.

The process is as important as the final concept design. As concept artists we accept that truly great designs will most likely reveal themselves toward the end of the process as opposed to the beginning. Iteration becomes a fundamental path in peeling away the layers to the best core design. We explore, evaluate, reevaluate, redirect, and iterate until we hit the mark.

This book showcases the concept art that went into creating Darkwatch. It will hopefully demonstrate, in part, the process and development of the concepts, as well as the evolution of the IP itself. Hopefully it will also give you a glimpse into the true talent, perseverance, and collaborative spirit of the concept artists that contributed to developing Darkwatch.

I'd like to single out a few individuals and thank them for their contributions to Darkwatch. John Rowe for having the vision to help build High Moon Studios, where new worlds could be created. Chris Ulm, Paul O'Connor, and Emmanuel Valdez for being the best creative partners. Clinton Keith for structuring the technology that enabled us to build and interact with the world of Darkwatch. Senior concept artist Francis Tsai for being the backbone of the concept department. Storyboard artist Sergio Paez for bringing motion to our story. Lead artist Sean Miller and his senior artists, Ivan Power, Mike Brown, Sean Letts, Randy Stebbing, and Andrea Cordella were the point of contact where the rubber met the road. Their team of artists and animators are the reason the 2-D vision of Darkwatch was translated so beautifully into the game. Editor Dave Cravens for his amazing sense of timing and storytelling. Audio manager Gene Semel, for constantly reminding all of us that sound is 50 percent of the image. Mohammed Davoudian and Brainzoo Studios for masterfully producing all our cinematics. Last but not least, the producers did an incredible job, and I'd like to specifically thank Brian Johnson, Steve Sargent, Chuck Quevas, and Aaron Habibipour since they had to put up with me the most.

I sincerely hope you will enjoy this book and Darkwatch.

Farzad Varahramyan
Creative Visual Director

THE VISUAL DNA OF DARKWATCH

Farzad Varahramyan and his band of concept artists have created the fantastic array of images that you now hold in your hands. It's a cohesive set of weapons, characters, vehicles, and landscapes that work together to weave the visual web of a haunted West dominated by the brooding organization of the Darkwatch. But the vision was an evolutionary process – in the early stages of the project, we explored many visual and game concept directions and labored mightily to come up with a signature look and feel.

When we set out to create the concept that later became Darkwatch, it was originally called Code of the West and was about a ne'er-do-well gambler named Chaz Bartlett. The early visual designs leaned toward the humorous. While it was creatively interesting, these early concepts fought against the over-the-top action level we envisioned for the gameplay. By sticking to a traditional Western, we also found that we were very limited by the technology and transportation of the times: Colt Peacemakers, Winchester rifles, the occasional Gatling gun, and horses. While this was appealing in its own right, we wanted to give players an experience of the West through a more modern lens.

So, Code of the West became Darkwatch, and Bartlett became vampiric gunslinger Jericho Cross. The concept became more horrific and centered on the Darkwatch, a secret society, which gave our hero access to nontraditional weapons and vehicles.

Once we decided to change to a vampire/Western theme, the next question was what visual direction should we follow to make our world interesting, unique, and consistent? We determined that we needed a high-level synopsis that would define and explain the background "rules" by which the world of the Darkwatch must abide.

Here's a portion of the visual DNA that Farzad and his team so brilliantly used as a starting point to create the concept artwork in this book:

THE DARKWATCH

They're merciless. They grind the bones of their enemies for fuel, fashion their skin into cloaks, and drink from their skulls. And these are the good guys.

The Darkwatch are an organization that is judge, jury, and executioner. They use mystical alchemic techniques based on stolen artifacts and dark tomes to augment their technology and defeat the forces of darkness, though they are now tainted by their proximity to evil. In the same way the Native Americans used the buffalo, the Darkwatch uses every element of the creatures they hunt to create their weapons, uniforms, and vehicles. One key material is the flayed and cured skin of vampires, which is self-repairing and nearly invulnerable, and is used to make form-fitting uniforms.

WEAPONS

Darkwatch weapons are more advanced than their counterparts in the West, and they are enhanced with technology gained from mystical insights. Darkwatch inventors have become mad scientists as they are "pushed" by self-imposed dark insights gathered from artifacts, tomes, and arcane experimentation. Visually, this should translate into using big signatures of the West (Winchester-cocking mechanisms, bolt actions, revolvers) with fang-edged details. All Darkwatch weapons have a bladed gun-butt aspect to them that directly ties in to our melee-strike gameplay mechanic.

VEHICLES

The Darkwatch vehicles need to have modern proportions and visually reflect their role/performance in the game. Whenever possible, we should try to imagine the uses that the Darkwatch would have for these vehicles in relation to their primary mission—assaulting graveyards and vampire nests with ease. Vehicles should have a stabbing-ram attack and be covered with vampire skin or armor. The Darkwatch vehicles are propelled by concentrated steam and mechanical rotors, belts, etc. However, these are not slow, barely working engines. They have the stamina and power of modern engines and need to sound like it.

ENVIRONMENT

The Darkwatch is not concerned with comfort, and their environment tends to have a medieval aspect, which is consistent with the long history of the Darkwatch. They illuminate their shadow enclaves with kerosene gas jets and prefer stone over wood whenever possible. Like all Darkwatch visuals, the Darkwatch environments should use the fang motif.

Using this primitive DNA as a starting point, the incredibly creative and talented Darkwatch concept team was able to create twists on the theme, bringing to life the truly original, haunted West you see within these pages.

Enjoy the book—I know I will!

<div align="center">

Chris Ulm

VP, Design Director

</div>

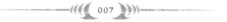

CHARACTERS: FRIENDS

<<< I >>>

In any narrative, the characters are the vehicle through which we experience the story. How much we believe in these character's emotions and reactions determines our willingness to be swept away to some far-off world or unfamiliar time period. Movies are a perfect example of this idea.

We develop the visual look of any character much like a good character actor constructs the person they will play. Wherever possible, we define each character with a back story and key life events, which help form the personality and emotional framework, as well as the physical look. Once this is accomplished, we visually construct the character layer by layer with clues and defining details that hopefully offer a sense of history and familiarity as to the type of character you may be dealing with. Every design starts with tiny thumbnails, which help us define these characters purely with stance, posture, and unique silhouettes, before we get into any details.

The following pieces are examples of the development process of our characters and our methodology.

1. DESIGN BY FARZAD VARAHRAMYAN DETAILS BY STEVE JUNG & SHANE NAKAMURA
2. DESIGN BY FRANCIS TSAI / 3. DESIGN BY SERGIO PAEZ

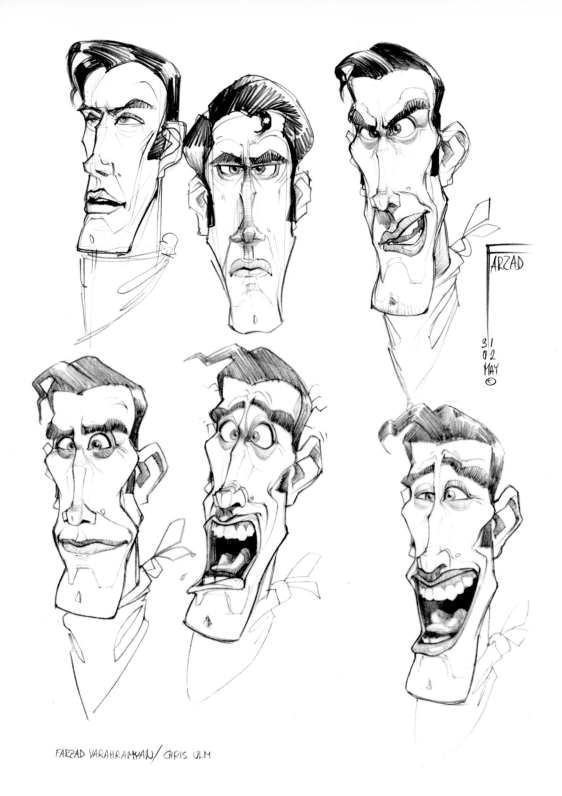

FARZAD VARAHRAMYAN/ CHRIS ULM

THE EVOLUTION OF JERICHO

ALL DESIGNED BY FARZAD VARAHRAMYAN

If you read Chris Ulm's The Visual DNA of Darkwatch, you know by now that the look all started out as a much more humorous take on the Western genre. However, this visual direction did not ultimately accommodate the action-packed gameplay we all had invisioned. The game's visual evolution will be seen throughout the book, but, it's most evident in Jericho's evolution.

As seen on the opposite page, bottom right and top left, Jericho and the cast of characters started out as iconic caricatures of the cinematic American West genre. Although entertaining to look at and perhaps a good solution for an animation property, these images were not suitable for a first-person shooter. The following sketches show the gradual departure from carica-ture, to more cartoony and stylized humans.

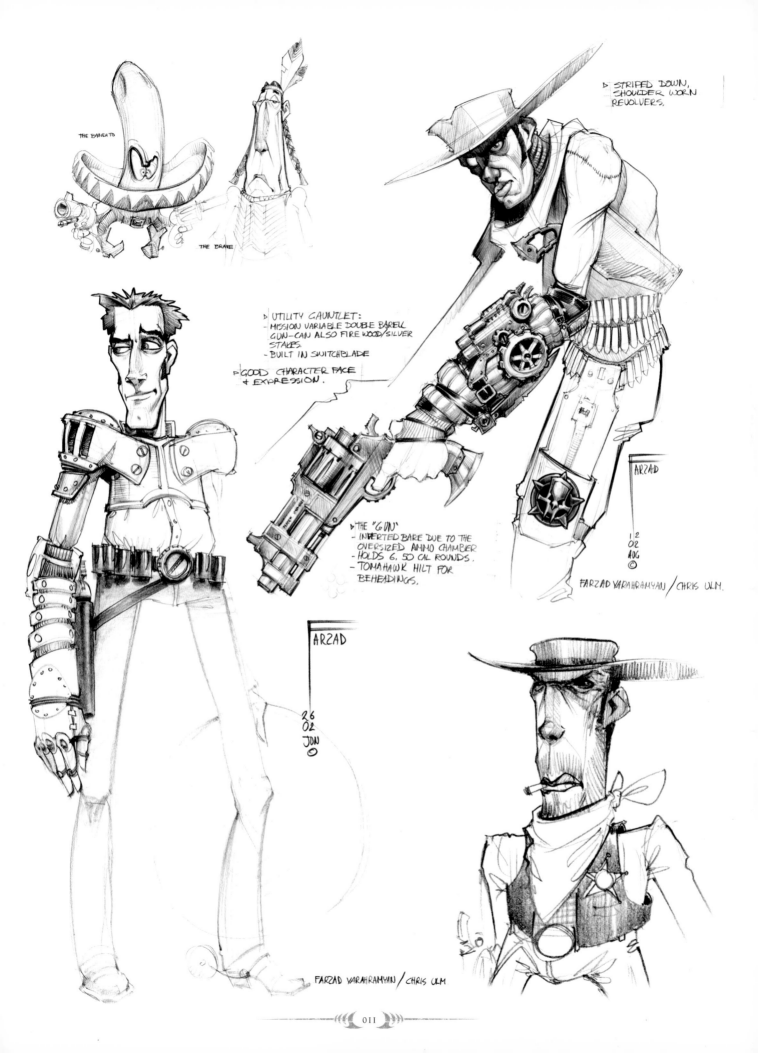

THE BANDITO

THE BRAVE

▷ STRIPED DOWN,
SHOULDER WORN
REVOLVERS.

▷ UTILITY GAUNTLET:
- MISSION VARIABLE DOUBLE BARELL
GUN - CAN ALSO FIRE WOOD/SILVER
STAKES.
- BUILT IN SWITCHBLADE

▷ GOOD CHARACTER FACE
& EXPRESSION.

▷ THE "GUN"
- INVERTED BARE DUE TO THE
OVERSIZED AMMO CHAMBER
- HOLDS 6, 50 CAL ROUNDS.
- TOMAHAWK HILT FOR
BEHEADINGS.

FARZAD

1 2
02
ADG

FARZAD VARAHRAMYAN / CHRIS ULM.

FARZAD

26
02
JON

FARZAD VARAHRAMYAN / CHRIS ULM

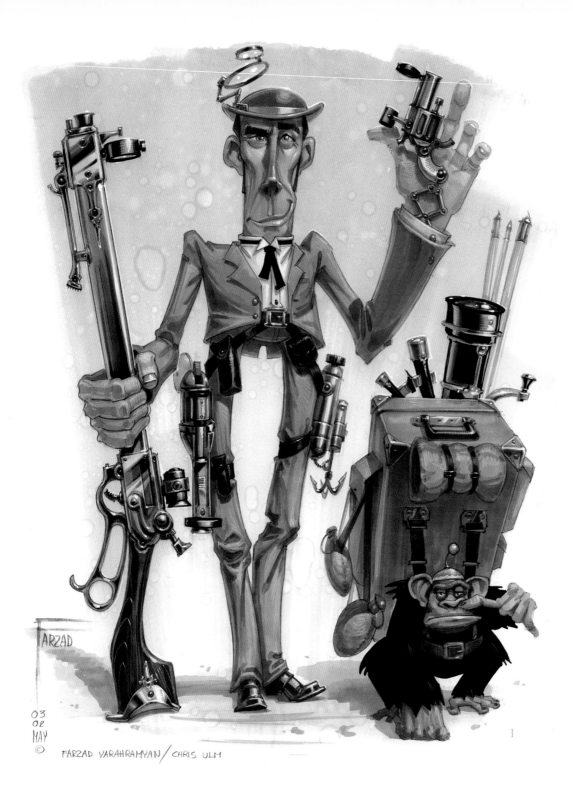

FARZAD

03
02
MAY
© FARZAD VARAHRAMYAN / CHRIS ULM

THE EVOLUTION OF OLD JERICHO

This sketch reflects an early story idea of having a New York watchmaker and gambler, Chaz Bartlett, head west to repair a strange clocktower in a very unusual and remote Western town. The watchmaker angle enabled the character to build special and advanced weapons and vehicles for the time. This would allow the game design to create weapons, vehicles, and gameplay that would be far more fun and entertaining, than if the gameplayer had been restricted to a plain six-shooter, horses, and horse wagons. This premise of creating story conditions to enable you to have fun weapons, environments, and vehicles was one of the key driving forces in developing the Darkwatch Visual DNA.

The monkey is there because Farzad felt a New York watchmaker wouldn't want to carry his own gear and gizmos while trekking in the Old West.

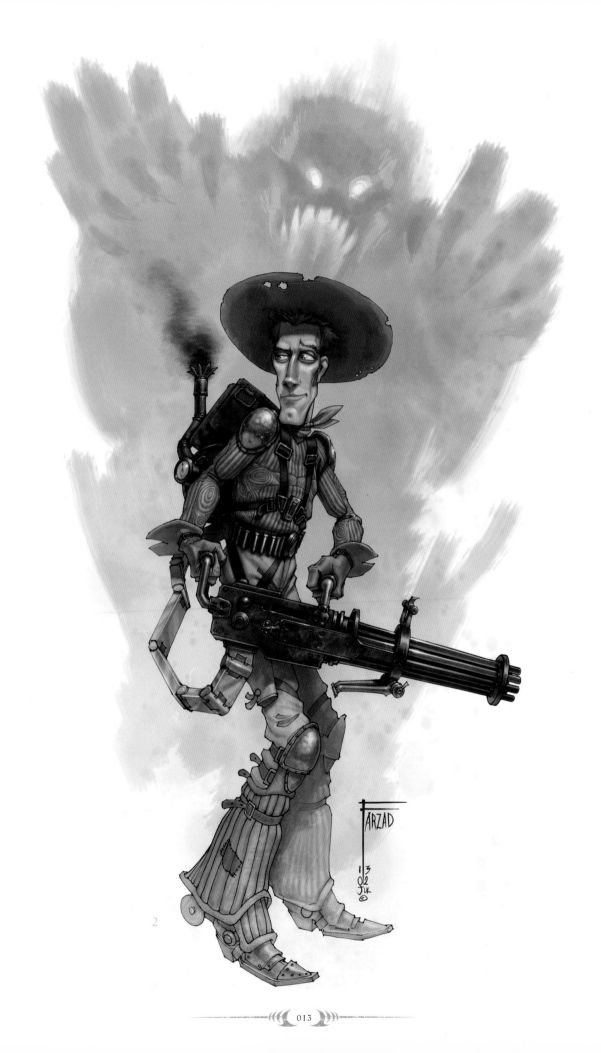

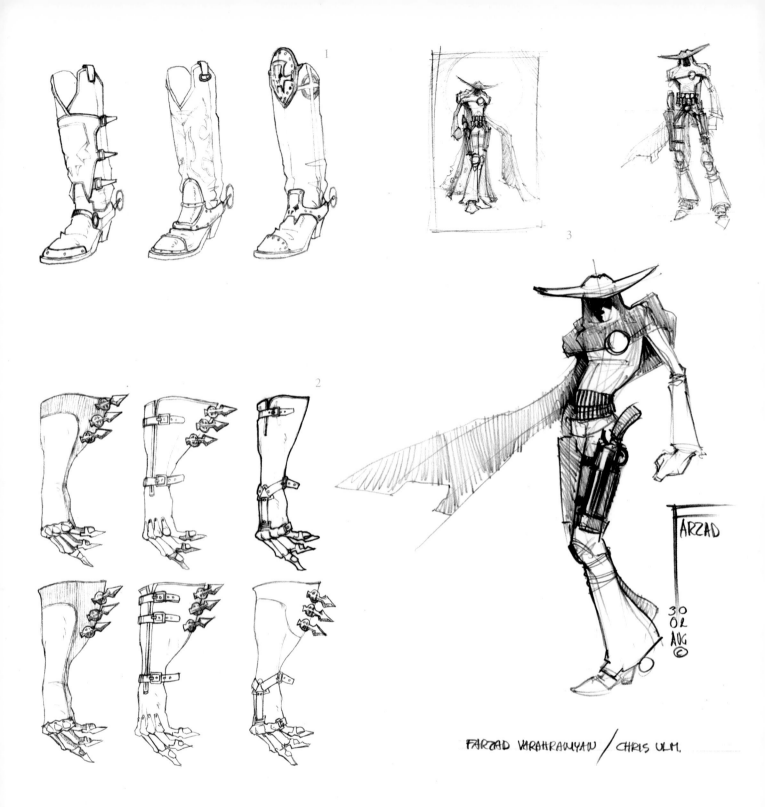

JERICHO

1 & 2 DESIGNED BY STEVE JUNG
3 & 4 DESIGNED BY FARZAD VARAHRAMYAN

Young Jericho Cross left Missouri and joined the Union army after an argument with his slave-owning father. Disgusted by the atrocities he witnessed during the Civil War, Jericho deserted his regiment and drifted out West. The backstory above was instrumental in helping to shape and push the story, gameplay, and visuals toward a more over-the-top action and maturely themed game.

The small thumbnails help design strong and recognizable silhouettes without getting caught in the details too early. The large sketch of Jericho is the very first drawing that nailed the look and feel we were looking for in this Darkwatch universe.

The gauntlet and boot iterations show the fine-tuning process, of the Darkwatch uniform aesthetic.

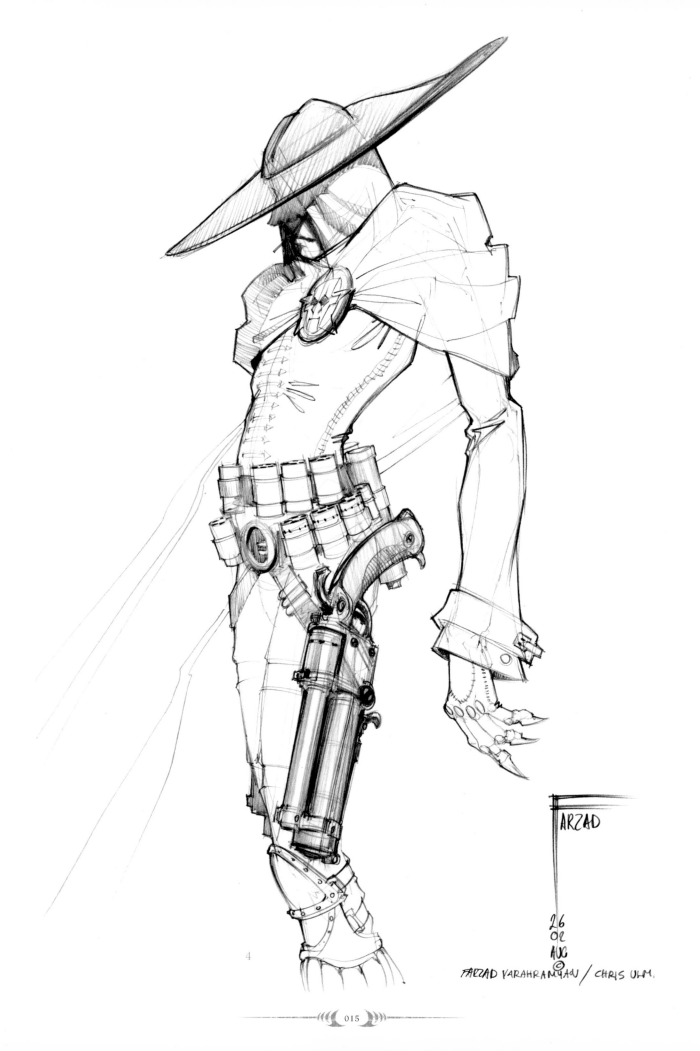

FARZAD

26
08
AUG

FARZAD VARAHRAMYAN / CHRIS ULM.

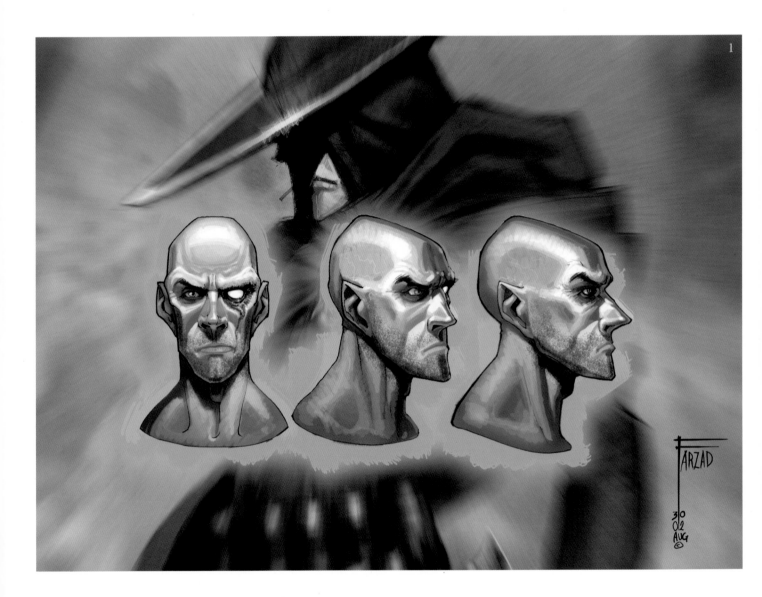

JERICHO

1. DESIGNED BY FARZAD VARAHRAMYAN
2. DESIGNED BY FARZAD VARAHRAMYAN / DETAILS BY SHANE NAKAMURA & STEVE JUNG

In 1876, Jericho's attempt to rob a Darkwatch train neatly landed him in the middle of a millennia-old war between the undead and the Darkwatch. Bitten by the Vampire-Lord Lazarus, Jericho sought the Darkwatch citadel and was aided by the ghost of Cassidy Sharp. After a brutal right of initiation, Jericho set out with the aid of the secret organization to rid the West of Lazarus and his army of the undead.

The sketch to the right is the final design for Jericho. A lot of refinements both obvious and subtle have been made to get to this image from the original sketch. Proportions alone can say a lot about a charcter. The Darkwatch revolver, the Redeemer, was further refined by Shane Nakamura. The gauntlet and boot details were further refined by Steve Jung.

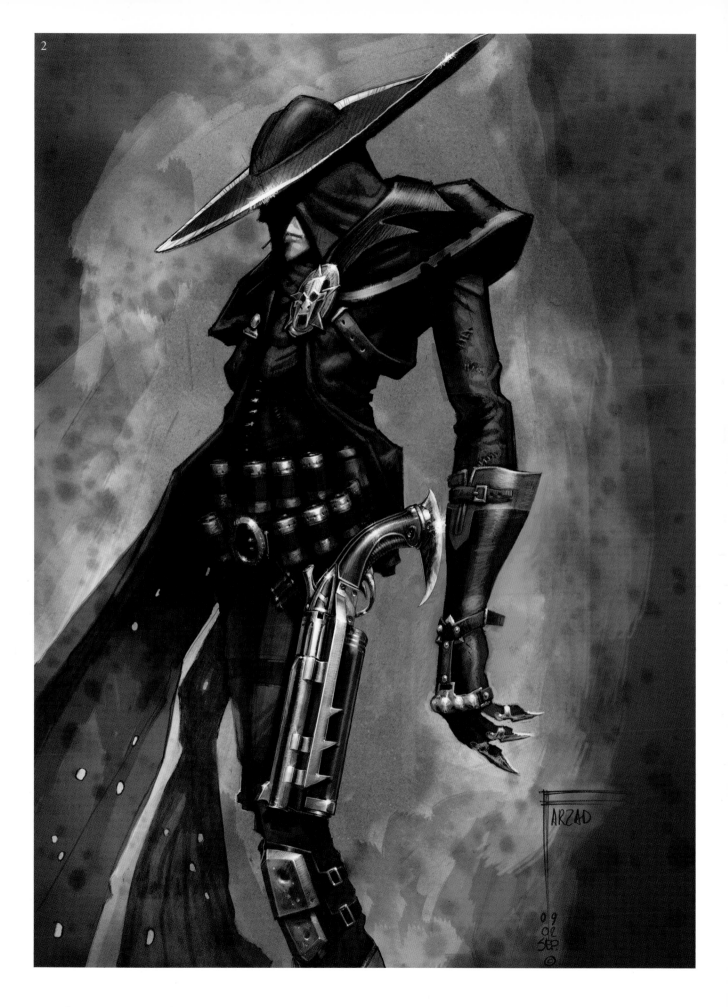

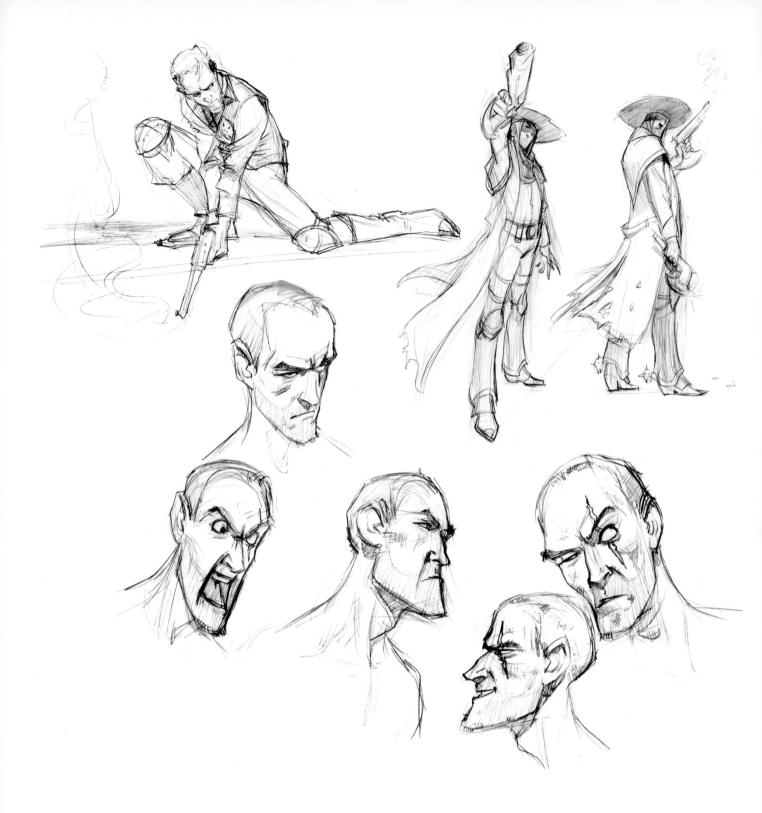

JERICHO

ILLUSTRATED BY SERGIO PAEZ

Once we had Jericho visually designed, storyboard artist Sergio Paez was asked to create many pages of sketches showing Jericho in action, in repose, facial expressions, and range of emotion. These studies further helped us to refine Jericho as a character and his personality. It became really obvious what emotional makeup and personality traits we wanted, and more importantly, which ones did *not* define Jericho. Having these parameters becomes critical when a variety of storyboard artists, editors, animators, voice talent, advertising companies, and many more other people, have to work with this brand-new character. You need to have a consistent character and everyone needs to be consistent with the character.

For example, we discovered that visually, Jericho looks best from specific angles, in specific poses, and with lighting that keeps his face in shadow.

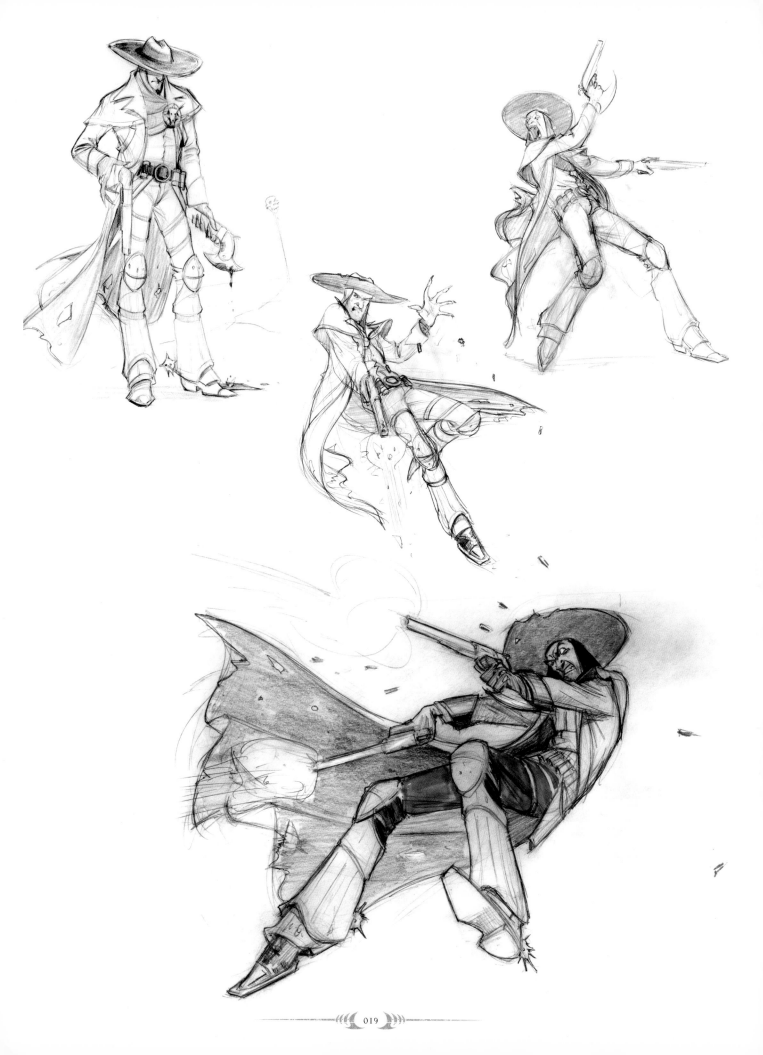

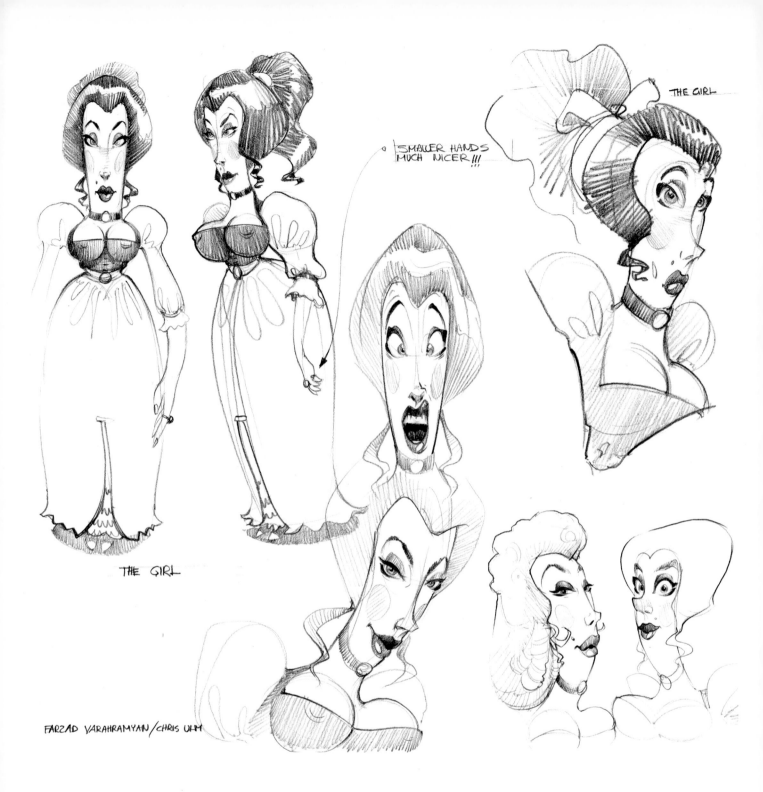

THE GIRL

SMALLER HANDS MUCH NICER !!!

THE GIRL

FARZAD VARAHRAMYAN/CHRIS ULM

THE EVOLUTION OF CASSIDY

DESIGNED BY FARZAD VARAHRAMYAN

These sketches represent a similar visual-development path that Cassidy Sharp went through. On the opposite page is our midpoint design for Cassidy. She's still very stylized and more appropriate for a cartoony and whimsical world. One of the elements that has survived conceptually past this design stage was the special bulletproof shirt she is wearing which eventually evolved into the bulletproof vampire-skin shirt that Darkwatch agents wear.

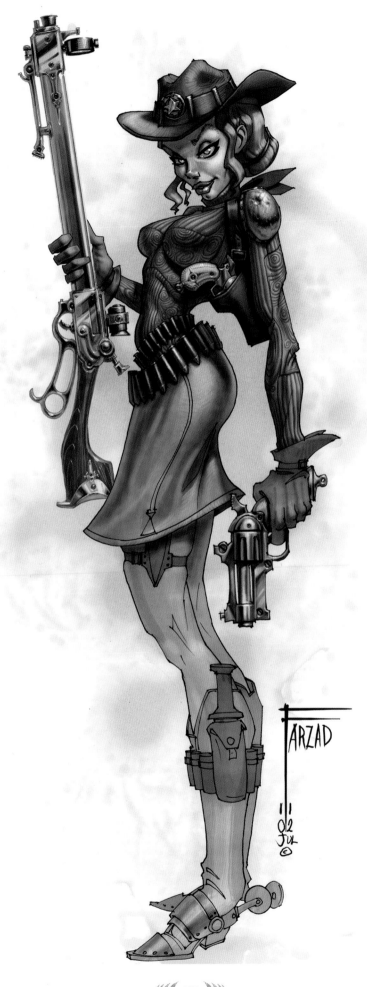

CASSIDY SHARP

DESIGNED BY STEVE JUNG

Orphaned when vampires slaughtered her parents, Cassidy Sharp was raised as a ward of the Darkwatch and trained to become a Darkwatch agent. Steve Jung was given the task of designing Cassidy to fit into the more edgy and twisted gothic West of Darkwatch. Various factors including the face, hairstyle, and degree of sex appeal, were determined through multiple iter-

ations. The Darkwatch uniform developed for Jericho became the launching point for developing the varying uniforms that defined the Darkwatch and its diverse members.

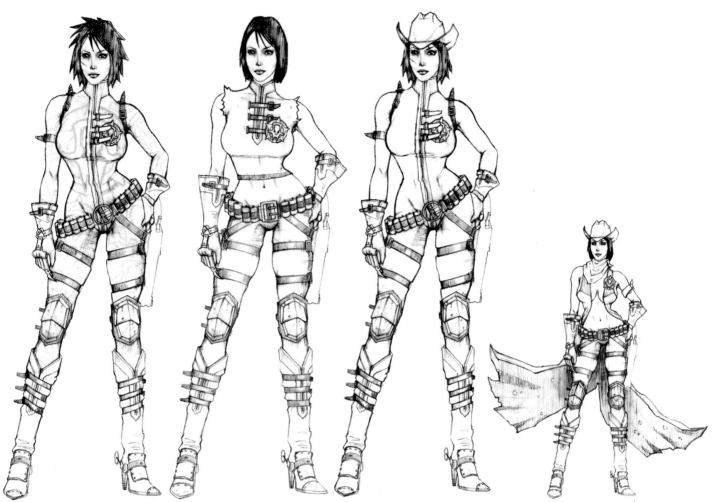

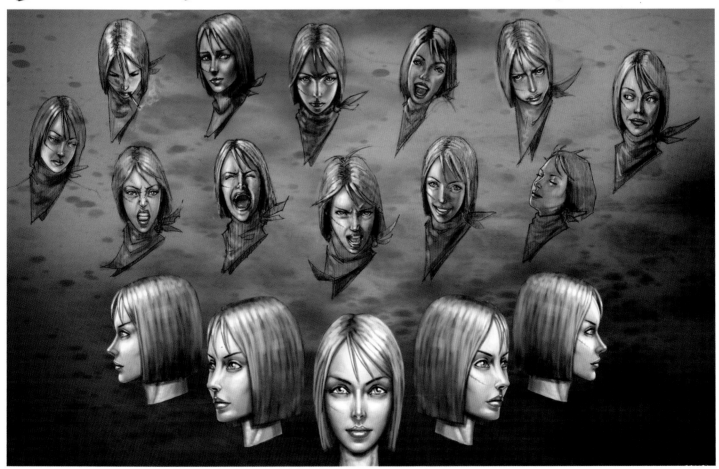

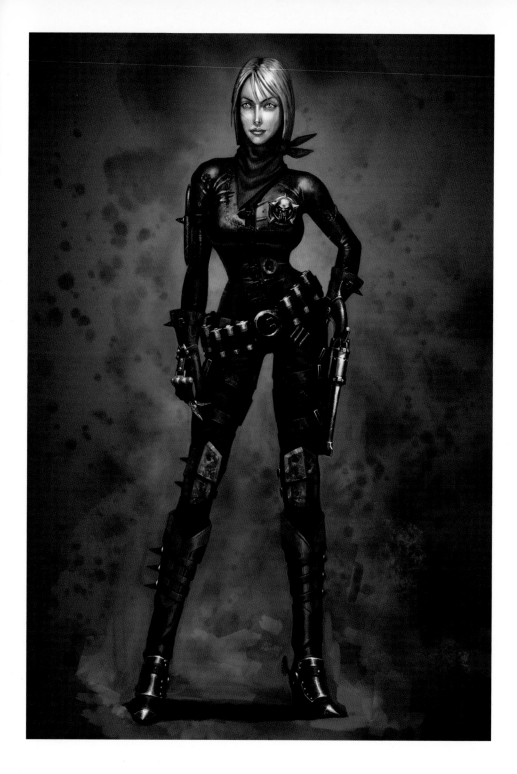

CASSIDY SHARP

DESIGNED BY STEVE JUNG

Cassidy's final design embodies an attractive but no-nonsense, all-business and ready-for-action attitude. It's easy to see how Steve Jung has expanded on the Darkwatch aesthetic and that we are starting to get the beginnings of a cohesive and consistent art direction for the Darkwatch agents.

At one point in the story, Cassidy becomes a ghost, and it was important to see what her ethereal form would look like. We chose to preserve much of her beauty and attitude, while also illustrating what type of visual FX would look best to embellish her new state in the story and in the game.

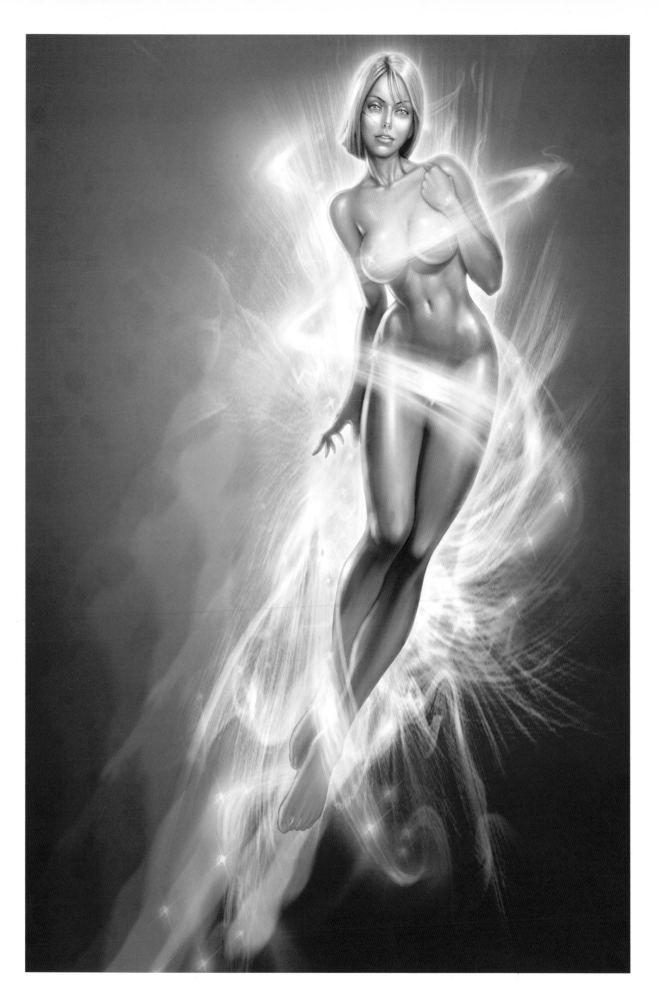

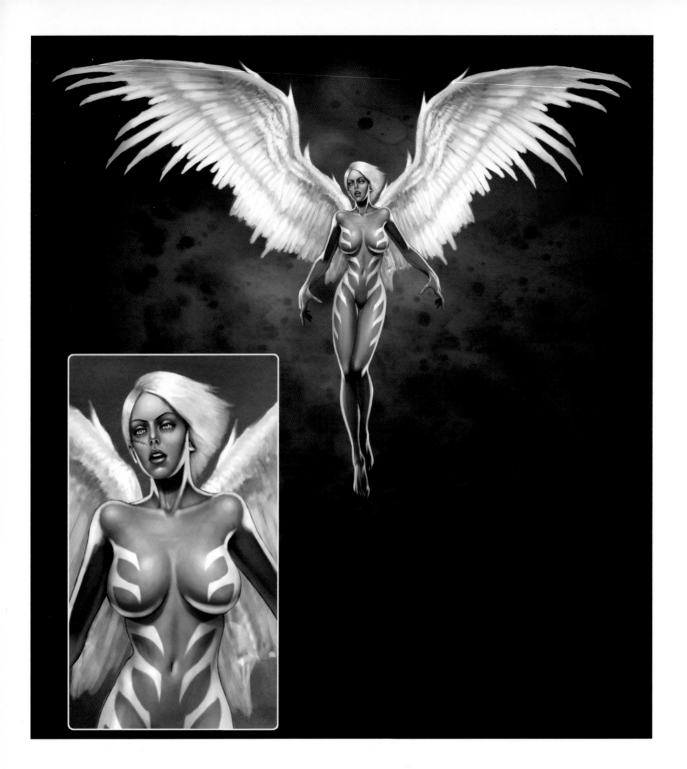

CASSIDY SHARP

DESIGNED BY STEVE JUNG

Cassidy's final boss transformation is skillfully illustrated here by Steve Jung. It was important, to build upon her ghostly state and create a formidable opponent. Even though we gave her angelic wings, we chose to create jagged and pointy-shaped wings to make her appear more tough. We supported this direction graphically by creating similarly sharp- and aggressive-looking graphics for her body.

Here is just one of Cassidy's many powers rendered here as a visual effect. Providing direction for FX is very useful to the FX artist. It also provides a solid visual direction, easily understood and not misinterpreted, for the programmers who need to see exactly what is required of the particular FX tools they are writing code for.

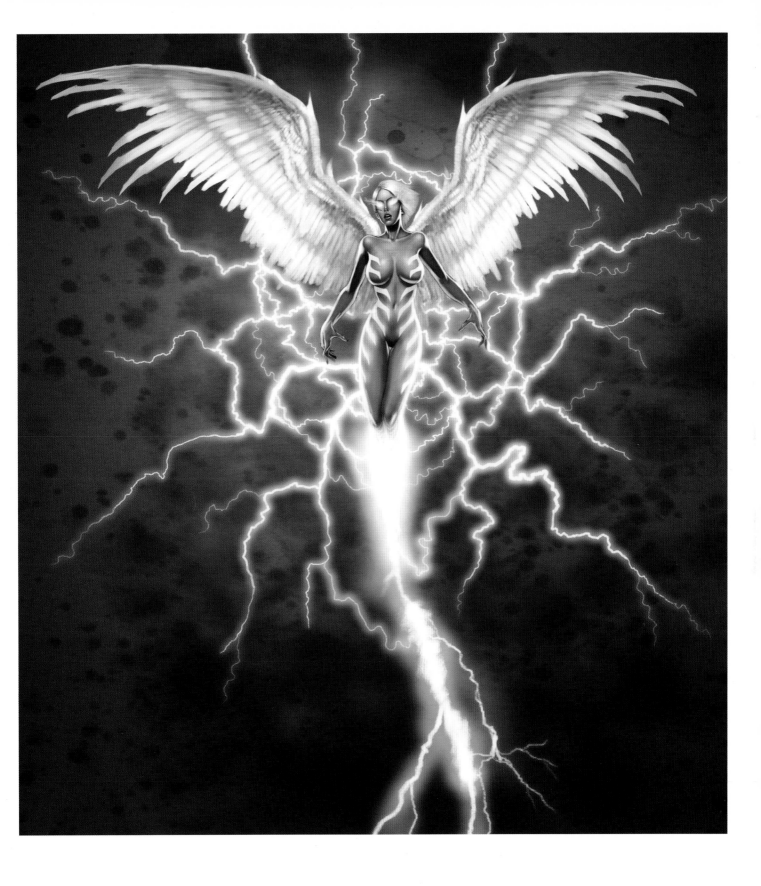

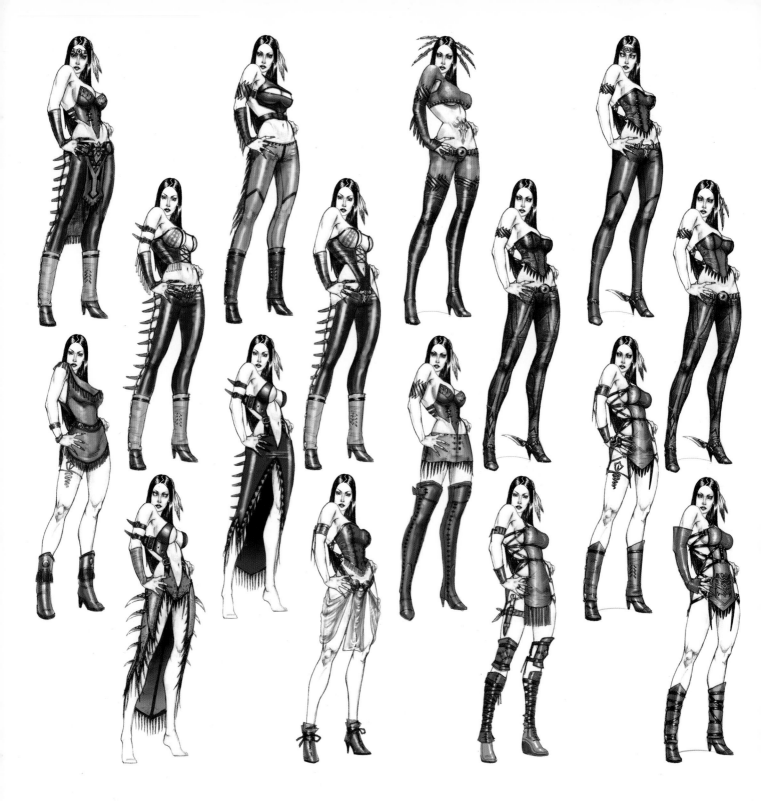

TALA

DESIGNED BY STEVE JUNG

Tala, whose name means "Stalking Wolf," was born to an ancient line of Native American shamans. From a young age, Tala's innate ability to communicate with the spirits made her a misfit and an outcast from her own tribe. As a character, Tala is the opposite of Cassidy. She is playful, mischievous and brutally violent when she needs to be; while at the same time she is unafraid of using her sex appeal and feminine side to get what she wants.

Steve had a lot of fun designing Tala. You see here a portion of the design process that went into creating her dark, vampiric side. Although many designs are explored, we always try to distill and simplify to the purest design. For the game medium in particular, we found that simple and recognizable graphics work best.

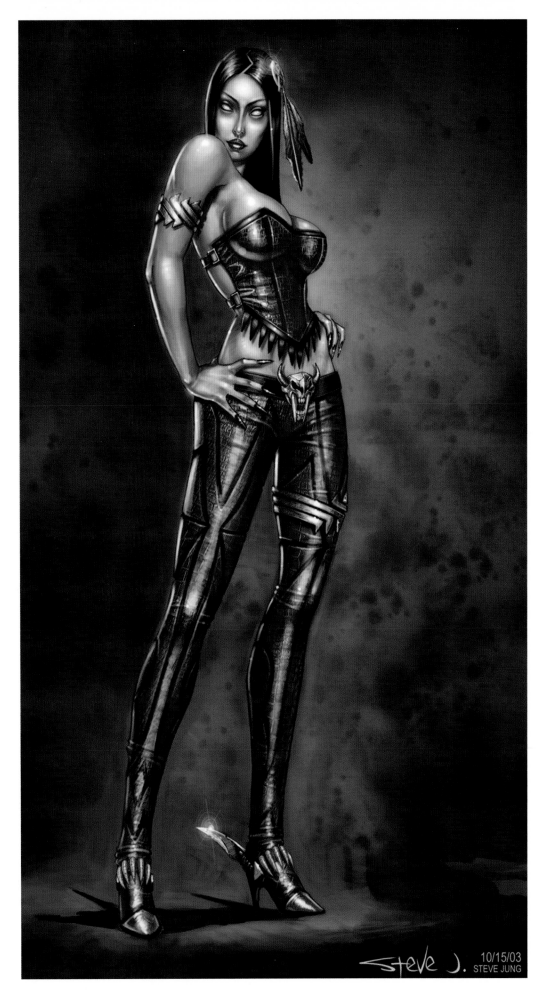

STEVE J. 10/15/03
STEVE JUNG

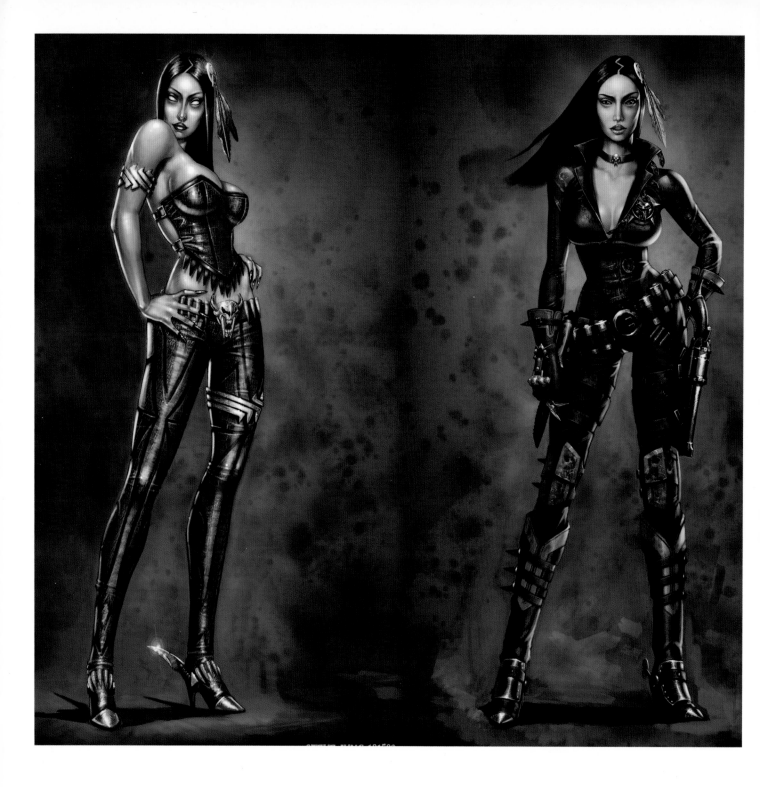

TALA

DESIGNED BY STEVE JUNG

Here are Darkwatch Tala and vampire Tala. Although the latter wears the same Darkwatch outfit–Cassidy with minor refinements–it's clear this is a different character with a different attitude. Something in the eyes hints at a darker, hidden agenda.

Boss Tala is also a winged incarnation. It was easier to visually communicate her evil role. Much like Cassidy, we developed a graphic treatment to aggressively but sensually break up her torso and thighs. We used the idea that some residual membrane from her transformation stage still lingered behind and formfittingly adhered to her curves.

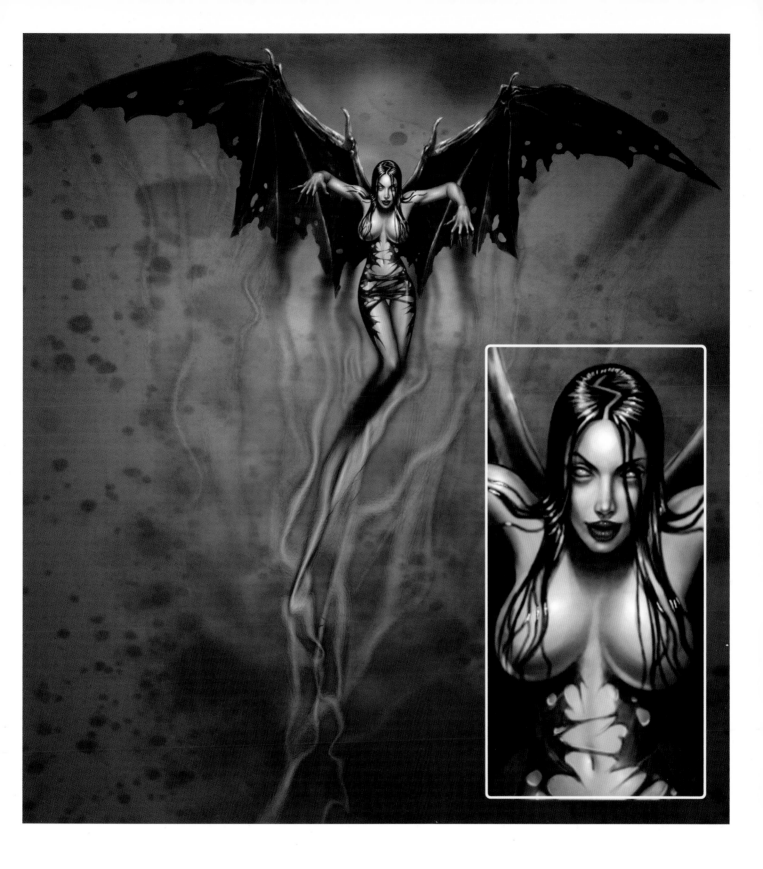

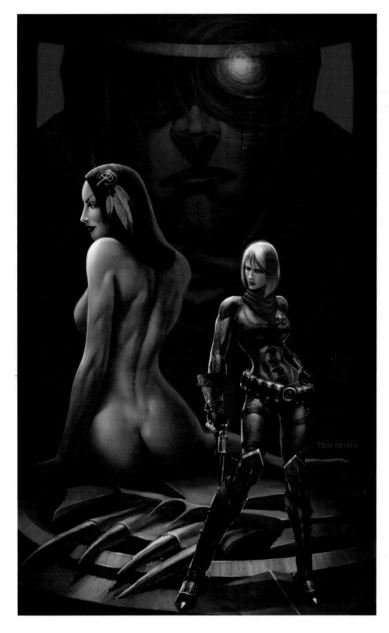

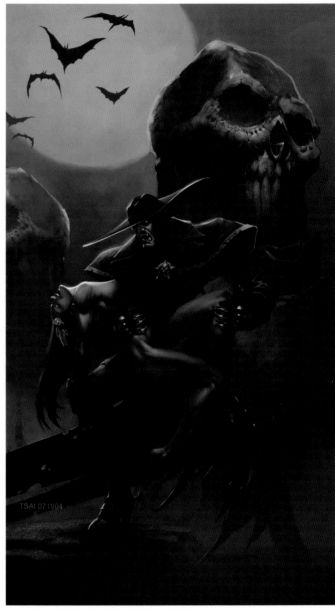

PASSIOΠ

ILLUSTRATED BY FRANCIS TSAI

At various stages in the development of the IP and the game, you have to start promoting the game and the Darkwatch universe. This is where the PR machine kicks in. Most people forget that a large quantity of art is also created to promote a video game.

These pieces were skillfully created by Francis Tsai to showcase the dark, gothic, and mature themes that are present in Darkwatch. Being the only gothic vampire-Western game thematically separates you from a lot of other products in the same first person shooter genre. Every image we created tried to communicate this unique point.

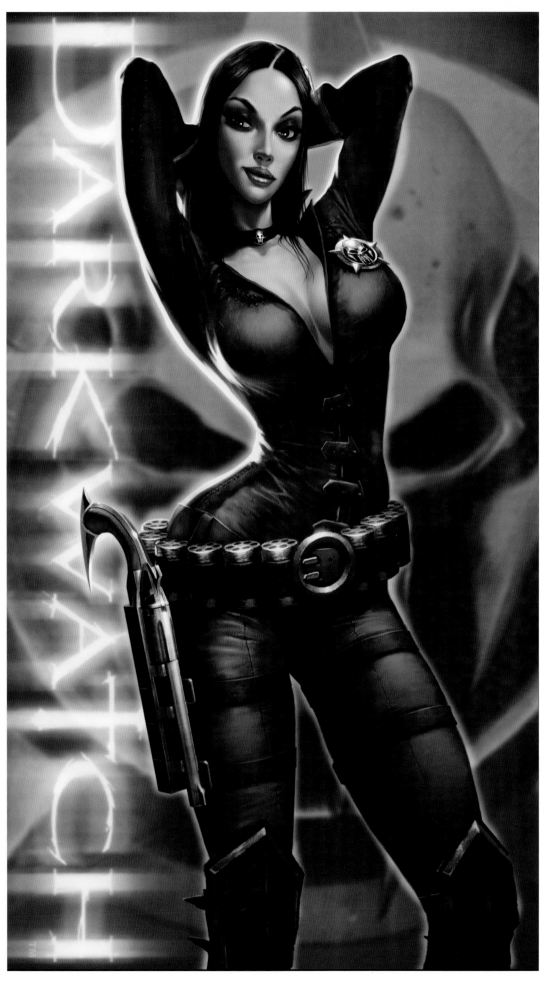

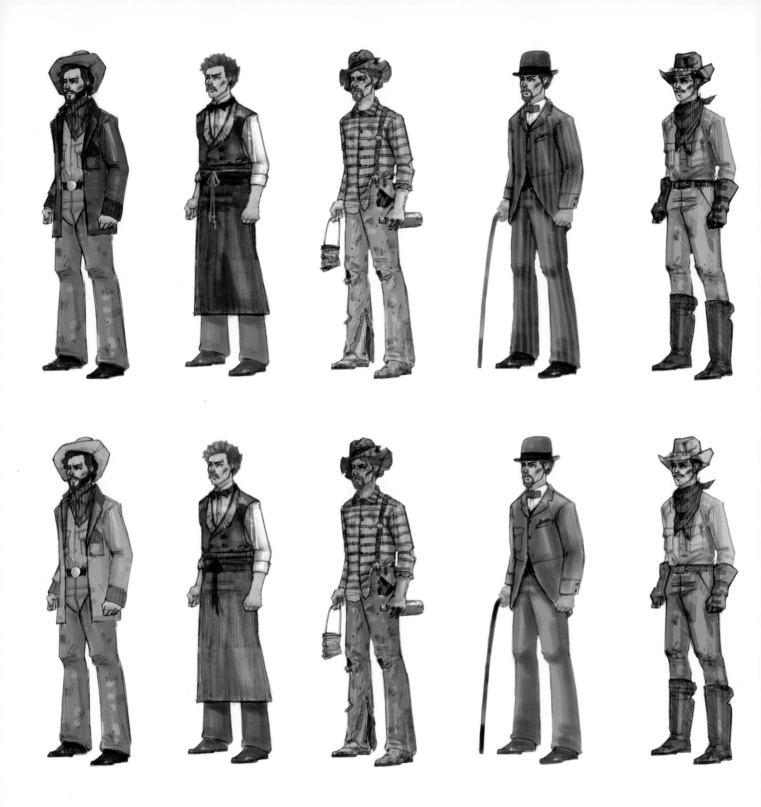

ᛏOWΠSFOLK AΠD GEΠERAL CLAY CARTWRIGHT

DESIGNED BY STEVE JUNG

A veteran of several U.S. wars, General Clay Cartwright took over the Darkwatch in the late 1860s. His no-nonsense approach, brutal tactics against the undead, and support of advancing technology earned him the steadfast loyalty of his troops. However, his ambition ultimately became his undoing.

Cartwright was based on Western icons Buffalo Bill and General Custer. We tried to illustrate his tough and charismatic qualities, as well as the hint at the brutal past and history that made him the man he is now. For instance, his scarred face and walking cane hint at a violent past. His impeccably clean uniform, rank insignia, and posture all hint at a man of experience, high standing, personal pride, and probably inflexible single-mindedness. He's dressed in black because Darth Vader wore black.

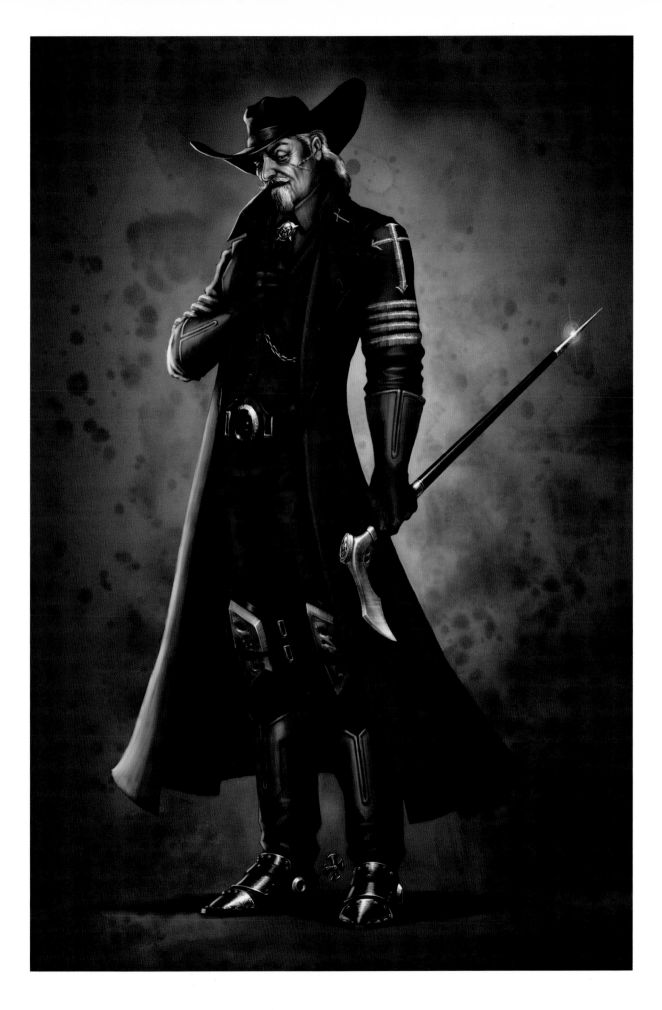

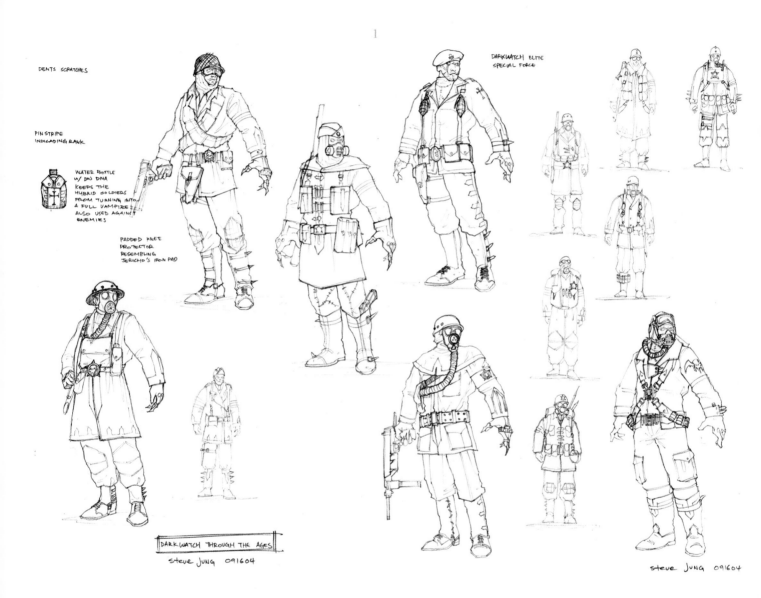

DENTS SCRATCHES

PIN STRIPE
INDICATING RANK

WATER BOTTLE
W/ DW DNA
KEEPS THE
HYBRID SOLDIERS
FROM TURNING INTO
A FULL VAMPIRE
ALSO USED AGAINST
ENEMIES

PADDED KNEE
PROTECTOR
RESEMBLING
JERICHO'S IRON PAD

DARKWATCH ELITE
SPECIAL FORCE

DARKWATCH THROUGH THE AGES
STEVE JUNG 091604

STEVE JUNG 091604

DARKWATCH THROUGH THE AGES

1. DESIGNED BY STEVE JUNG / 2. DESIGNED BY FRANCIS TSAI

The Darkwatch is an ancient secret society formed during the Roman Empire to secretly battle the forces of evil and the undead. These next few pages represent a quick pass at visually defining what Darkwatch agents have looked like during specific historical times. For all but the futuristic Darkwatch agent, we tried to apply a 80/20 formula meaning we grounded the designs to be around 80 percent historically accurate and then added about 20 percent Darkwatch visual DNA to the designs. For the futuristic agent, Francis pretty much had carte blanche to do blue-sky designs with, of course, the 20 percent Darkwatch DNA added in.

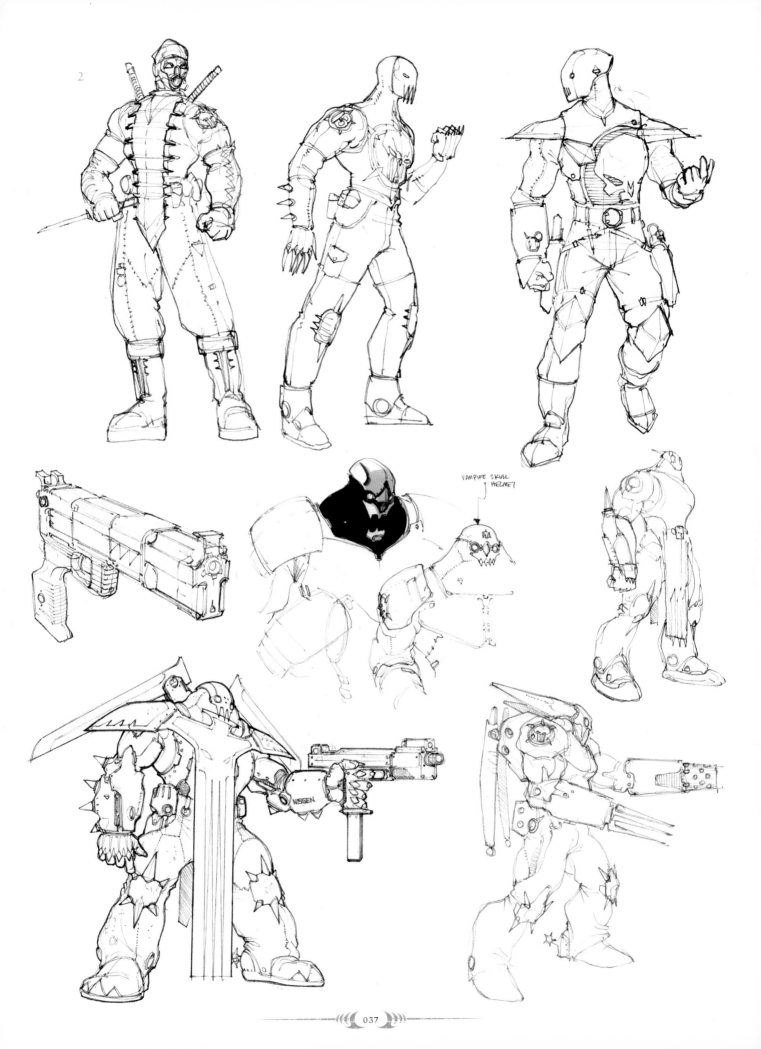

2

VAMPIRE SKULL
HELMET?

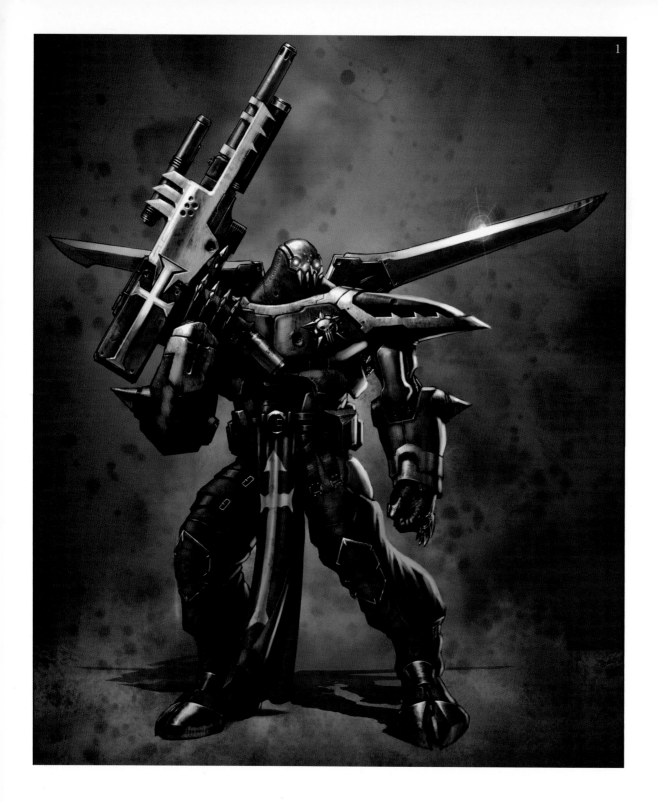

1. DESIGNED BY FRANCIS TSAI
2. DESIGNED BY MONGSUB SONG 3. DESIGNED BY SHANE NAKAMURA
4. DESIGNED BY FARZAD VARAHRAMYAN 5. DESIGNED BY STEVE JUNG

DARKWATCH THROUGH THE AGES

The finished pieces of the Darkwatch agents through the ages are tied together visually, belonging to the same organization thematically but also clearly conveying their single-minded purpose of quickly and brutally terminating evil.

From a business point of view, these images were invaluable in clearly communicating the franchise potential of an original IP such as Darkwatch.

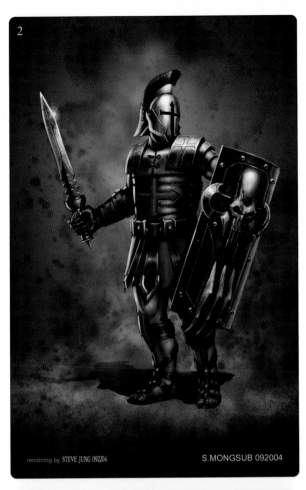

2

rendering by STEVE JUNG 092204　　　　　　　　S.MONGSUB 092004

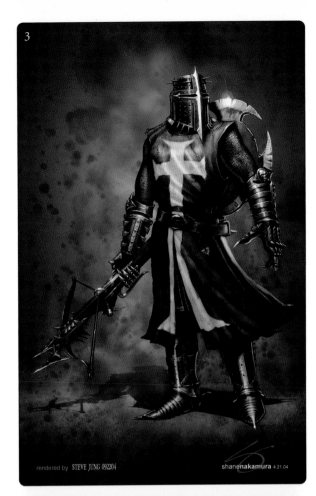

3

rendered by STEVE JUNG 092204　　　　　　　shanenakamura 4.21.04

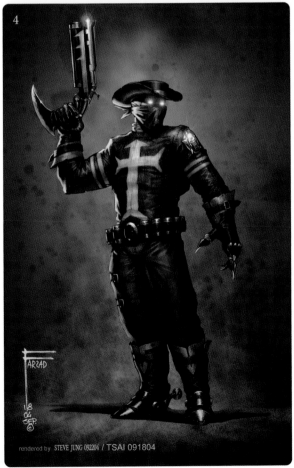

4

rendered by STEVE JUNG 092204 / TSAI 091804

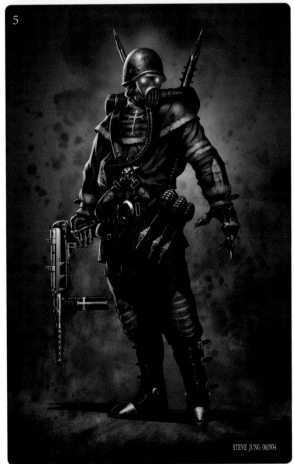

5

STEVE JUNG 061504

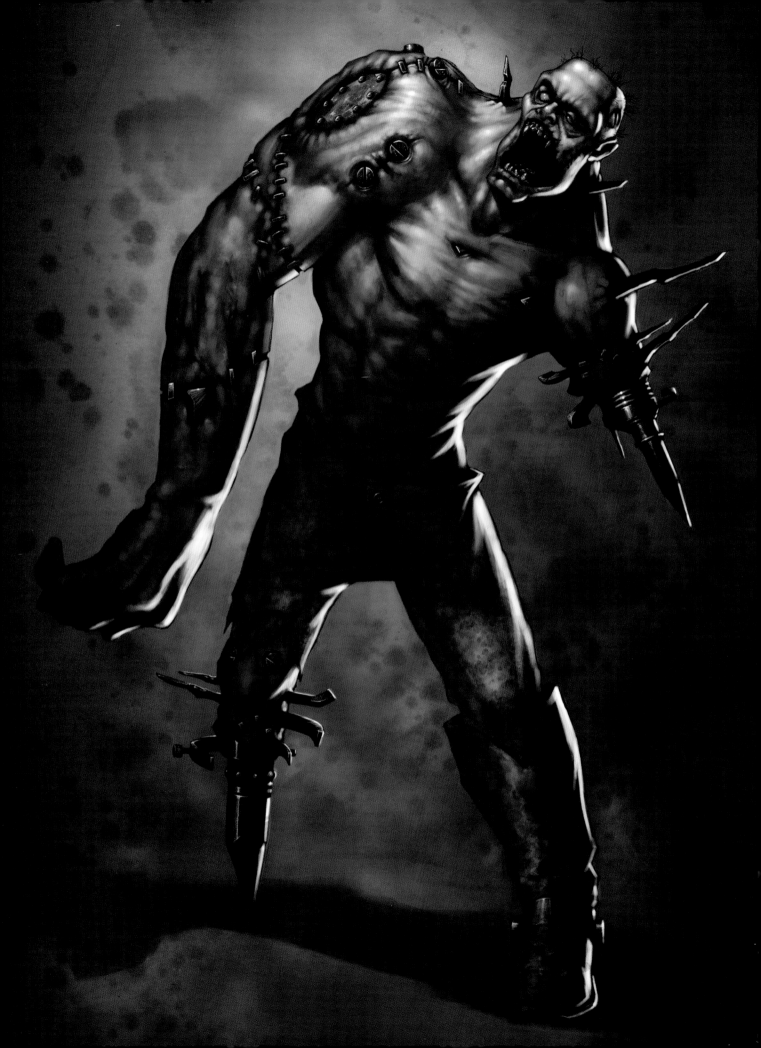

CHARACTERS: ENEMIES

2

Villains are a pivotal element in any narrative. A fully developed antagonist provides something invaluable to a story–conflict. There is no story without conflict, and a great hero can't exist without a great villain.

Video games are evolving into a uniquely interactive and immersive storytelling medium. Here the player is in direct and interactive conflict with the villain and not merely observing danger through the eyes of another.

With Darkwatch the goal was to create villains that viscerally moved the story forward and gave the player the ultimate experience and satisfaction of living out their evil slaying-fantasies in the haunted West.

1. DESIGNED BY STEVE JUNG 2. DESIGNED BY FRANCIS TSAI

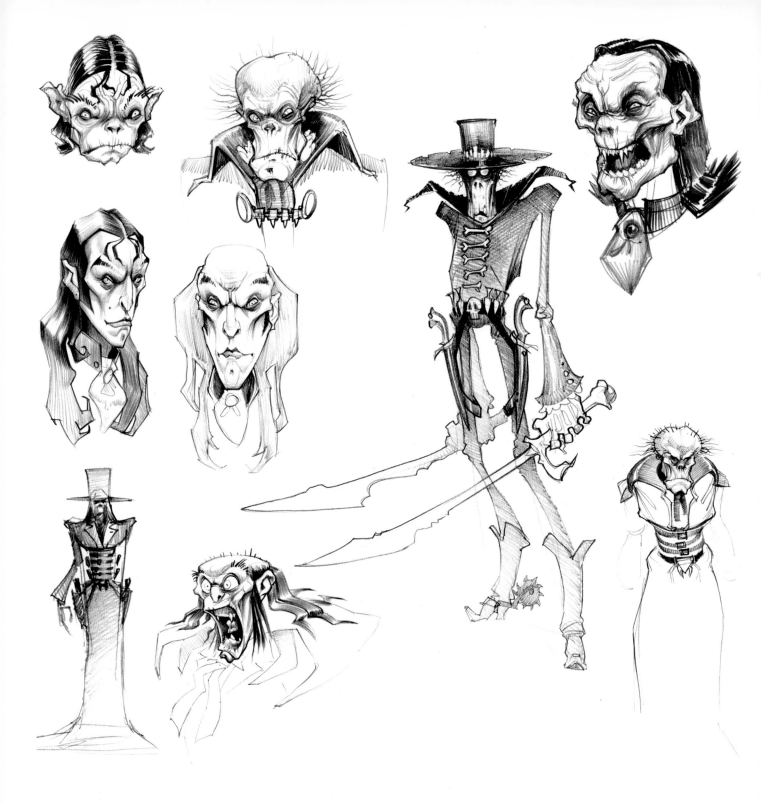

OLD VAMPS

ALL DESIGNED BY FARZAD VARAHRAMYAN

Before we settled on Lazarus Malkoth for the name of our vampire nemesis, he was called initially Croatoan and later Scourge. We settled on Lazarus because it had the right ring and feel to it, was easier to pronounce and remember, and was also unused. Again, you can see the early progression similar to what Jericho went through. Farzad explored a variety of directions and varying degrees of stylization.

On the opposite page is the midpoint design for Lazarus. The main concept here was that Lazarus could quick-draw and fire four revolvers in such rapid succession that not only were his hands a blur, but it sounded like he was firing a machine gun.

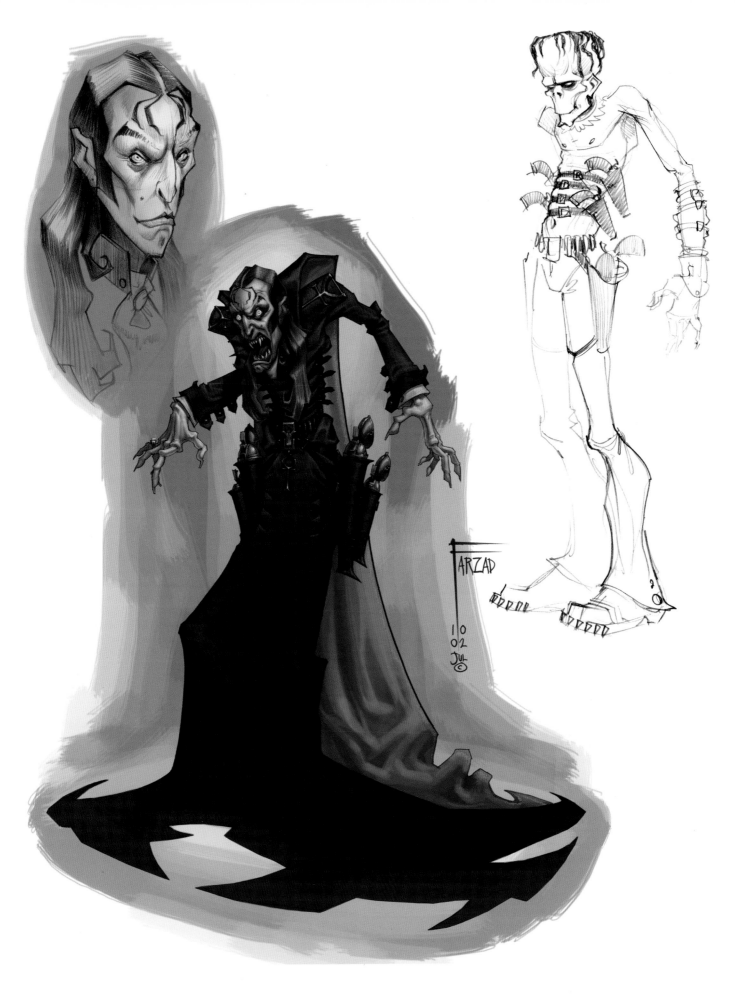

FARZAD

1 0
0 2
JUL ©

CROATOAN: Stage 01

Reveal of hidden inner mouth and fangs.

When desired, facial skin, retracts up to the eyes.
This reveals, 4 large articulated fangs that hold the victim
in place, while the 2 front fangs plunge into the victim.

An inner upper and lower jaw, facilitate
the consumption of the victim.

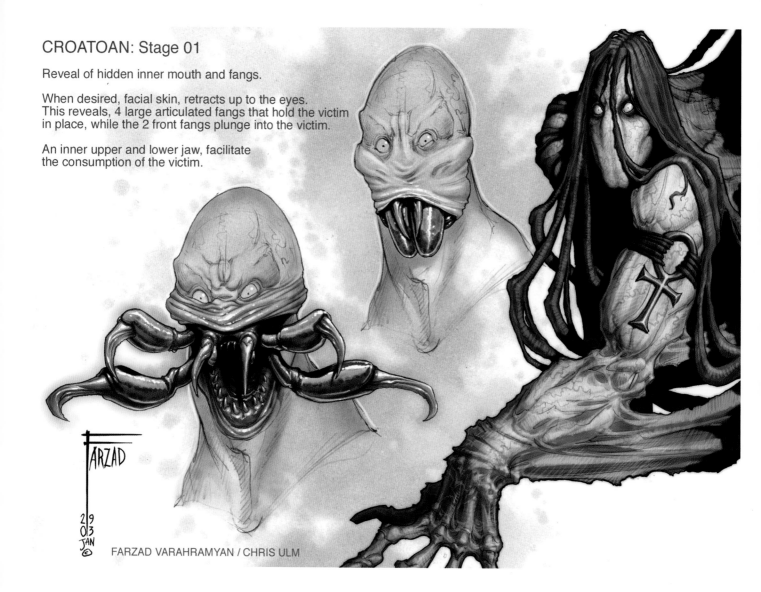

FARZAD VARAHRAMYAN / CHRIS ULM

LAZARVS MALKOTH

ALL DESIGNED BY FARZAD VARAHRAMYAN

The next incarnation of Lazarus was definitely a darker and far more menacing design, more in line with the darker and high-action gameplay that was envisioned for the game. With snakelike ability to slither on all surfaces, obvious size and strength, and a face-peeling action that reveals a maw full of poisonous fangs and carnivorous teeth, the design looked like it worked. However, when we focus-tested this design in Europe and in the United States, we found that with little exception the audience could't see this character in the Darkwatch universe because it was simply too alien. He simply wasn't believable to the target audience. The lesson here is to listen to and interpret what your audience says, and use that feedback to improve the work. Ultimately, you make the design choices. Constructive feedback is a valuable tool.

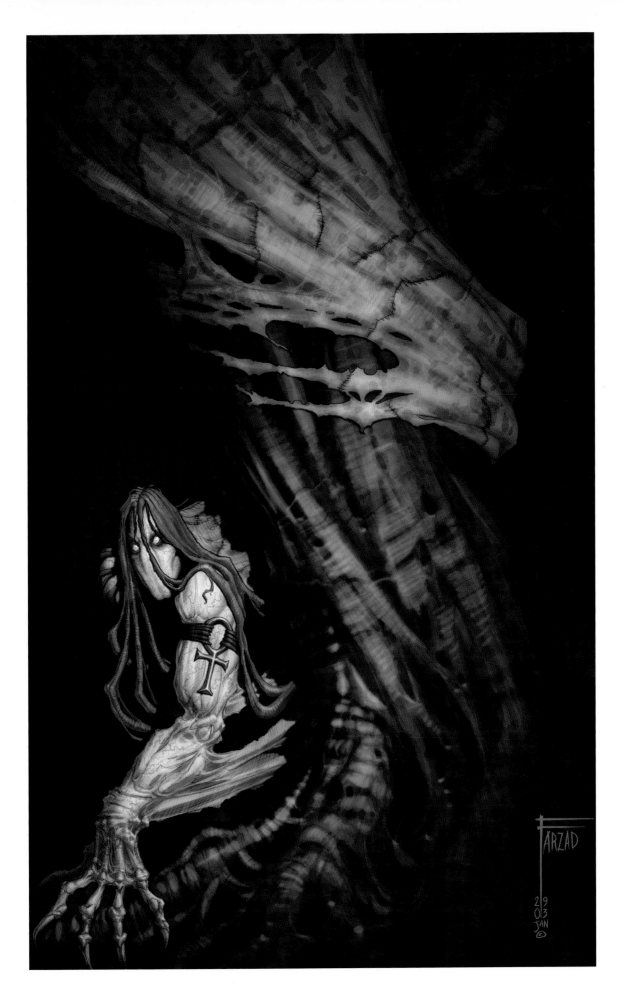

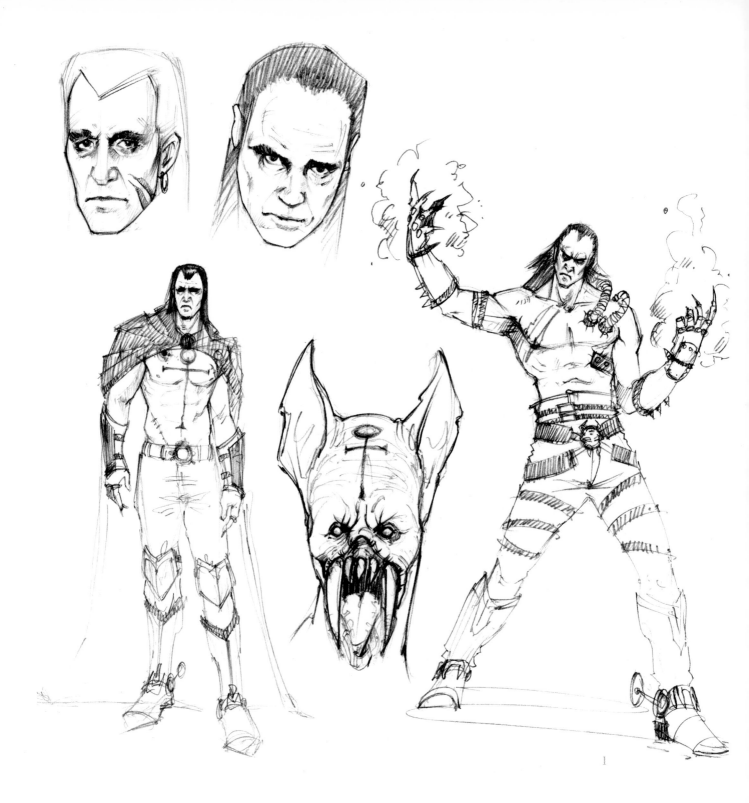

LAZARUS MALKOTH

1. BY DESIGNED BY STEVE JUNG
2. BY DESIGNED BY FARZAD VARAHRAMYAN

Here are more glimpses at other directions we pursued with Lazarus. We actually brought him back to be more of a human character, as well as explored more iconic, old vampire designs.

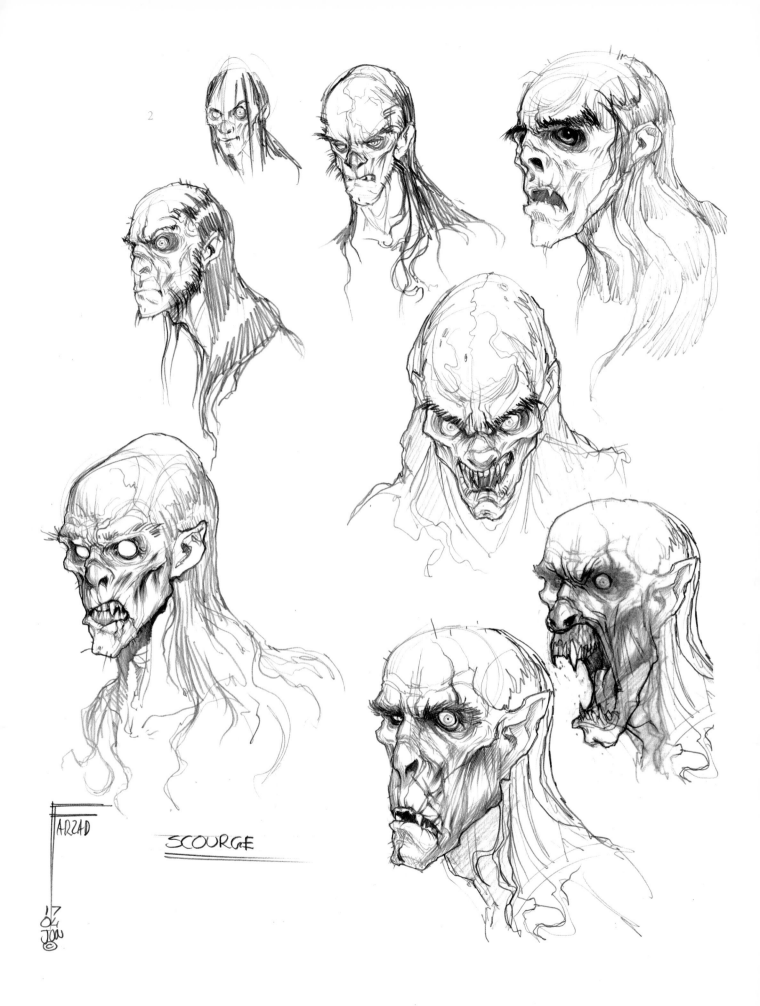

SCOURGE

FARZAD

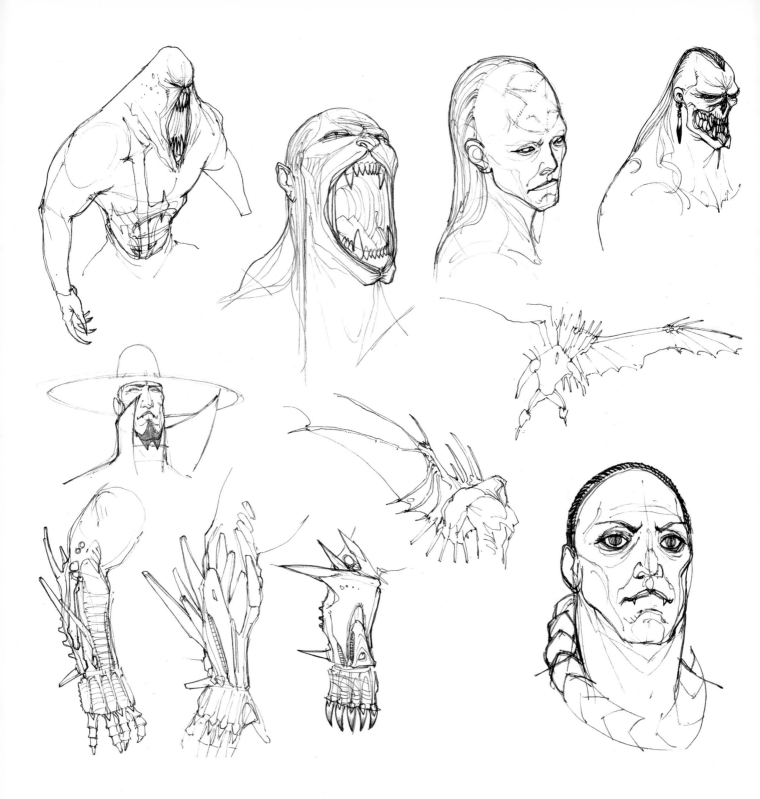

LAZARUS MALKOTH

ALL DESIGNED BY FRANCIS TSAI

Francis ultimately came up with Lazarus' design. In the early stages, the design shows a Lazarus that is deeply scarred, branded, and visibly weakened by his long incarceration. Once we were able to establish this more believable character, we were able to mutate him into his final and most lethal stage by the game's end.

For the final boss design, the challenge here was to create the baddest bat-winged vampires you've ever seen. We chose to build upon the classic bat-wing, but to enter a conceptual element–the wings, the largest graphic elements, were composed of the bones and skins of Lazarus' victims. Essentially, you are what you eat.

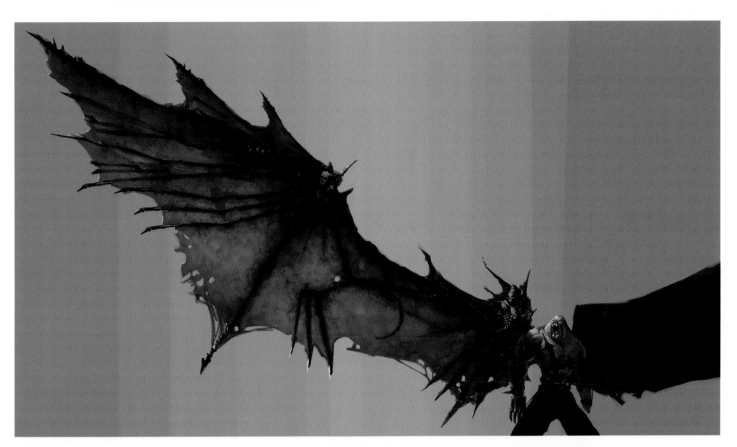

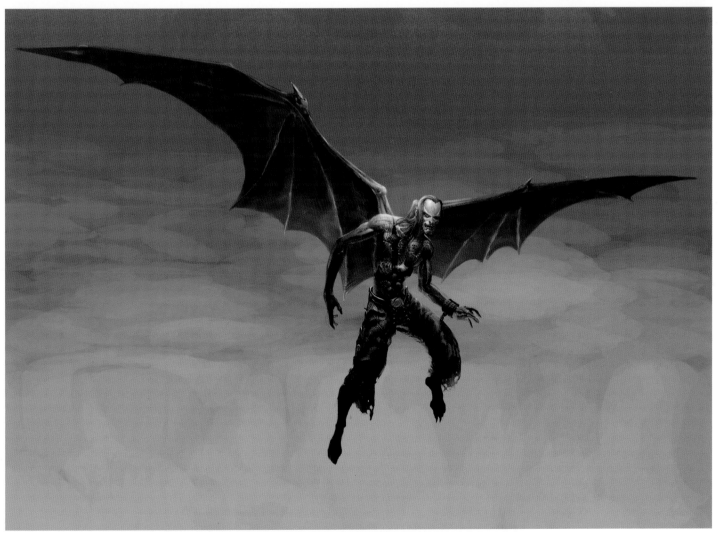

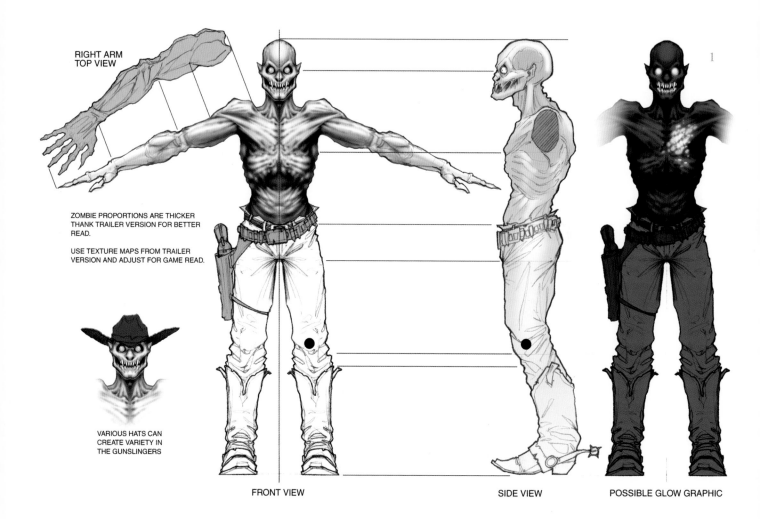

RIGHT ARM
TOP VIEW

ZOMBIE PROPORTIONS ARE THICKER
THANK TRAILER VERSION FOR BETTER
READ.

USE TEXTURE MAPS FROM TRAILER
VERSION AND ADJUST FOR GAME READ.

VARIOUS HATS CAN
CREATE VARIETY IN
THE GUNSLINGERS

FRONT VIEW SIDE VIEW POSSIBLE GLOW GRAPHIC

UПDEAD GUПSLIПGER

ILLUSTRATED BY JANG C. LEE DESIGNED BY FARZAD VARAHRAMYAN

There are two types of gunfighter—the quick and the dead. These guys are the latter, but being dead doesn't stop them from continuing their careers as hair-trigger guns-for-hire. The original gunslinger to the right was illustrated by Jang Lee. Although the design was well received, once we put it in the game it became clear that the thinner proportions in some of our characters would make them harder reads, resulting in a more frus-trating target to see and shoot. This is a great example of using game test-ing and feedback early on to adjust, redirect, and solve the design prob-lem. The drawing above illustrates that redirection. A thicker and repro-portioned gunslinger with more torso area to use as a target made for a better game experience.

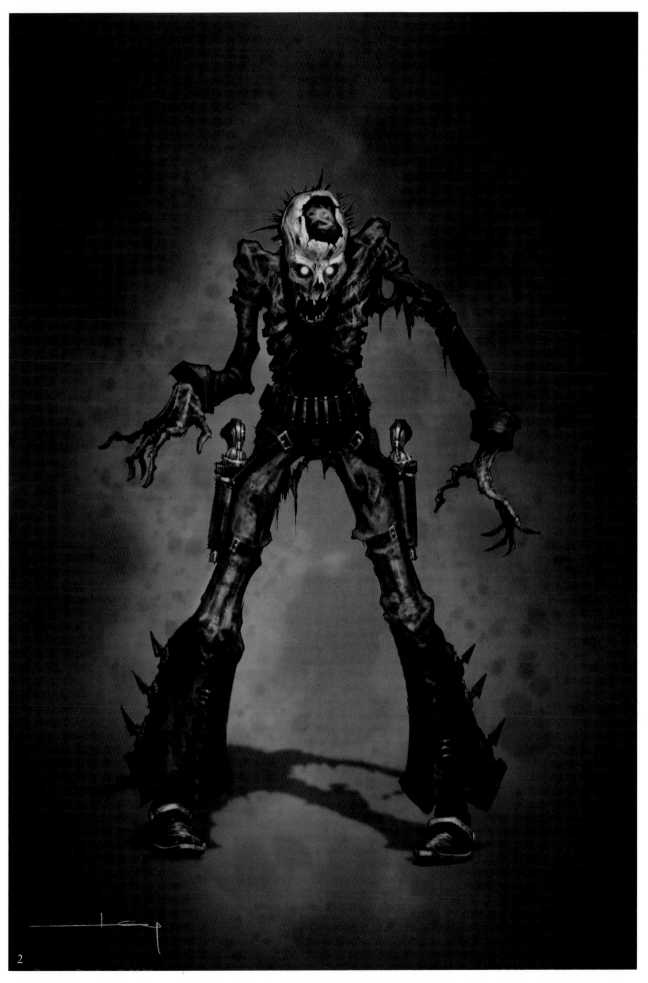

2

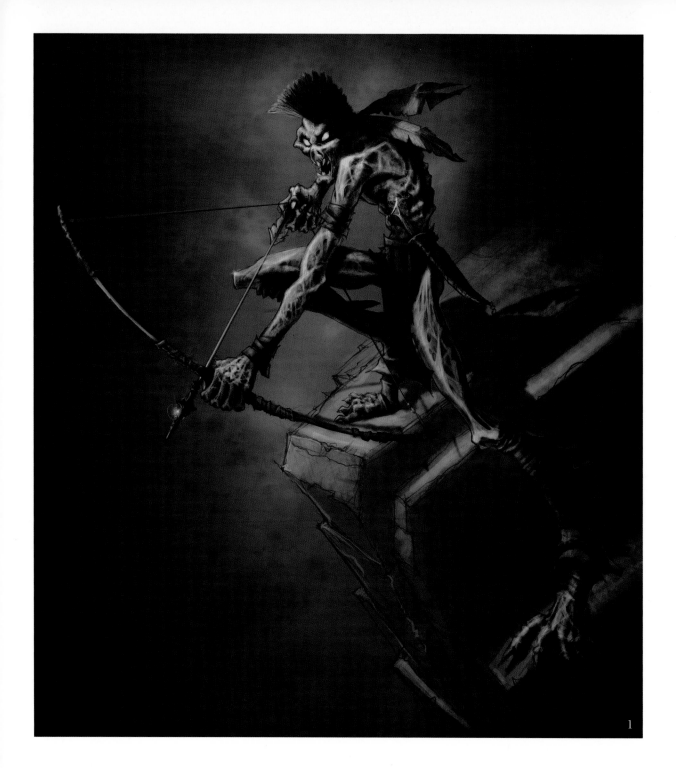

1

UΠDEAD BRAVE AΠD BAΠDITO

1. ILLUSTRATED BY SHANE NAKAMURA / 2. DESIGNED BY FARZAD VARAHRAMYAN

Vengeful Native American spirits raised from the dead and given human form by Lazarus, the braves are agile, quick, and deadly. Armed with tomahawks or bows, braves can perform superhuman leaps and are equally adept at close-range combat.

Some fat, hard-drinking bastards never die, even though everybody, including their mothers, wishes they would. In undead form, all that blubber hardens into armor, making banditos tough as hell. All those bar fights made them into great melee fighters too. At striking range, their shotguns pack a mean punch.

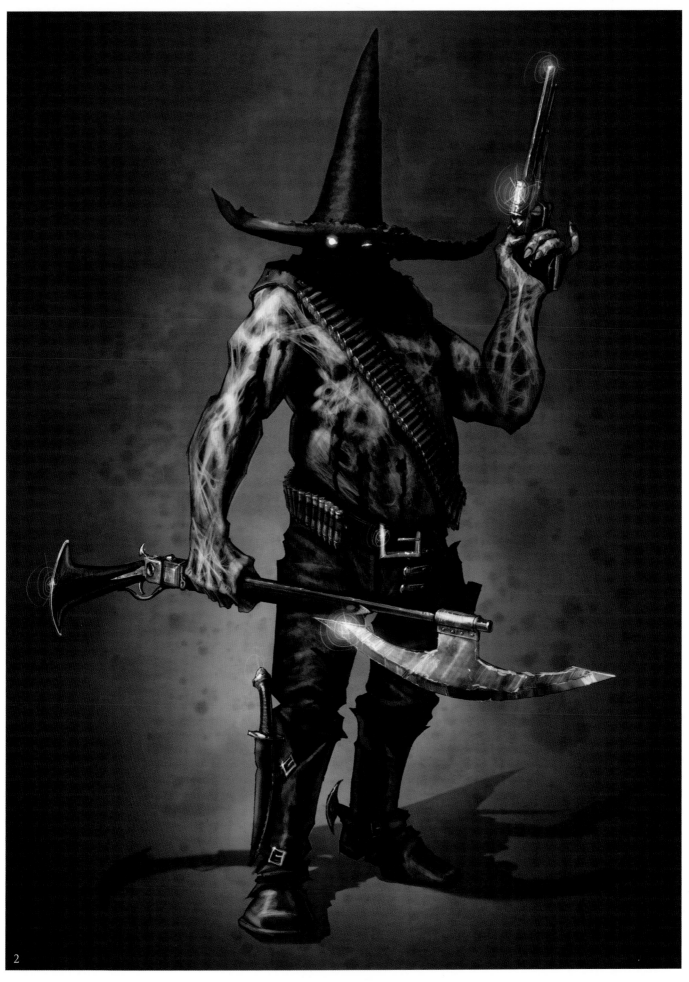

2

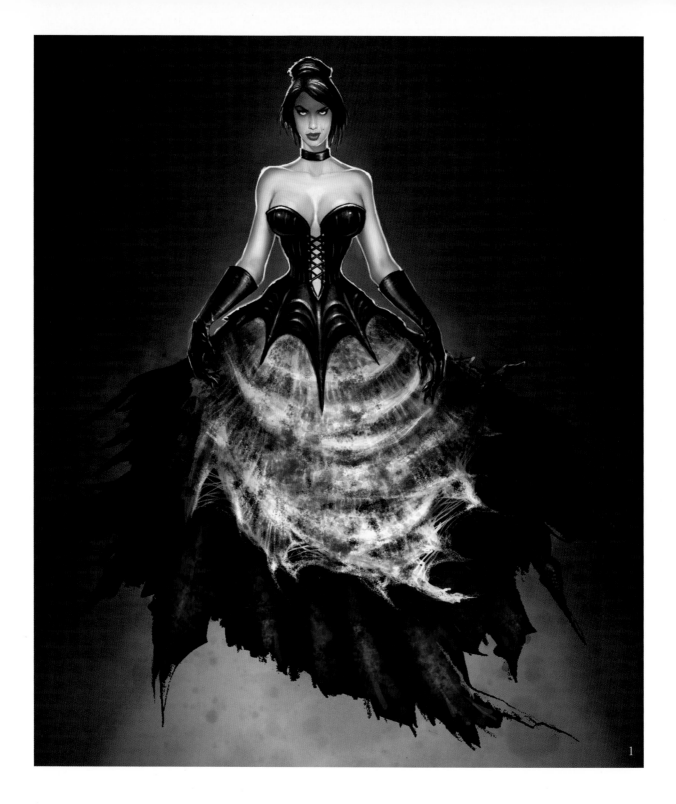

BANSHEE AND RED MOON

1 & 2 DESIGNED BY STEVE JUNG

Banshees are the murderous spirits of saloon girls done wrong. Normally, they use their hypnotic voices to lure wayward cowboys from their trails and make them lose their way in the wilderness. But their leader, Lazarus, however, has turned them into vicious killers who seek fresh souls to bring to their master.

The leader of a small Indian tribe, Red Moon fought bravely to save the life of Jericho Cross and aid him in his journey across the West. Red Moon's fate was sealed when the two mixed their blood in a pact of brotherhood.

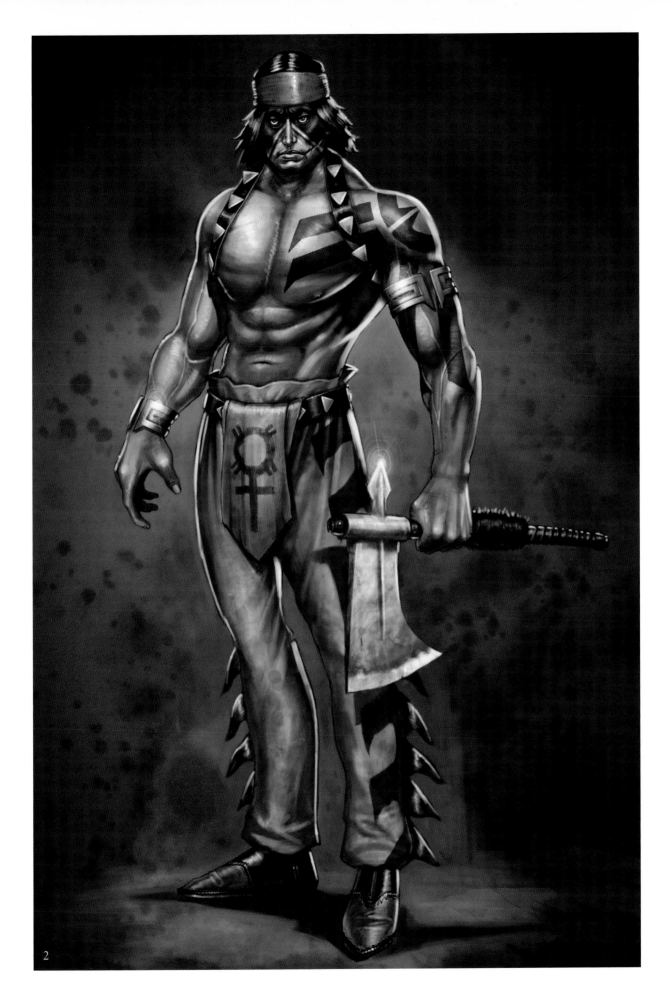

2

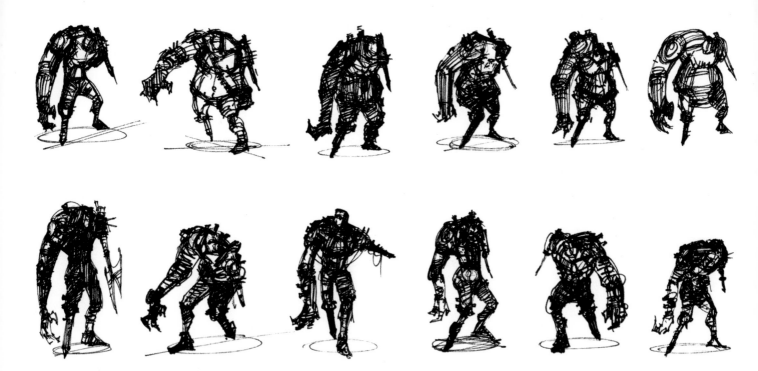

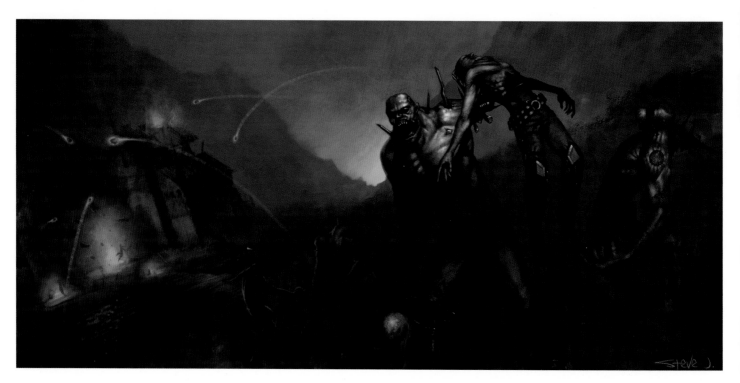

HELLION

ALL DESIGNED BY STEVE JUNG

The hellion is an abomination even to the world of the living dead. Assembled from parts of other undead creatures, melded with technology, and fueled by spectral forces, the hellion are able to take down massive structures in small groups and systematically slaughter all who lie within. The hellion will appear in Darkwatch II.

As seen above, all of our concept designs start with very small thumbnails, which help us to concentrate on the critical issues of a unique silhouette, proportions, and personality through pose. We don't worry about the details until we have a thumbnail that looks good and effectively communicates the main points, i.e.,monstrous, tortured soul, in pain, and capable of causing pain and brutal damage.

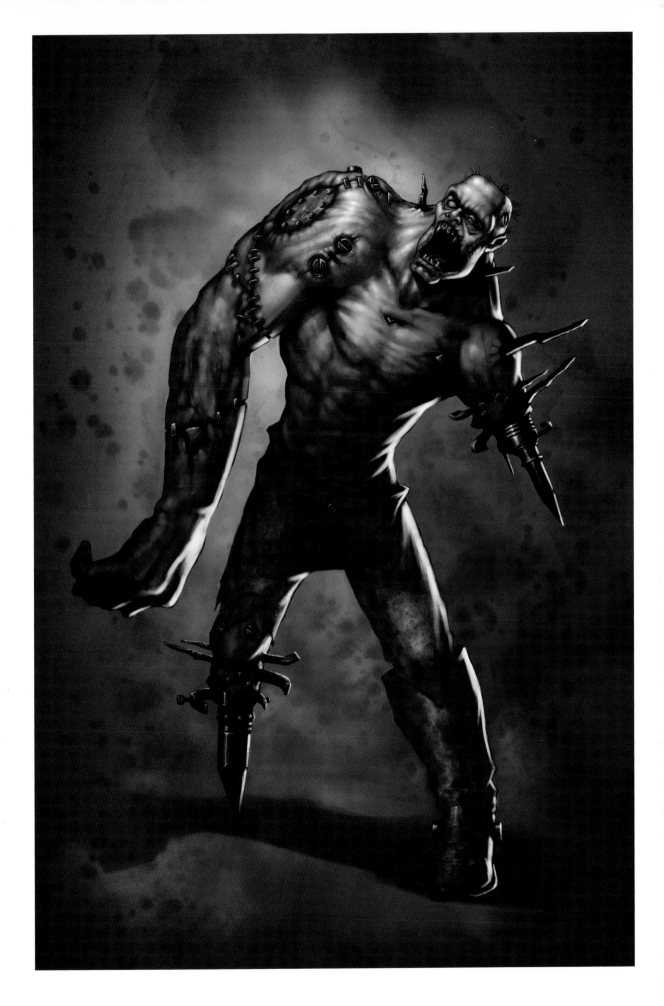

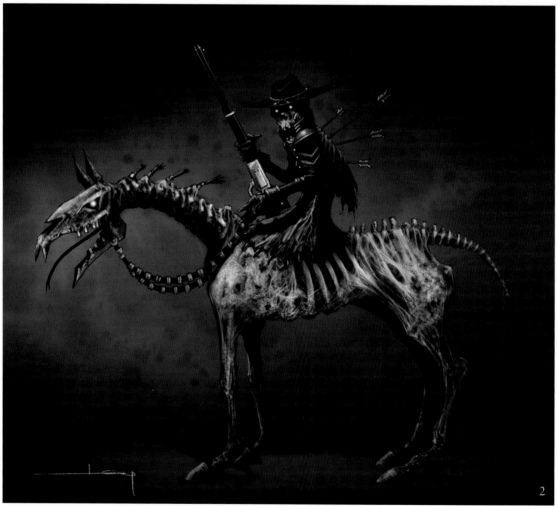

UNDEAD RIDER AND MOSQUIRATU

1 & 3 DESIGNED BY FARZAD VARAHRAMYAN
2. ILLUSTRATED BY JANG C. LEE

The fallen souls of frontiersmen and soldiers who died while lost in the open plains, undead riders traverse the arid deserts of southwest Arizona seeking victims to add to their numbers. The fiendish mosquiratu are a mutation of the vampire line, using their retractable proboscis to drain their victims of blood. An adult human can be drained of every drop in a matter of seconds; entire regiments of soldiers in the Civil War fell to these bloodsuckers in mere minutes. Even other vampires fear their insatiable appetite for blood. Look for them in Darkwatch II. This great concept for using other bloodsuckers was originally proposed by Emmanuel Valdez and opened up a whole range of new creature designs. Mosquitos are essentially vampires.

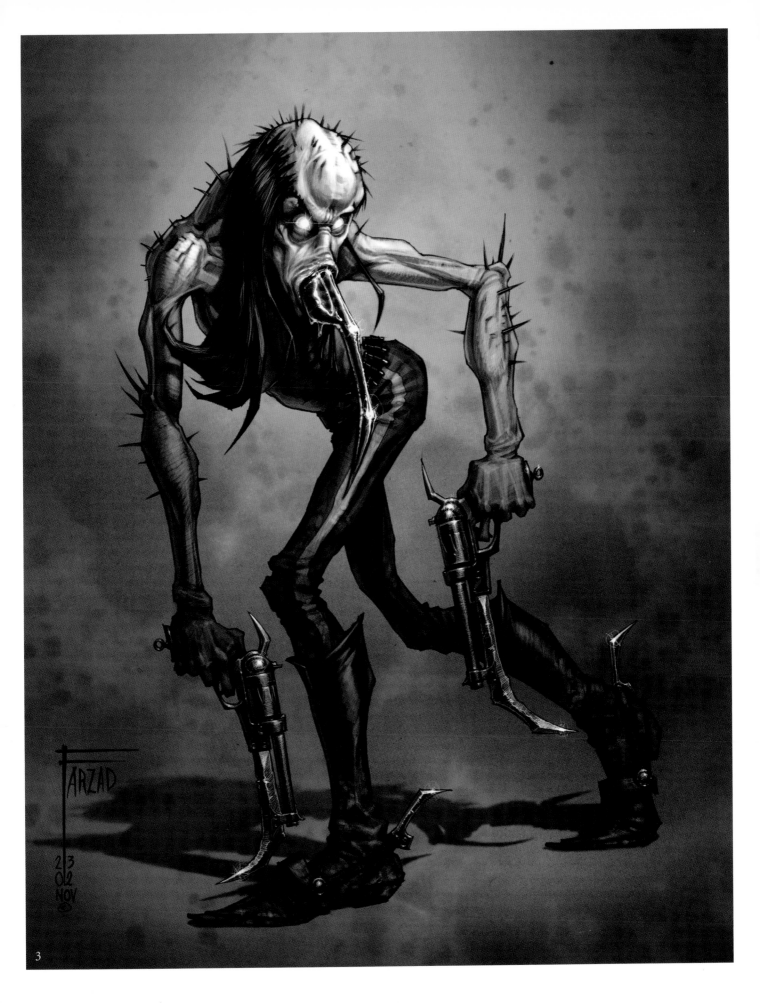

▷ "NIGHTMARES" ARE
CLOAKED IN TOP
HATS & OVERCOATS
CONSEALING THEIR
TRUE NIGHTMARISH
SELVES.

▷ WEAPON: THEY
SPIT WEBS TO
TRAP YOU & THEN
COCOON + SUCK
YOU DRY.

▷ LOCOMOTION:
THEY APPEAR TO
GLIDE WHEN
CLOAKED.
- ACTUALLY THEY
TIPTOE ON 8
LEGS

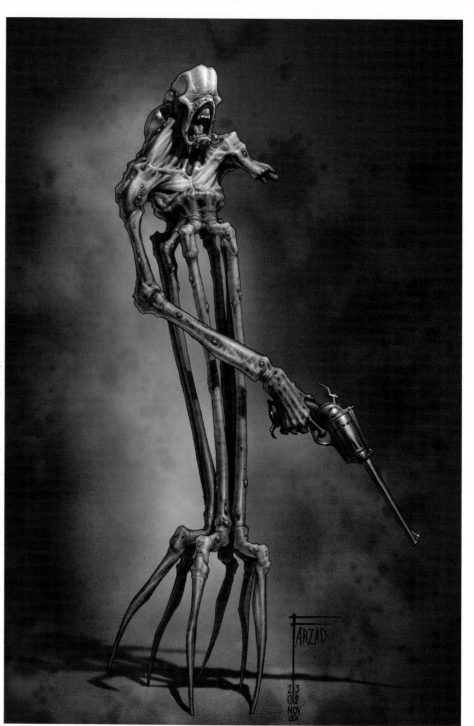

ПIGHTMARE

ALL DESIGNED BY FARZAD VARAHRAMYAN

Wraithlike, undead duelists will make their debut in Darkwatch II. Farzad's approach to this character was to create a walking nightmare. The concept is that you are confronted by a bizarre vision of a Western undertaker. After you repeatedly shoot him his cloak disintegrates and he screams, revealing the true nightmare beneath the cloak. The multiple bullet holes in the cloak hint at the formidable, still standing opponent that will face you. Decayed flesh, plague, arachnids, cannibalism, and the absence of eyes are some of the elements drawn upon to create this creature.

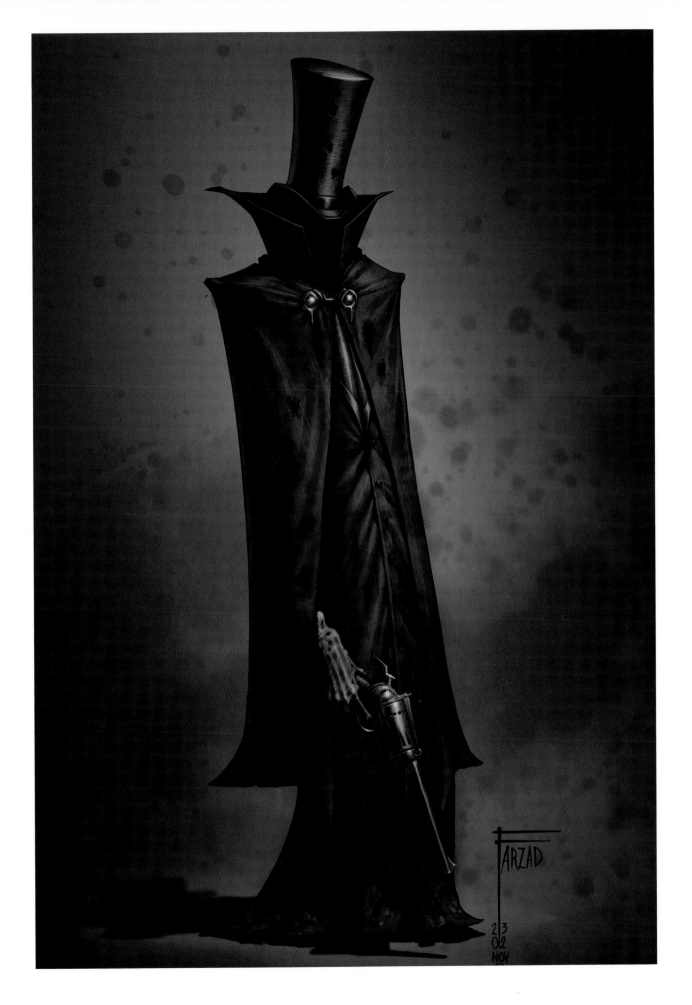

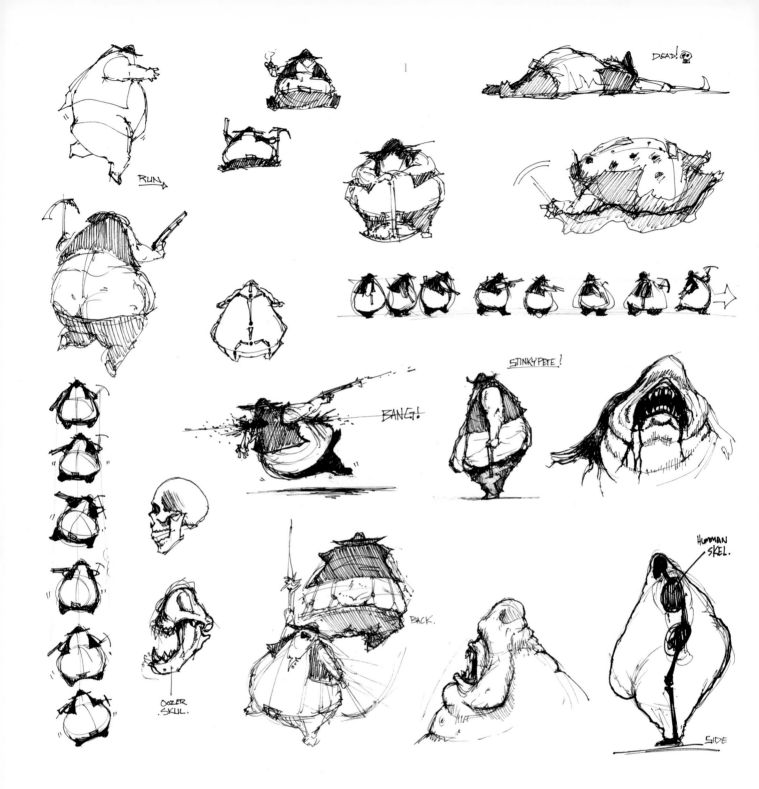

OOZER

1. ILLUSTRATED BY SHANE NAKAMURA / 2. DESIGNED BY FARZAD VARAHRAMYAN

Blind and malformed, the Oozer is the most underestimated among the undead. They are always mistaken for being dumb and slow, and many Darkwatch regulators who made this assumption met bloody ends.

This design was inspired by another idea Emmanuel had–a creature so engorged with blood and human flesh that it grew to gigantic and bloated proportions. This initial inspiration led to this sightless, piglike creature that uses his own vomit as an offensive projectile weapon.

Above, Shane Nakamura explores in thumbnails everything from possible locomotion to bone structure.

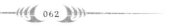

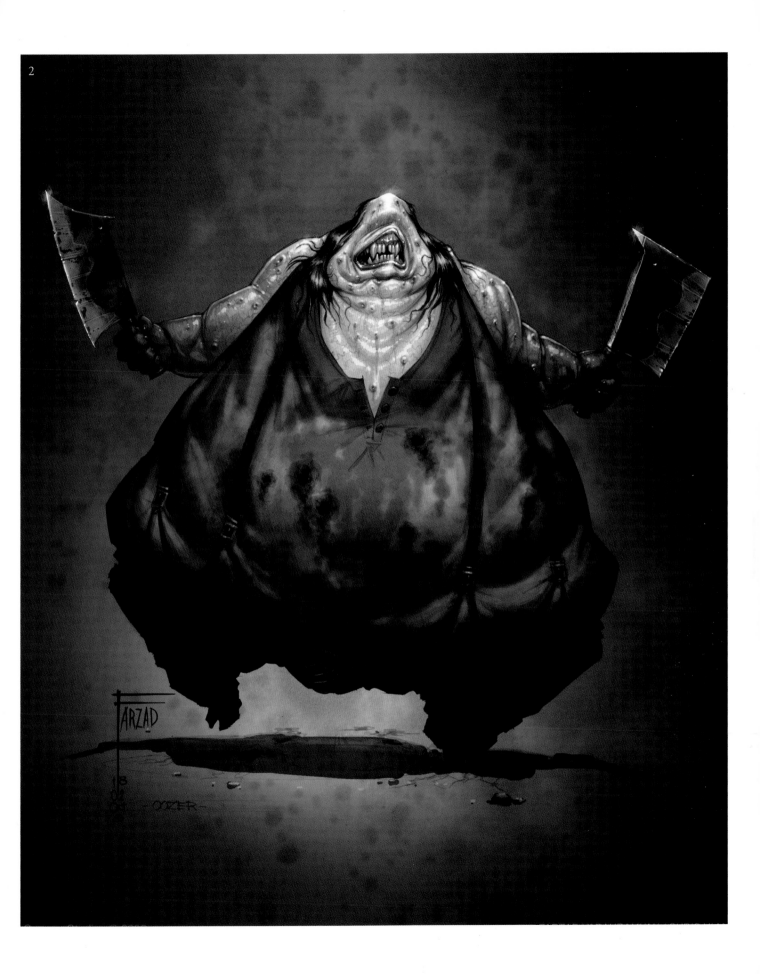

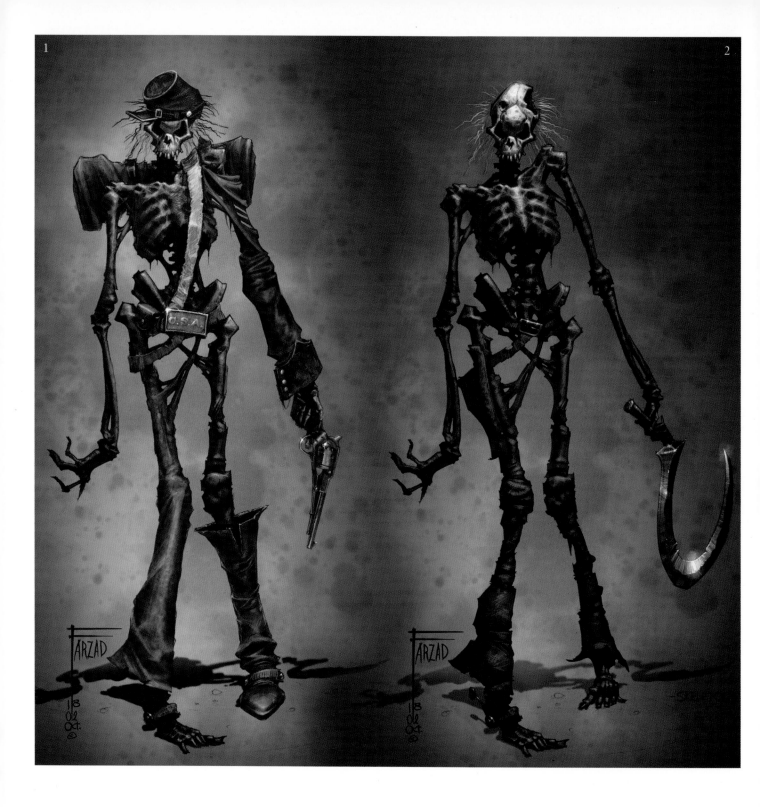

REAPER

1 & 3 ILLUSTRATED BY SHANE NAKAMURA / 2. DESIGNED BY FARZAD VARAHRAMYAN

In the game, reaper skeleton is one of the most common found across New Mexico and Arizona. Slight in stature, the reaper is frequently underestimated by those unaccustomed to fighting the undead. Its bone-thin body mass and unnaturally quick reflexes make it very difficult to target and even more difficult to escape from. Reapers enjoy feeding on the flesh of the living and traveling in packs.

Much like the gunslinger, some refinements and rescaling for the in-game versions of the reaper, produced a thicker, and more easily targeted enemy.

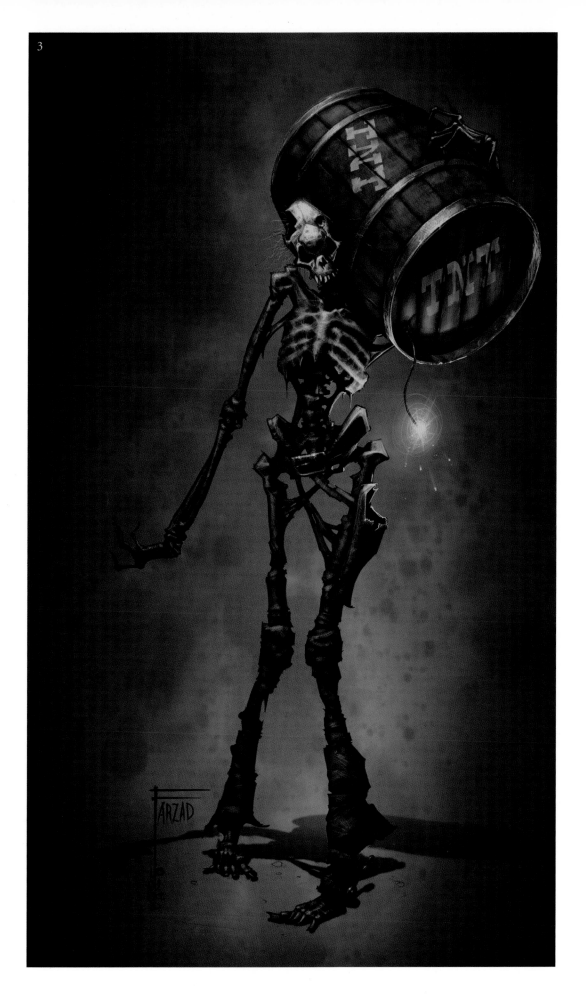

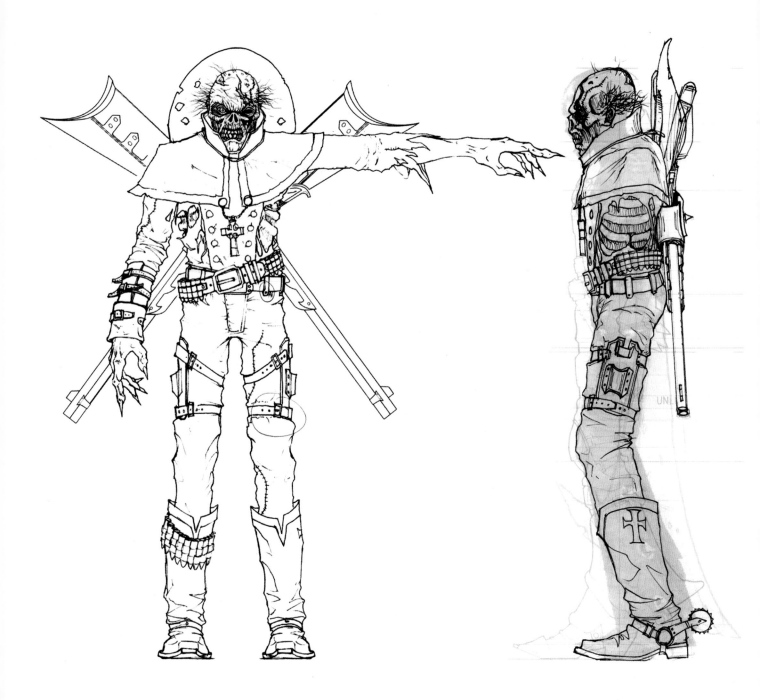

UNDEAD RIFLEMAN

ALL DESIGNED BY SHANE NAKAMURA

These fallen Darkwatch soldiers are perhaps the most deadly of the undead, for they carry the armaments and armor of the Darkwatch.

Concept art is usually thought of as the final rendering or illustration everyone sees in the "art of" books. Concept artists also spend a large por-tion of their time figuring out the design details and doing multiple draw-ings from all angles, often producing detailed drawings that will enable a modeler and texture artist to build and texture the design.

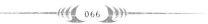

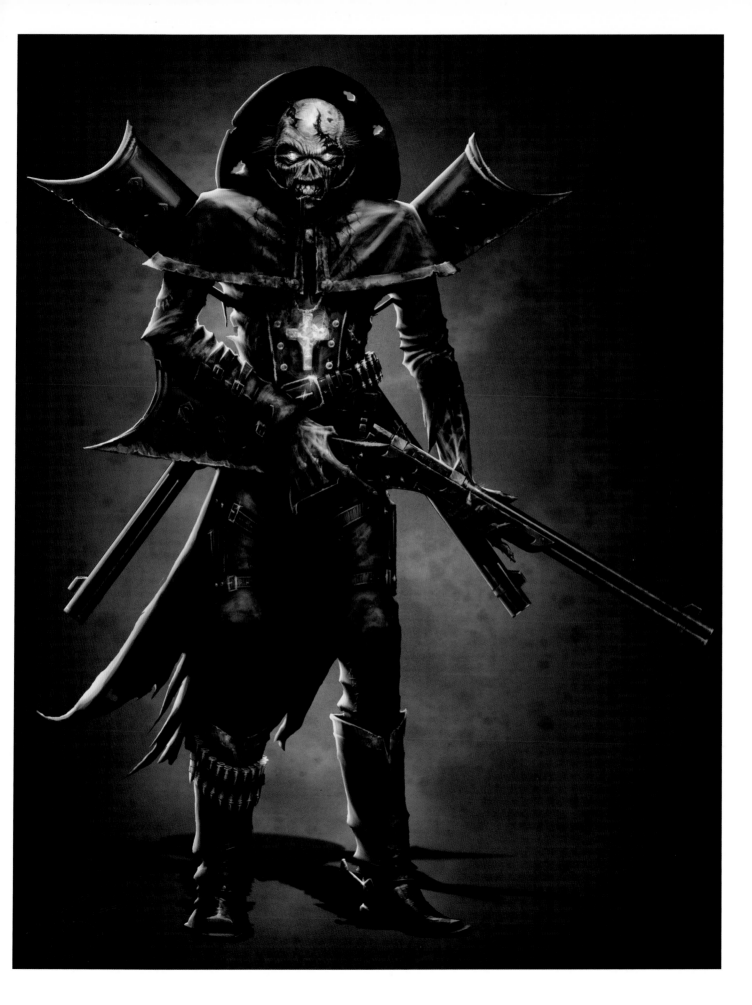

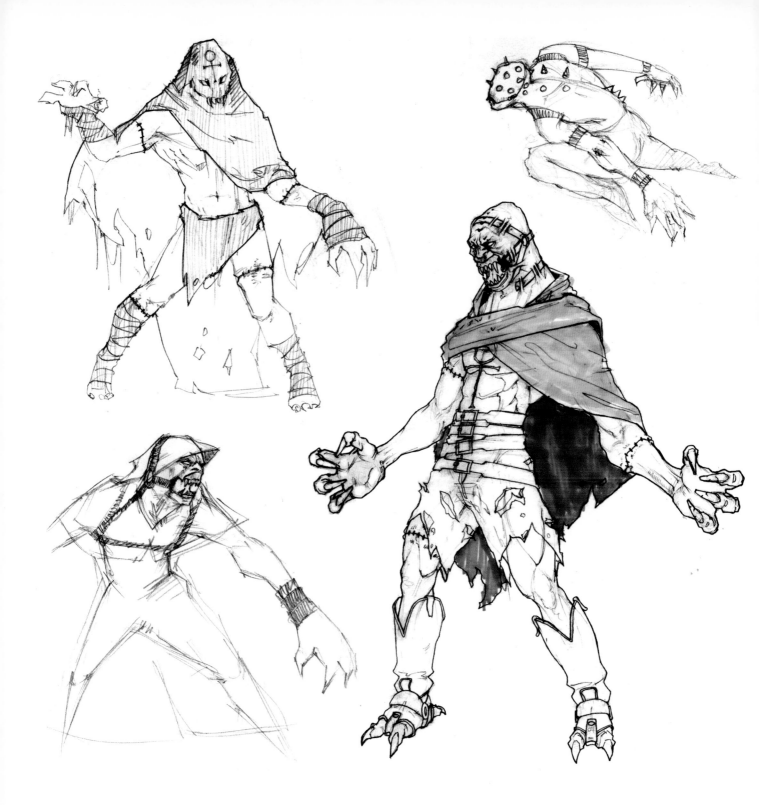

VIPER

ALL DESIGNED BY STEVE JUNG

A form of supervampire, vipers can vanish and travel through space at the
blink of an eye turning up behind their victims in an instant so that they
have little time to put up a fight. The first glimpse of a viper is usually the
last.

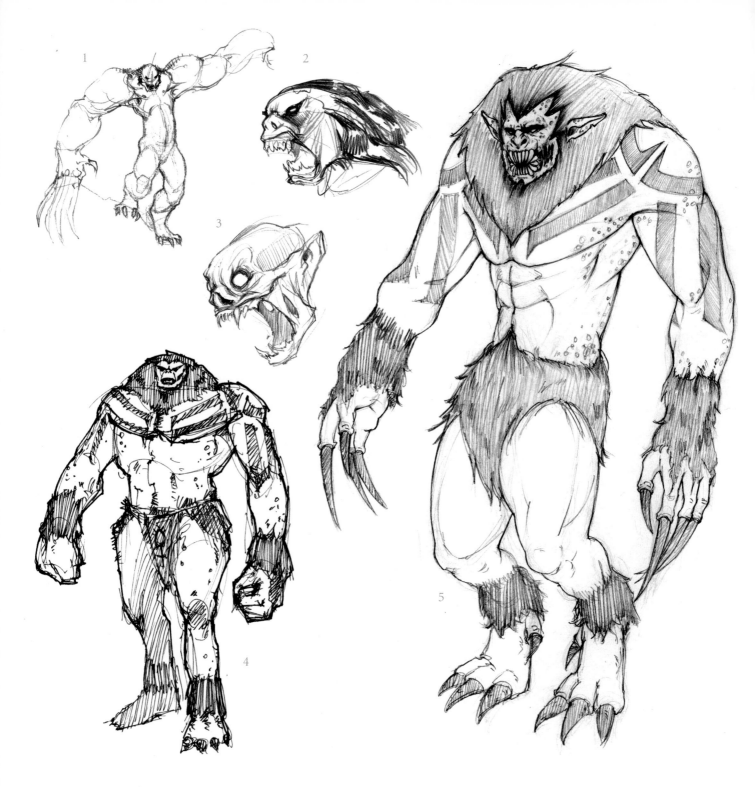

1, 2 & 3 DESIGNED BY FARZAD VARAHRAMYAN
4 & 5 DESIGNED BY STEVE JUNG
6. DESIGNED BY FARZAD VARAHRAMYAN / ILLUSTRATED BY STEVE JUNG

WEHDIHGO

Red Moon's pact of brotherhood with Jericho infused his blood with that of the undead, twisting his mind and body into the horror that is the Wendigo. Bloodthirsty and absolutely insane, the Wendigo kills for pleasure as well as nourishment. Red Moon's alter ego will also make its appearance in Darkwatch II.

Often in a production, multiple artists will work collaboratively on the same concept. Both Steve Jung and Farzad worked on the Wendigo design.

6

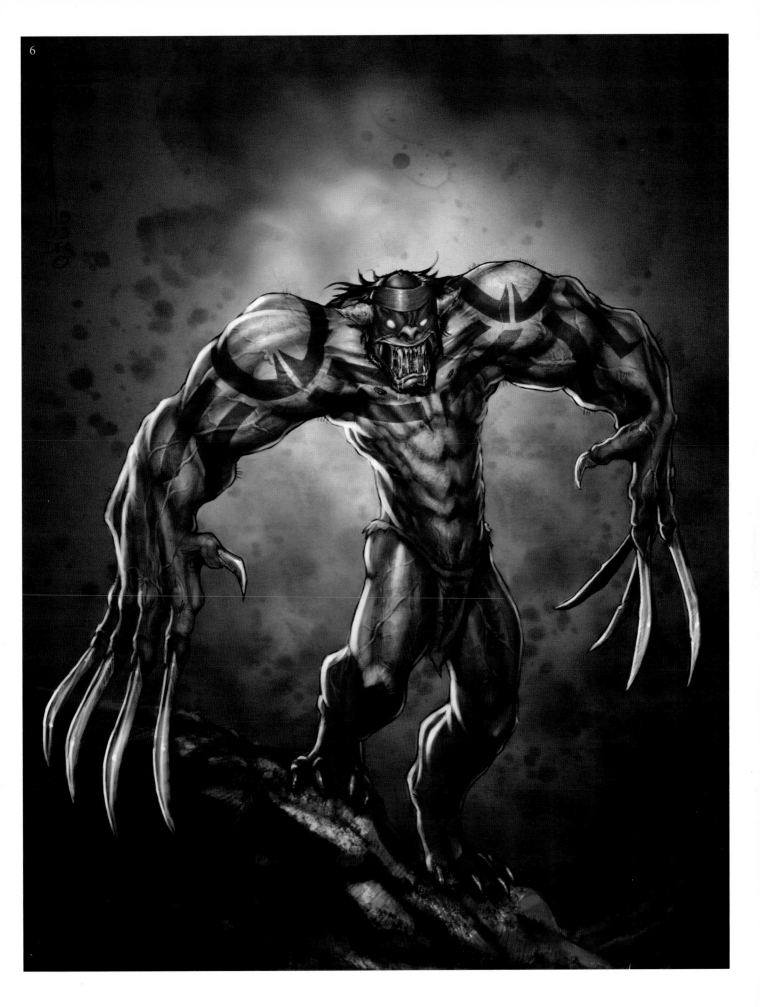

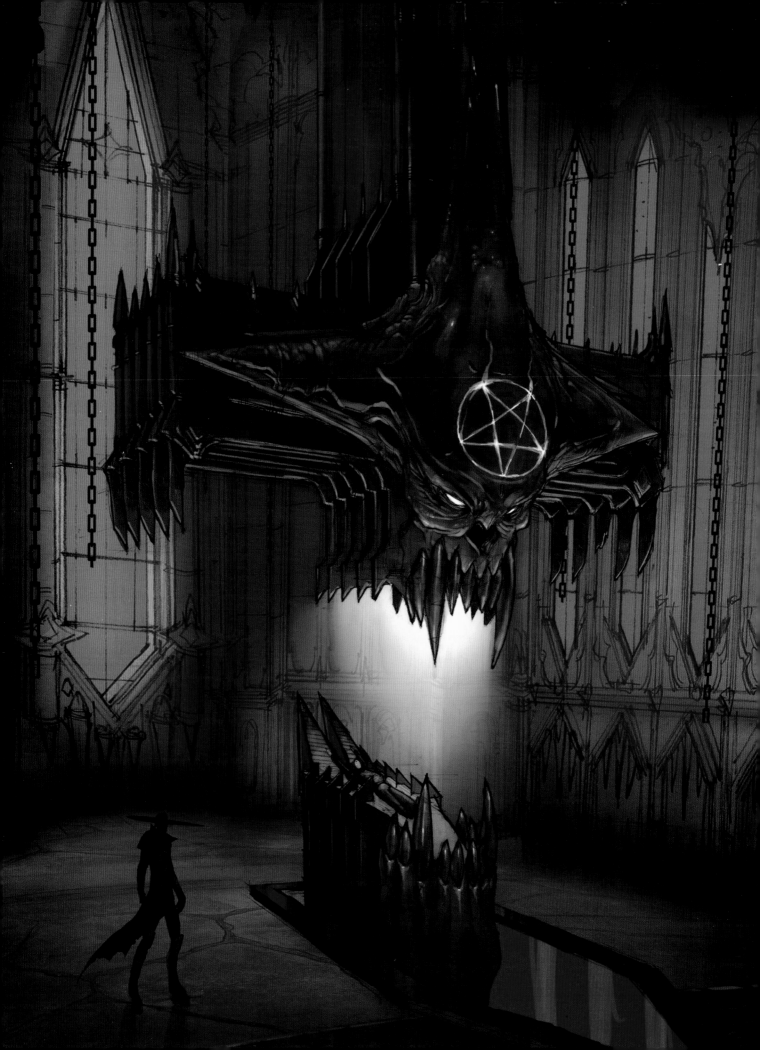

EПVIROПMEПTS

— 3 —

In a game, the setting is the framing device that contains and defines the interactive experience you are having as a player. In Darkwatch, environmental design is key because it brings all the other elements together and gives the player a sense of setting and mood that previously had never been seen in a video game–an old West haunted by vampires and the evil undead.

When approaching any original environment, vehicle, or object design for that matter, we also think of them as characters in the story. They need to have a personality, a sense of history, mood, and an emotional impact on the player. Visually, we drew on personal experience and reference material that could help us convincingly communicate the space and move the story along.

BOTH PAGES DESIGNED BY FRANCIS TSAI

DARKWA†CH

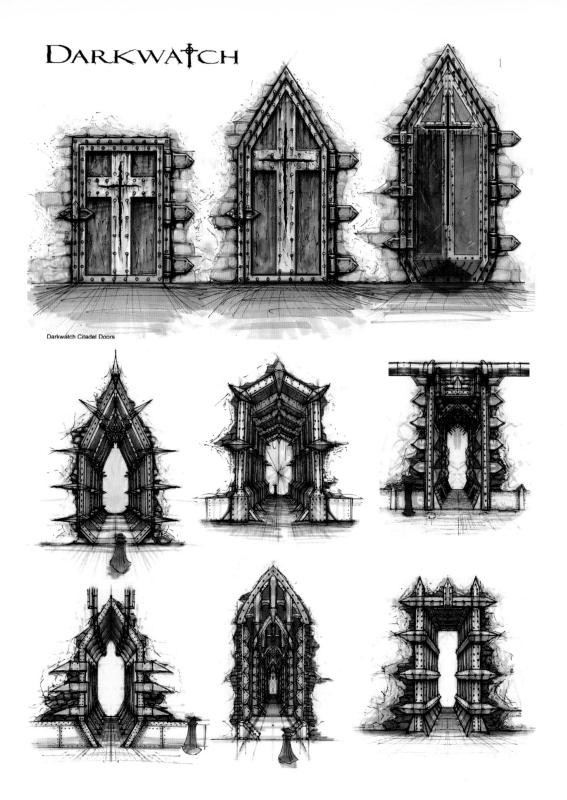

Darkwatch Citadel Doors

DARKWA†CH CI†ADEL

1. DESIGNED BY SHANE NAKAMURA / 2. DESIGNED BY FARZAD VARAHRAMYAN

We are starting to see the development and evolution of Darkwatch archi-tecture. These hallway designs utilize the Darkwatch philosophy to rein-force any occupied, preexisting structure with Gothic trusses and beams made from iron, steel, and often resembling fang–or knifelike shapes, and vampire spikes.

The panoramic view of the citadel, on the opposite page, was the very first drawing that Farzad produced that embodied the seed and potential vision for what is now the Darkwatch universe. Even though the final game looks different, it was a convincing image at the time and captured the collective imagination of the initial core creative team.

Concept artists have the skill and responsibility to communicate a clear and concise vision to any number of people, using a single image.

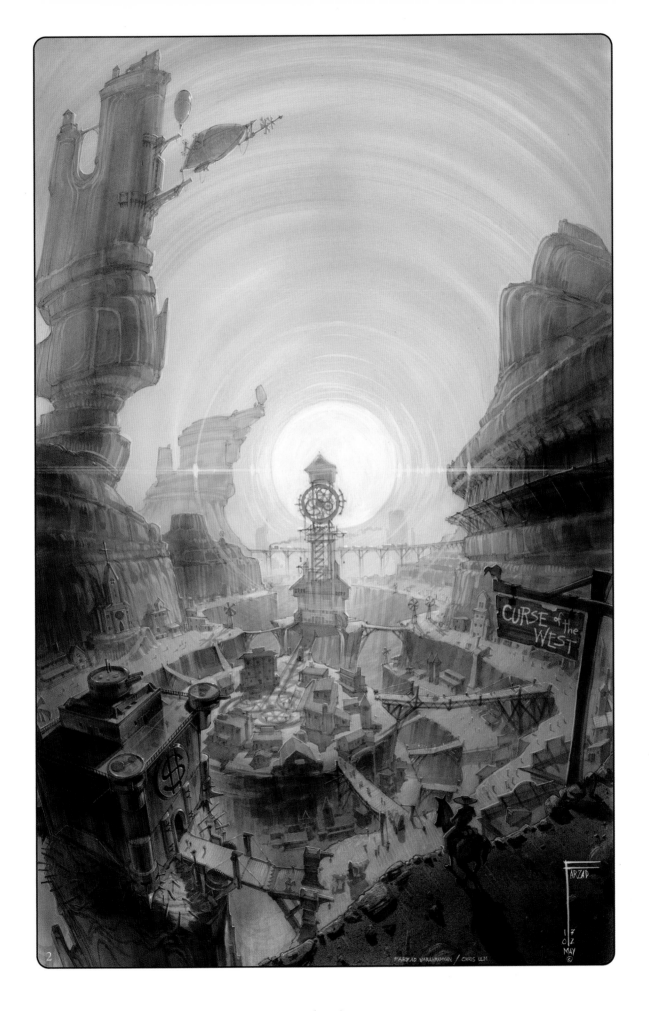

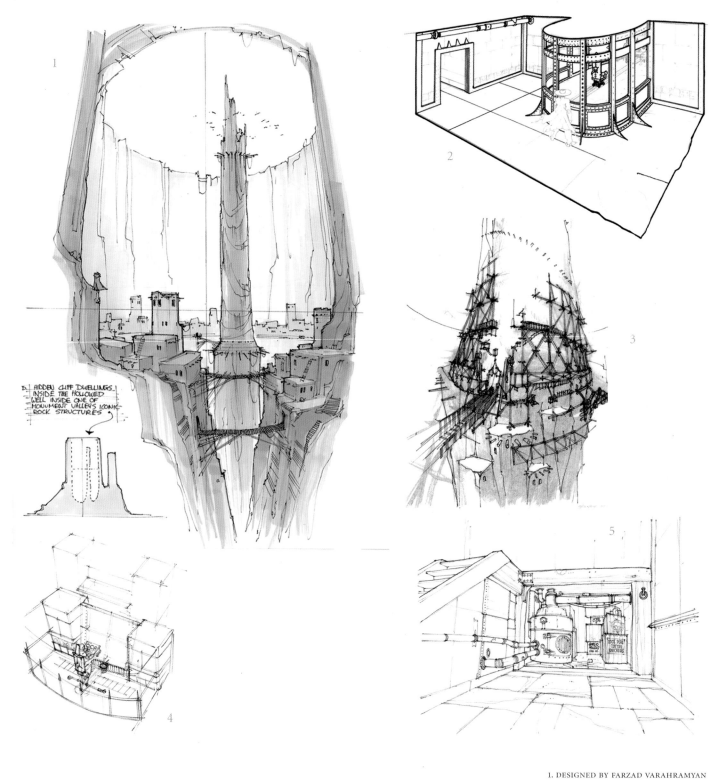

D.) HIDDEN CLIFF DWELLINGS INSIDE THE HOLLOWED WELL INSIDE ONE OF MONUMENT VALLEYS ICONIC ROCK STRUCTURES

DARKWATCH CITADEL

1. DESIGNED BY FARZAD VARAHRAMYAN
2 & 6 DESIGNED BY BILLY KING / 3. DESIGNED BY MONGSUB SONG
4, 5, 10, 11, 12, 13 DESIGNED BY FRANCIS TSAI / 7, 8, 9 DESIGNED BY JANG C. LEE

The Darkwatch citadel eventually evolved into a secret, hidden facility inside one of the larger, iconic buttes in the Monument Valley region of Arizona and Utah. The larger sketch shows the initial concept.

Almost everyone on the concept team contributed to refining the Citadel design, as well as the numerous props required to populate the Darkwatch West.

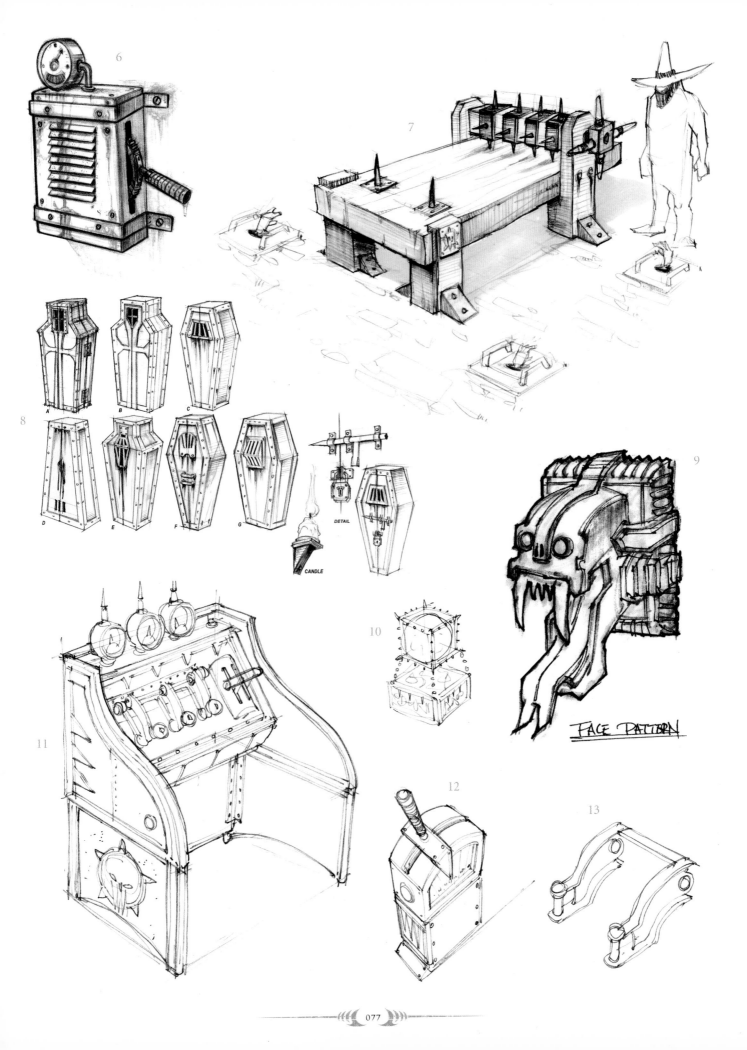

6

7

8

A B C

D E F G

CANDLE DETAIL

9

FACE PATTERN

10

11

12

13

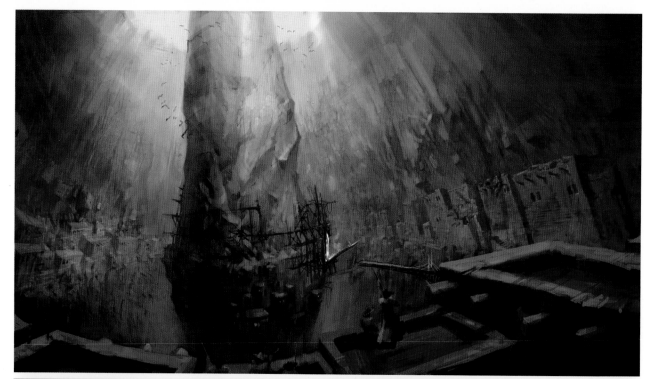

DARKWATCH CITADEL

ALL DESIGNED BY MONGSUB SONG

A secret den for the Darkwatch, the citadel is hidden from prying eyes in southwestern Arizona. This fortress is a veritable city, with all the trappings needed for self-containment, since the nearest trading post or town is several days away. The Darkwatch use the citadel as a launching point for most operations.

These beautiful paintings were created by Mongsub Song. They help commu-

nicate the scale, grit, mood, and lighting variations. Mongsub also designed the armored and steam-powered drawbridge that gives you access to the central tower in the citadel. We always try to draw upon familiar and well-rooted imagery and then add a little bit of the Darkwatch architectural DNA.

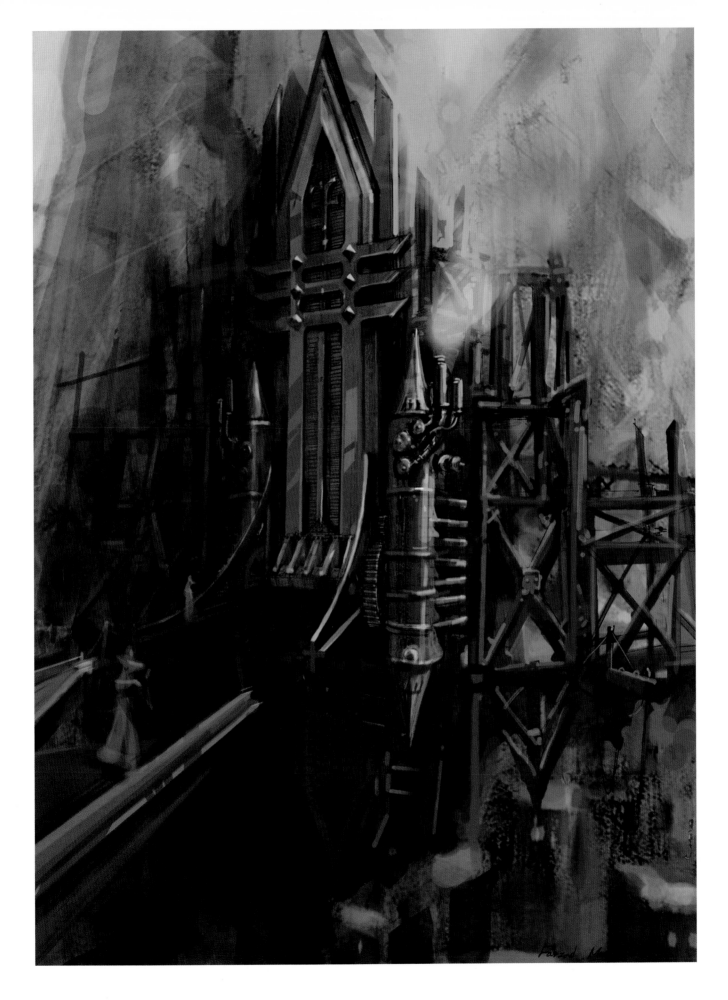

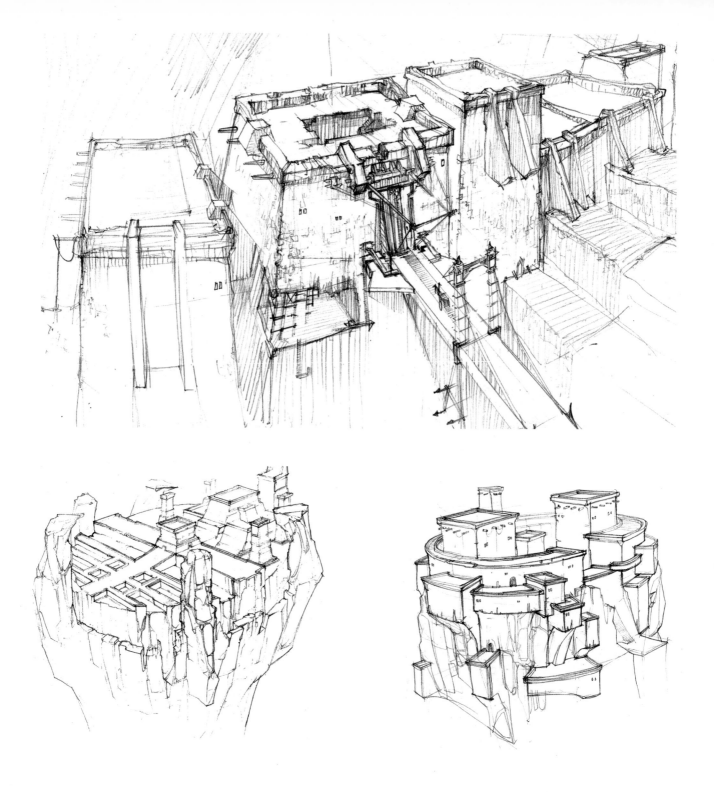

DARKWATCH CITADEL

ALL DESIGNED BY MONGSUB SONG

The concept behind the citadel architecture is that the Darkwatch have taken over a lost Native American cliff-dwelling village. In the customary fashion, the adobe buildings were reinforced and retrofitted with steam and Darkwatch technology to support the militaristic purposes of the organization. First and foremost the structure had to look like a Native American village. Then we added the Darkwatch DNA. The upper sketch started to hit the right note, whereas the two lower ones were becoming more Babylonian and Greek in feel and look.

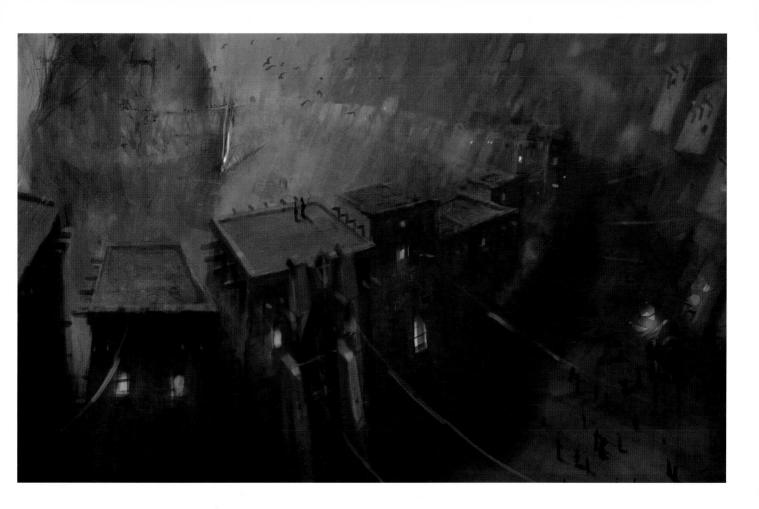

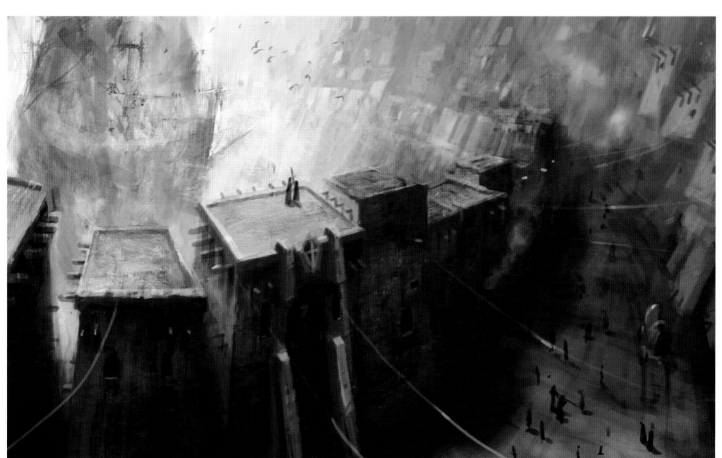

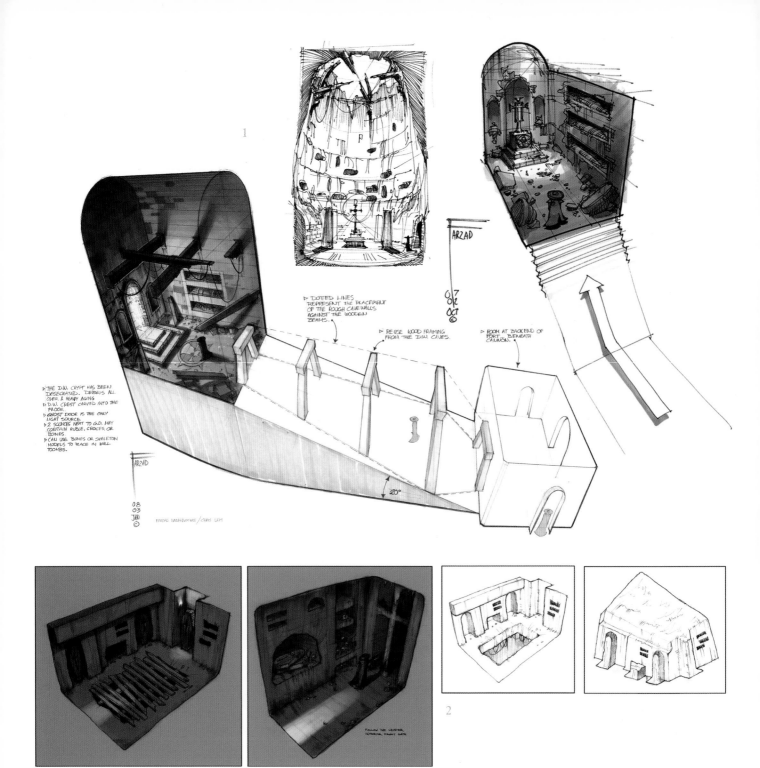

CEMETERY

1. DESIGNED BY FARZAD VARAHRAMYAN
2 & 3 DESIGNED BY STEVE JUNG

The catacomb spaces below the cemetery were based on the Christian catacombs in Italy and France. We took some liberties with size, scale, and lighting to make them better gameplay spaces, but overall we wanted to maintain the dank and stale feel of the catacombs. Steve's painting of the central chamber is a good example of the way we played with scale and size to produce a thematically sound space, which lent itself to tremendously fun vampire jumping (huge leaps with hang time) and multilevel shooting.

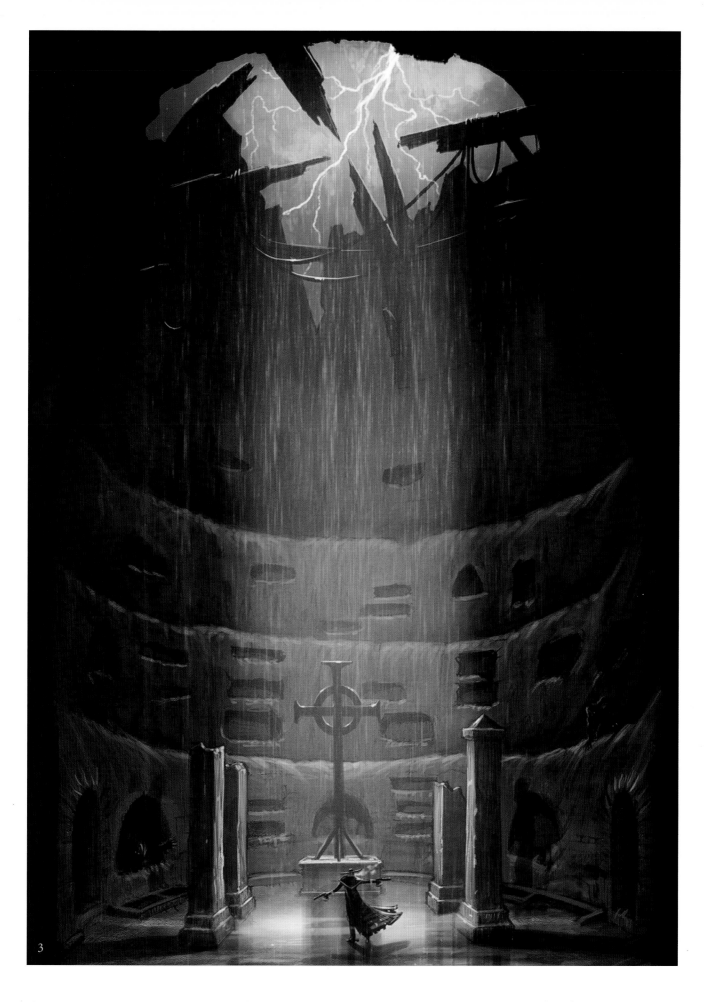

3

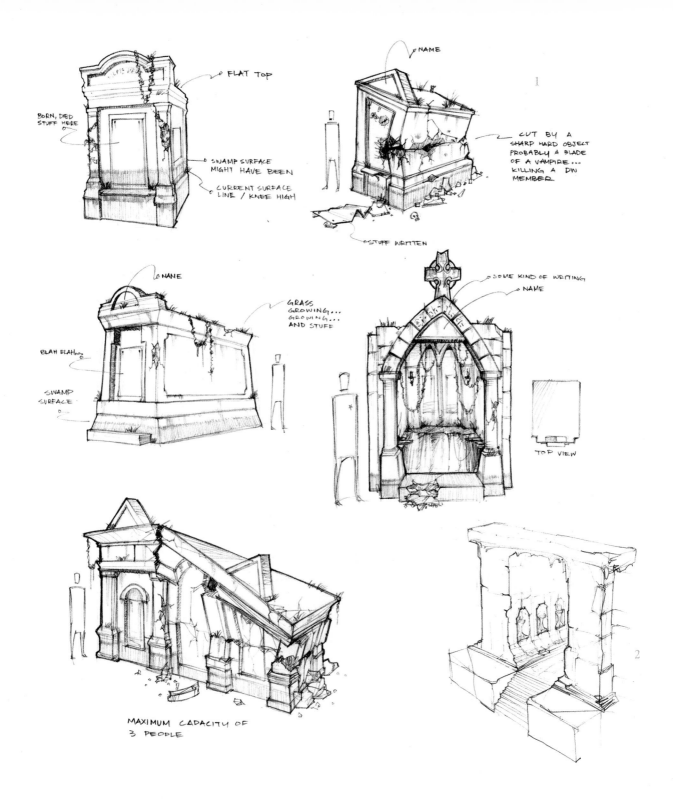

FLAT TOP

BORN, DIED STUFF HERE

SWAMP SURFACE MIGHT HAVE BEEN

CURRENT SURFACE LINE / KNEE HIGH

NAME

CUT BY A SHARP HARD OBJECT PROBABLY A BLADE OF A VAMPIRE... KILLING A DW MEMBER

1

STUFF WRITTEN

NAME

GRASS GROWING... GROWING... AND STUFF

BLAH BLAH...

SWAMP SURFACE

SOME KIND OF WRITING

NAME

TOP VIEW

MAXIMUM CAPACITY OF 3 PEOPLE

2

CEMETERY

1 & 5 DESIGNED BY STEVE JUNG / 2. DESIGNED BY MONGSUB SONG
3 & 4 DESIGNED BY FARZAD VARAHRAMYAN

Initially one of the styling cues we pursued for some of our cemetery exteriors was the aboveground crypts found in the Southern states of the East coast. However, they felt a bit too out of place in the American West desert with its cacti.

Even vegetation had to be designed. Here are sketches of trees that had to have strong silhouettes as well as be emotive and supportive of the moody environments they would populate. Personality can permeate any object, even background trees.

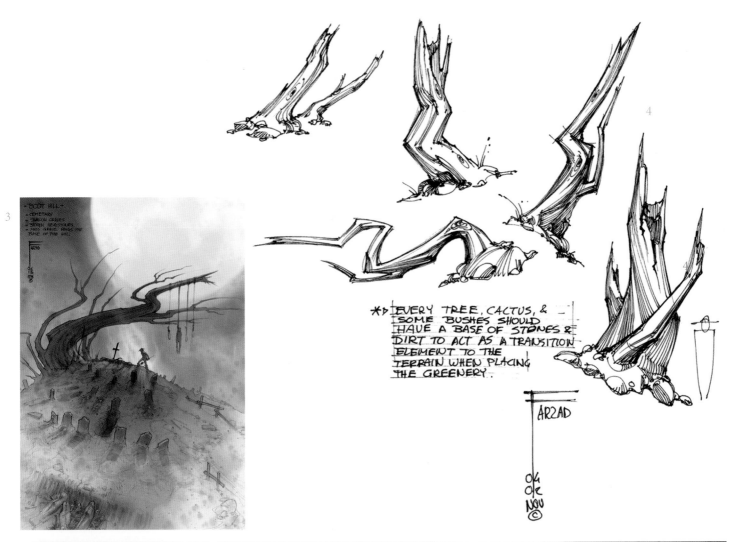

*▷ EVERY TREE, CACTUS, &
SOME BUSHES SHOULD
HAVE A BASE OF STONES &
DIRT TO ACT AS A TRANSITION
ELEMENT TO THE
TERRAIN WHEN PLACING
THE GREENERY.

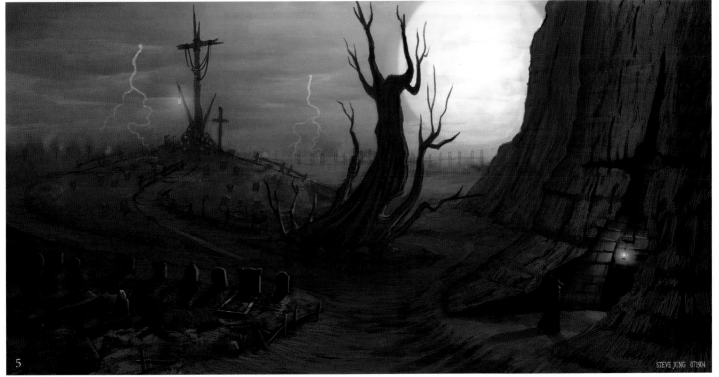

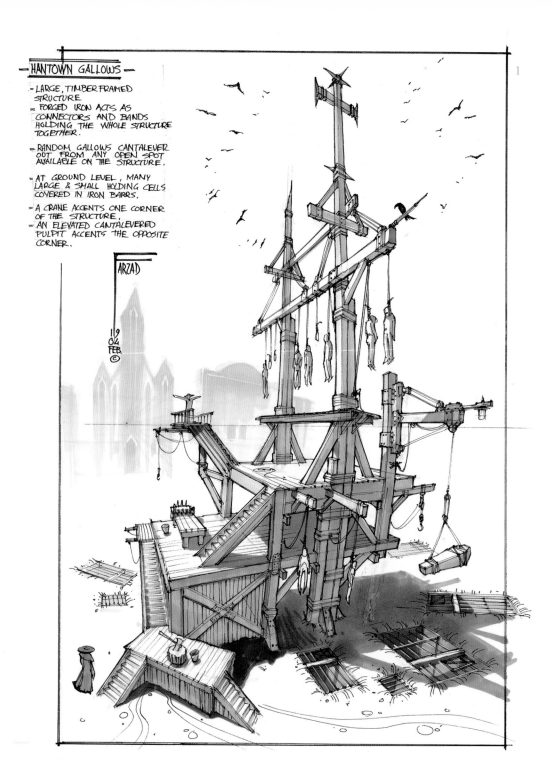

HANTOWN GALLOWS

- LARGE, TIMBER-FRAMED STRUCTURE
- FORGED IRON ACTS AS CONNECTORS AND BANDS HOLDING THE WHOLE STRUCTURE TOGETHER.
- RANDOM GALLOWS CANTALEVER OUT FROM ANY OPEN SPOT AVAILABLE ON THE STRUCTURE.
- AT GROUND LEVEL, MANY LARGE & SMALL HOLDING CELLS COVERED IN IRON BARRS.
- A CRANE ACCENTS ONE CORNER OF THE STRUCTURE.
- AN ELEVATED CANTALEVERED PULPIT ACCENTS THE OPPOSITE CORNER.

HANGTOWN

1. DESIGNED BY FARZAD VARAHRAMYAN / 2. DESIGNED BY STEVE JUNG

Formerly a rough-and-tumble Western town, Hangtown has become a playground of the damned, overrun by the undead, and haunted by the spirits of innocent men unjustly condemned to the town's signature gallows.

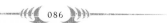

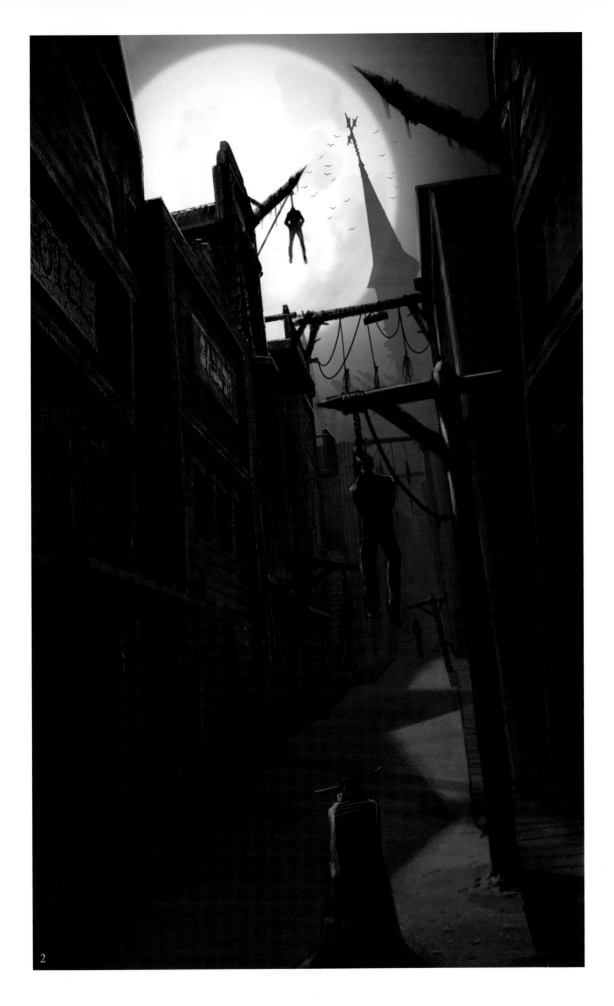

2

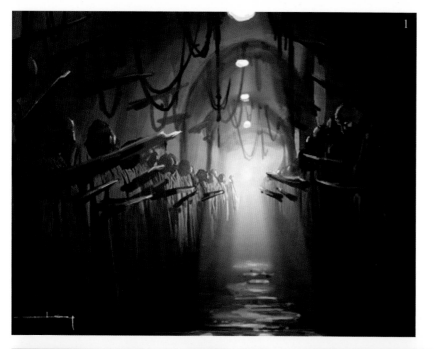

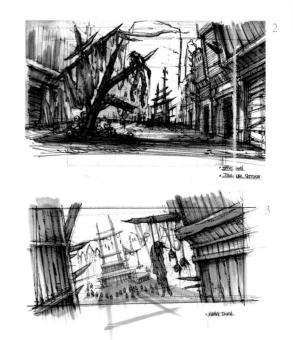

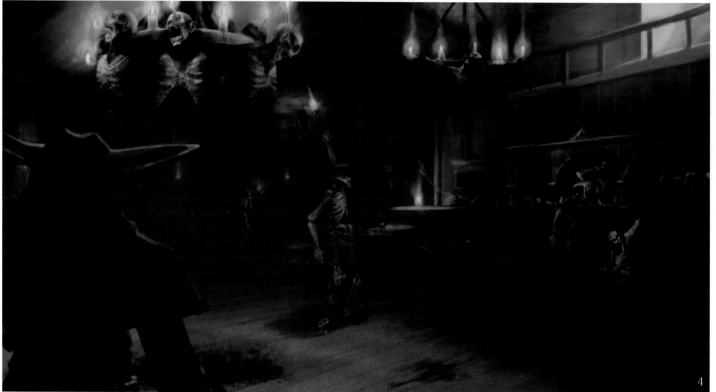

HAПGȚOWП

1, 2, 3 DESIGNED BY JANG C. LEE / 4. DESIGNED BY SHANE NAKAMURA
5 & 6 DESIGNED BY STEVE JUNG

A variety of spaces and looks were explored for the Hangtown's many environments. At one point there was going to be a climactic fight between Jericho and the vipers, in the town's bell tower. Other designs almost immediately became iconic to the property, such as the barroom brawl from hell, which was faithfully recreated in 3-D from Shane's painting.

5

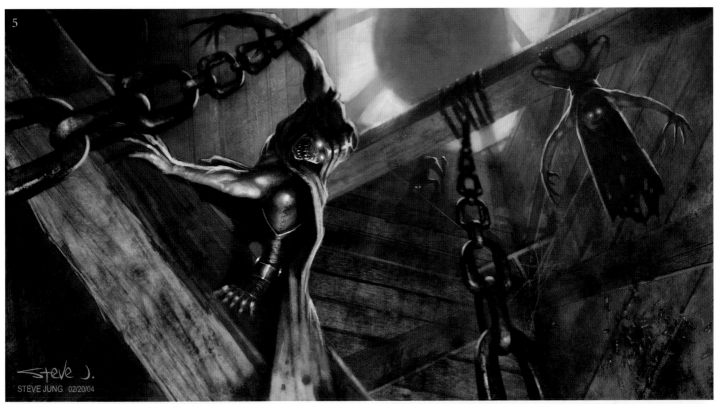

STEVE JUNG 02/20/04

6

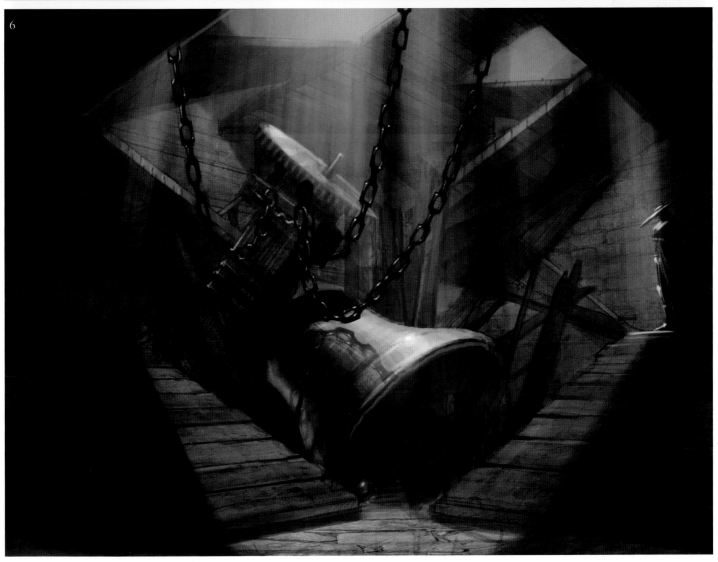

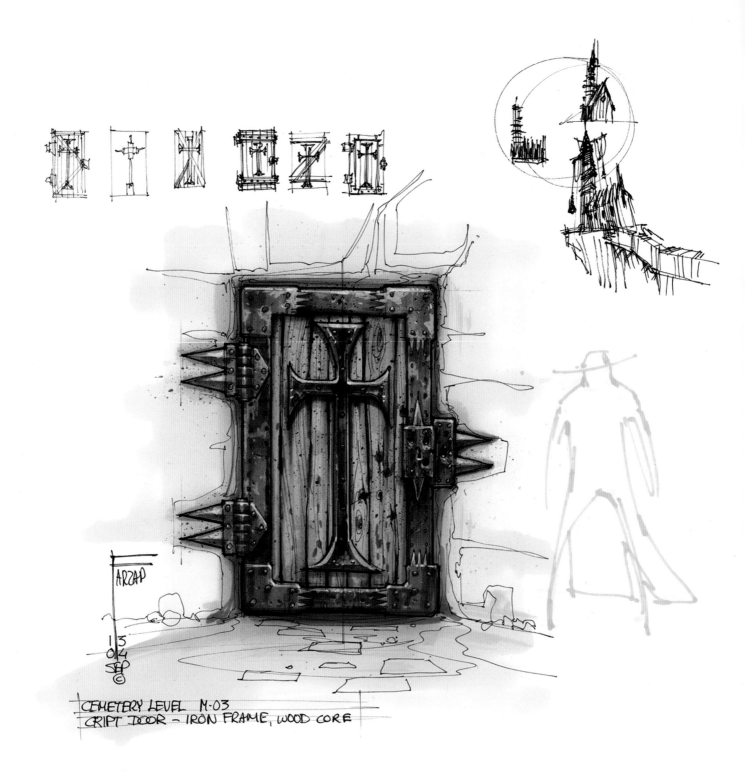

CEMETERY LEVEL M-03
CRIPT DOOR - IRON FRAME, WOOD CORE

HANGTOWN

ALL DESIGNED BY FARZAD VARAHRAMYAN

Whether it's a door design or a cathedral-sized church, small thumbnails once again help to quickly reach a strong graphic read or an iconic silhouette without getting lost in the details. Once you have the basic design, sizing up the thumbnails and adding the details is an easy proposition.

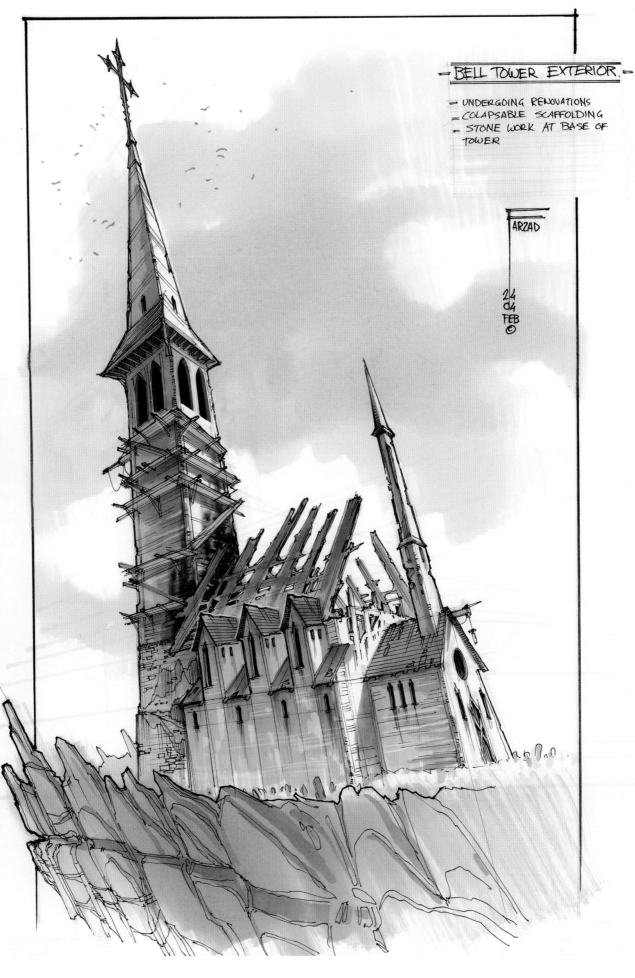

BELL TOWER EXTERIOR.

- UNDERGOING RENOVATIONS
- COLAPSABLE SCAFFOLDING
- STONE WORK AT BASE OF
 TOWER

FARZAD

24
04
FEB
©

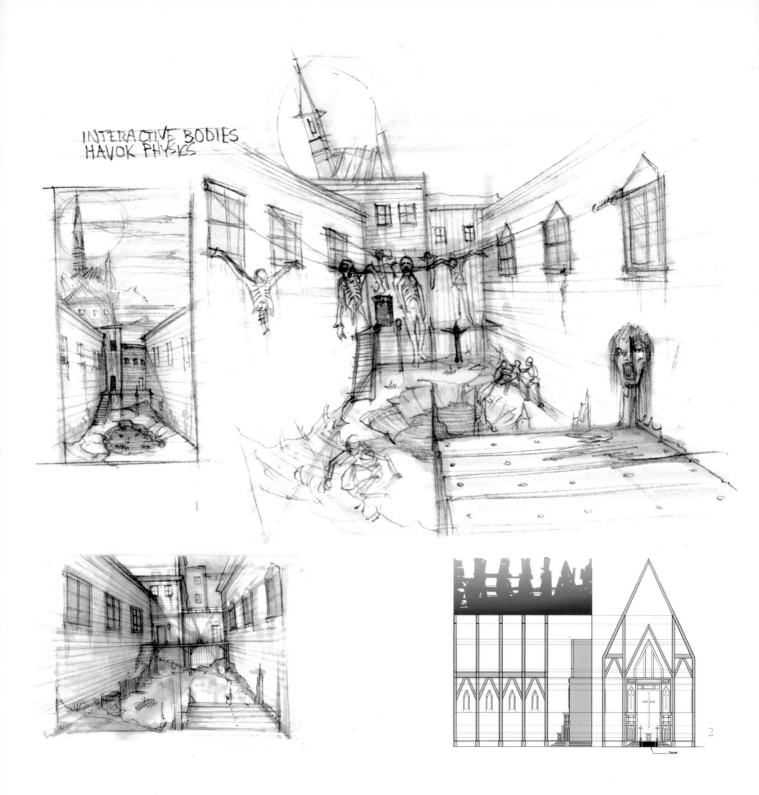

The following text is labelled in the image:

INTERACTIVE BODIES
HAVOK PHYSICS

1

2

HANGTOWN

1. DESIGNED BY SHANE NAKAMURA / 2. DESIGNED BY MONGSUB SONG
3. DESIGNED BY STEVE JUNG

Mood paintings such as this one of the church are preceded by many design iterations. In the sketches above, Shane explored the concept of an alleyway that was based on killing fields–a dumping ground for consumed victims. Once designs are chosen, accurate draftings are also created for the complicated spaces such as the church interior by Mongsub. Although draftings may seem less glamorous than paintings, they are critical to the process and success of the game space. It is here that the details and spatial problems are solved, making the building task easier for the 3-D artists.

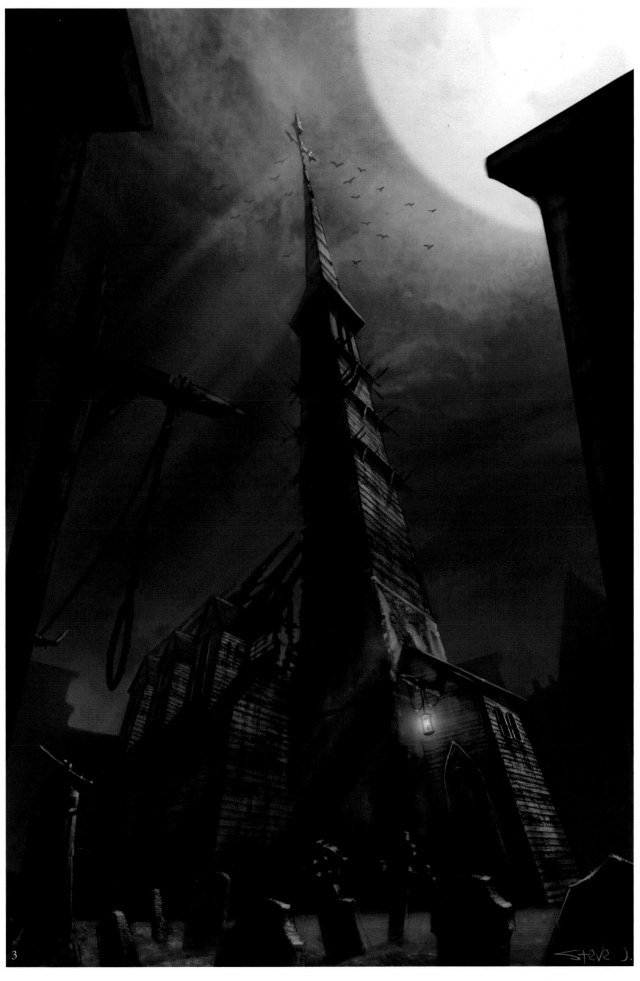

3

Steve J.

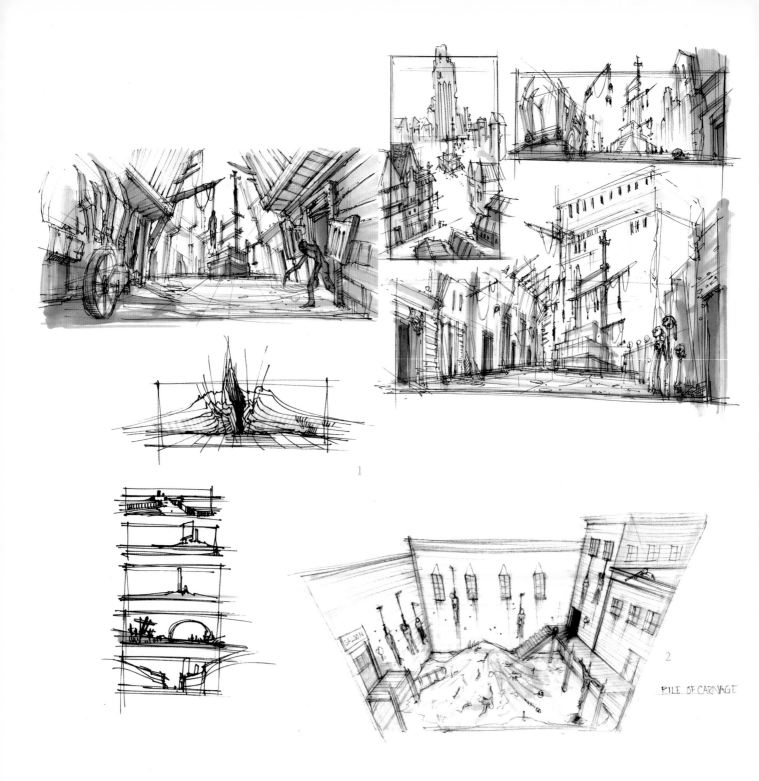

PILE OF CARNAGE

2

HANGTOWN

1. DESIGNED BY JANG C. LEE / 2. DESIGNED BY SHANE NAKAMURA
3. DESIGNED BY STEVE JUNG

More design exploration on the various spaces in Hangtown. The painting of the church hallway illustrates the combining of strong Gothic style with Western materials and construction methods of the period. We often found that simple design and good lighting had far greater impact than layers of granular details.

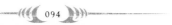

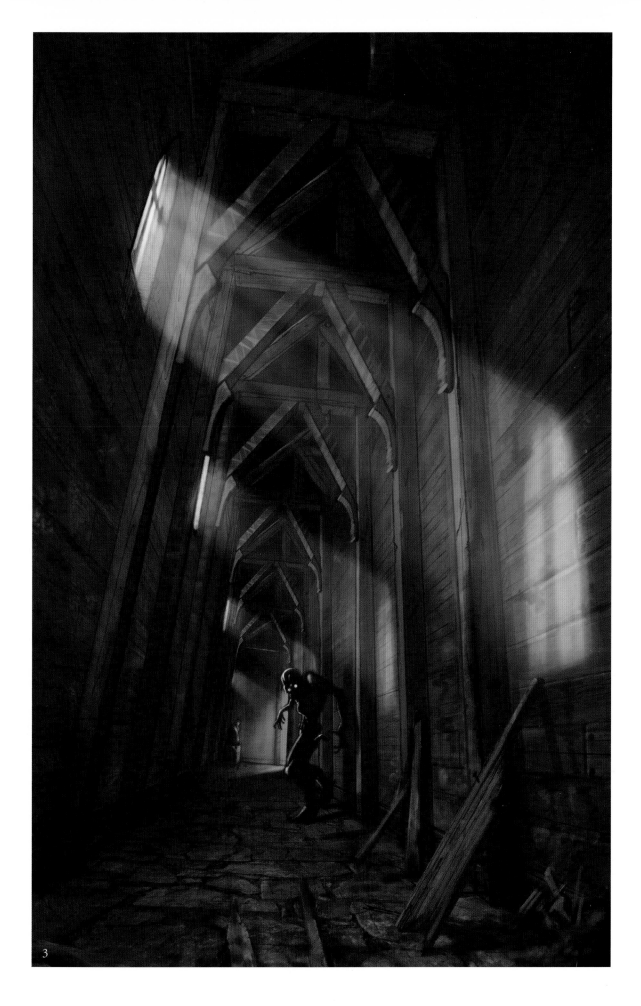

3

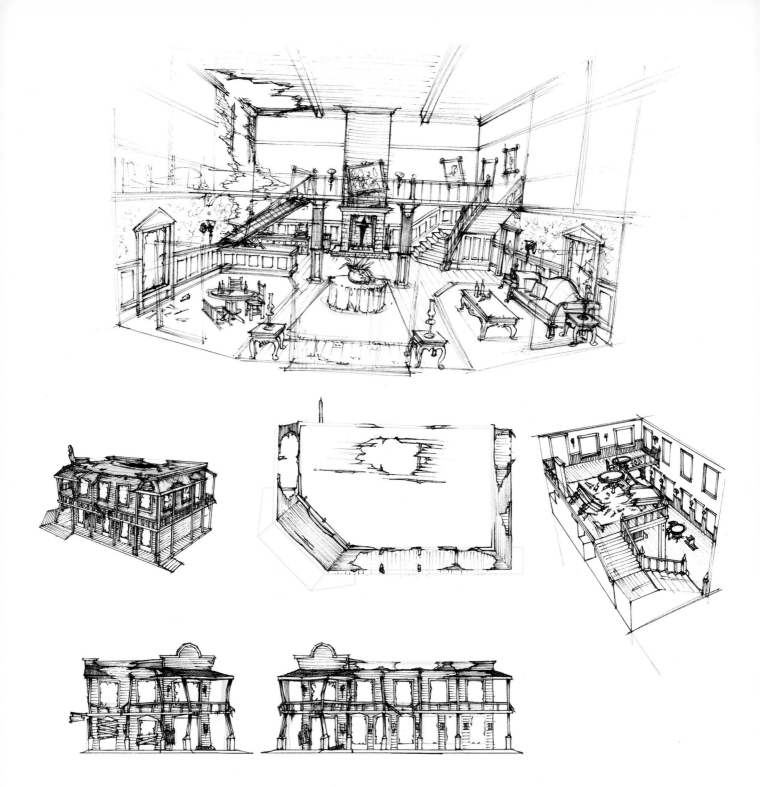

HELLTOWN

ALL DESIGNED BY SHANE NAKAMURA

The folks of Helltown made a deal to bring prosperity to their little, out-of-the-way village–but they made their deal with the wrong people. Now, the town has been plucked from the prairie and thrown into Hell itself, suspended in a blazing sky of twisting hellfire.

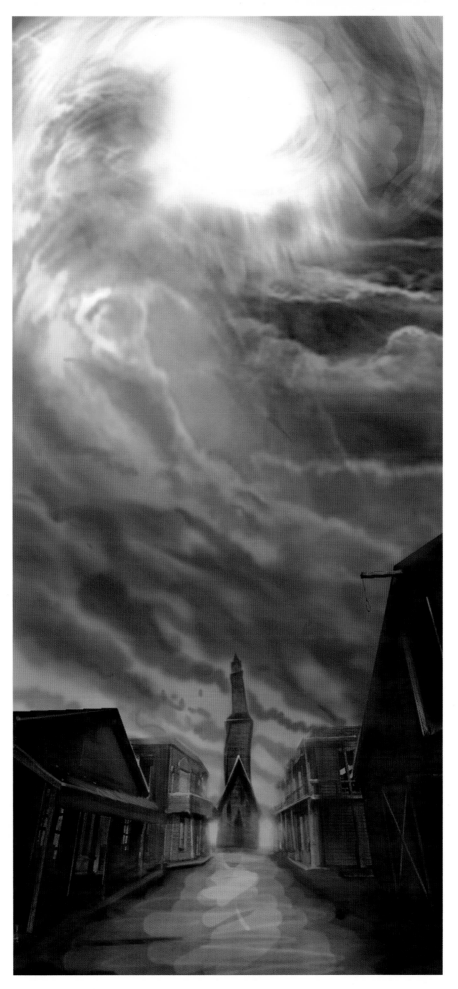

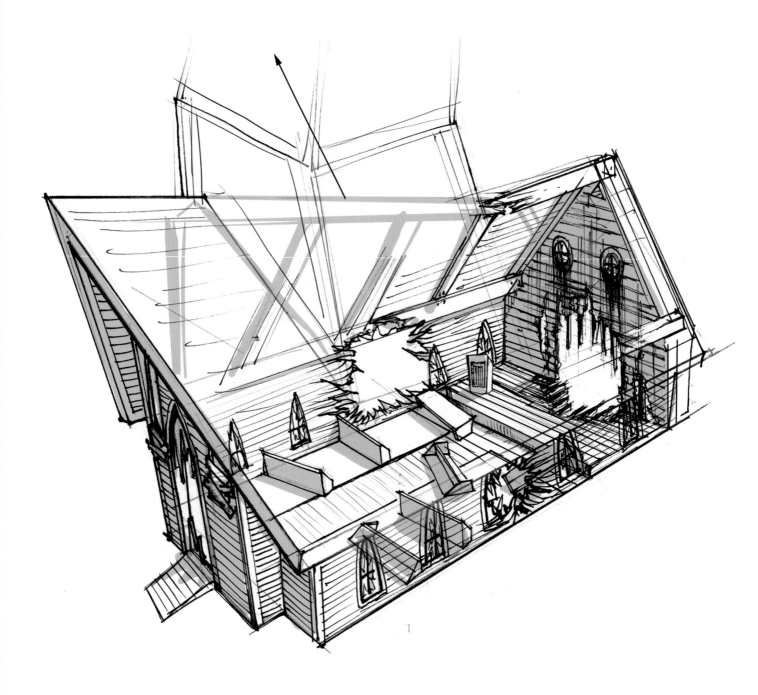

1, 2, 3 & 5 DESIGNED BY SHANE NAKAMURA
4. DESIGNED BY FARZAD VARAHRAMYAN

HELLTOWN

When designing anything from buildings and environments to props, we try to give them as much personality, visual history, and visual signature as possible.

Humans are very good at piecing together abstract visual-noise to form faces. Our concept artists used this information to either subtly or obviously manipulate graphic elements to hint at, in this case, evil faces.

2

3

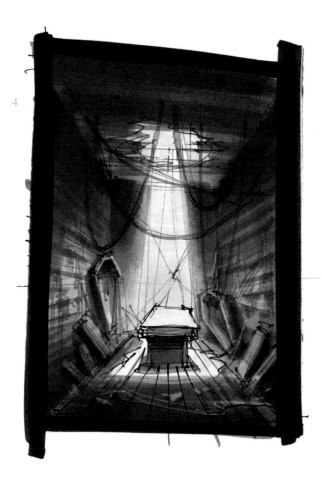

4

5

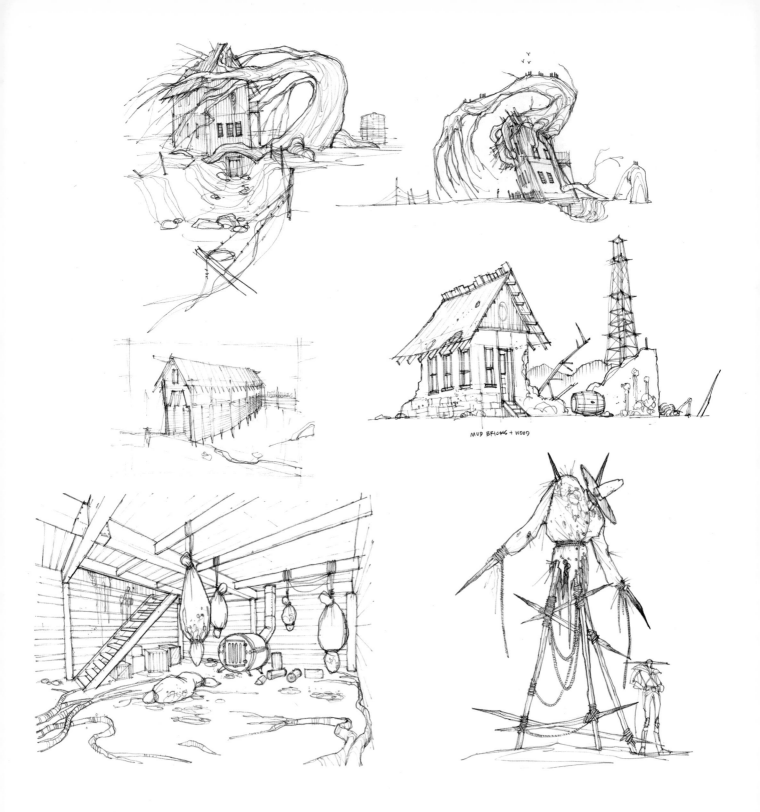

FARMSTEAD

ALL DESIGNED BY FRANCIS TSAI

Francis has turned a formerly prosperous farm into a farmstead of horrors. One of the key signature pieces is a tree affected by the pulse of evils that was released when Lazarus was unknowingly freed by Jericho. The tree grew and overtook the farm house like a cancer.

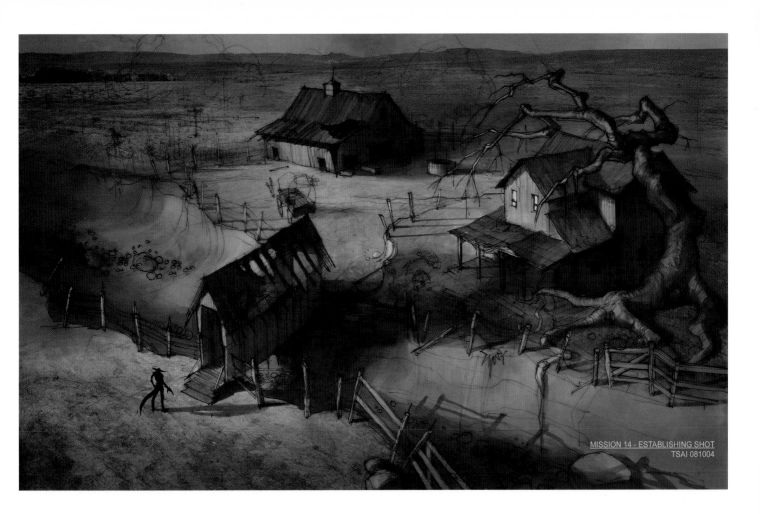

MISSION 14 - ESTABLISHING SHOT
TSAI 081004

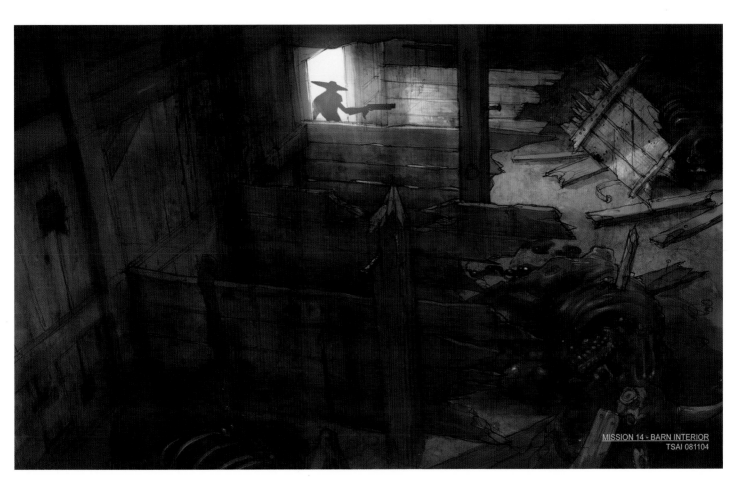

MISSION 14 - BARN INTERIOR
TSAI 081104

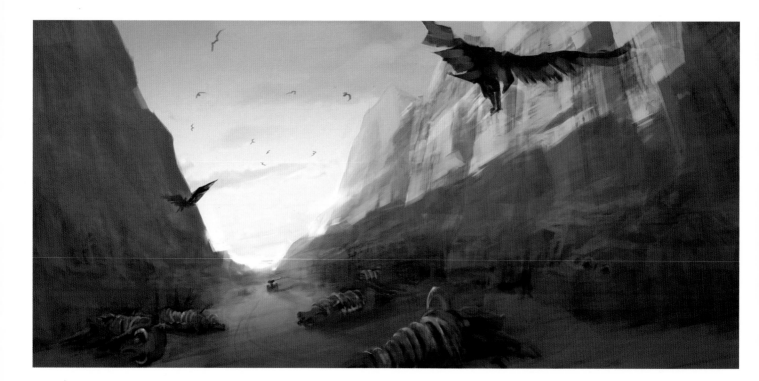

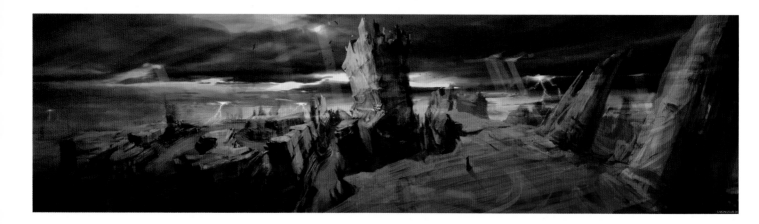

invasion

ALL DESIGNED BY MONGSUB SONG

Native American cliff dwellings, reduced to ruin after the abrupt abandonment of their inhabitants, are now a shadowy place of mystery and sudden death. Mongsub has skillfully created great mood, color, scale, and lighting paintings for some large-scale vistas. Pieces such as these give critical art direction to the artists who build, texture, and light these real-time game environments. They also help the sound designers who see the stormy conditions, lightning, wind, and vultures and create the sounds of death and desolation. Cavernous cliff walls hint at the need for added echoing for specific sounds.

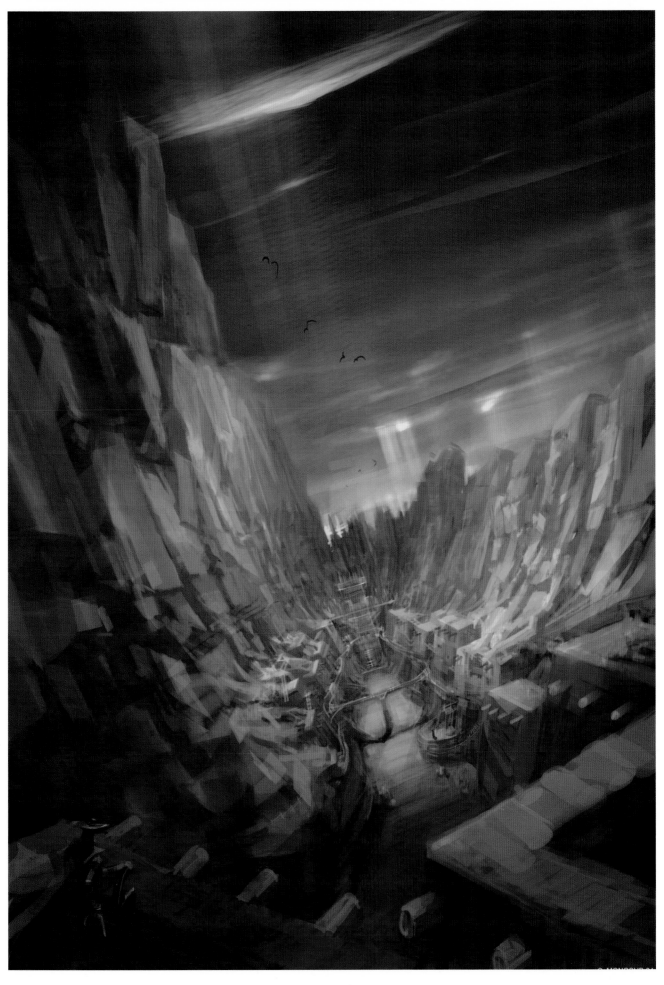

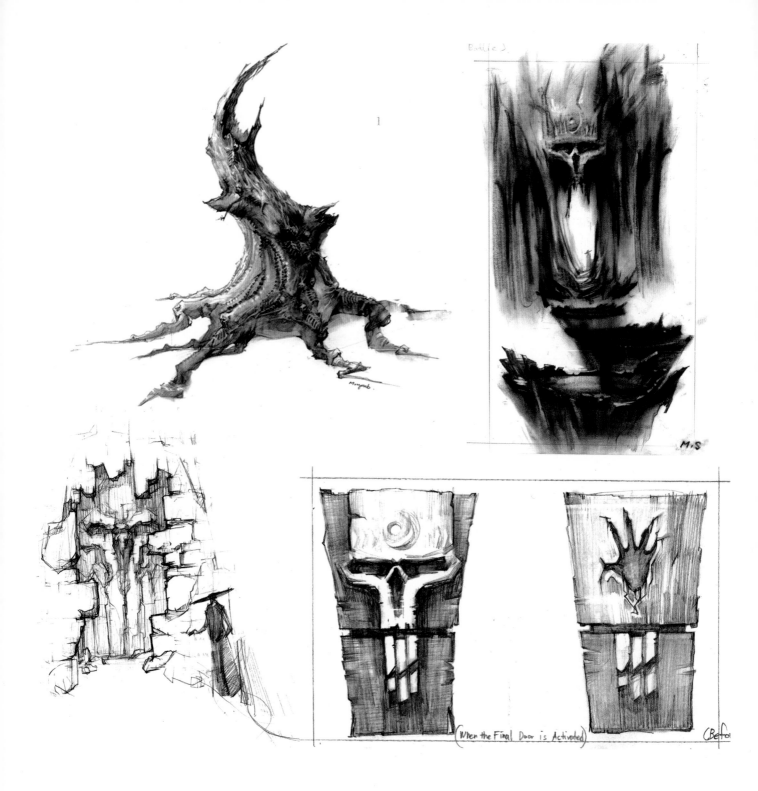

invasion

1, 2, & 3 DESIGNED BY MONGSUB SONG
4. DESIGNED BY JANG C. LEE

These caverns were originally meant to be deep, underground burial grounds for a lost Native American tribe. The approach with this design was that the deeper you traveled, the more Aztec the architectural elements became. This last element ties into the fact that you end up at a dead end so to speak–a sacrificial chamber.

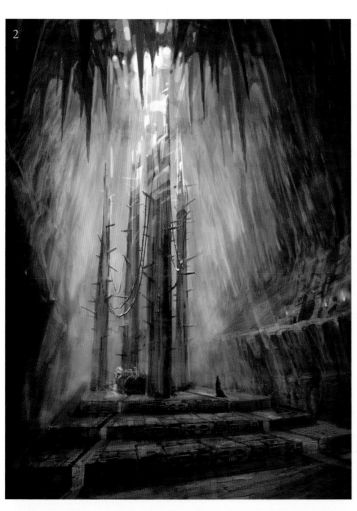

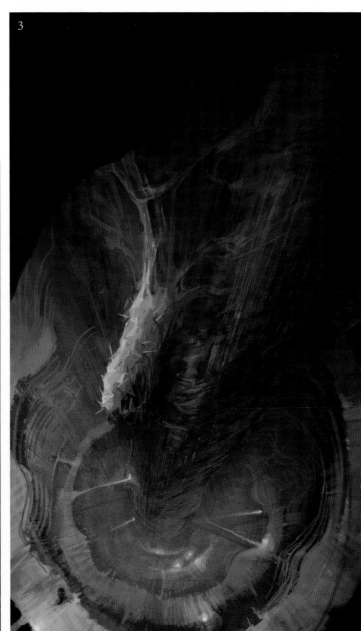

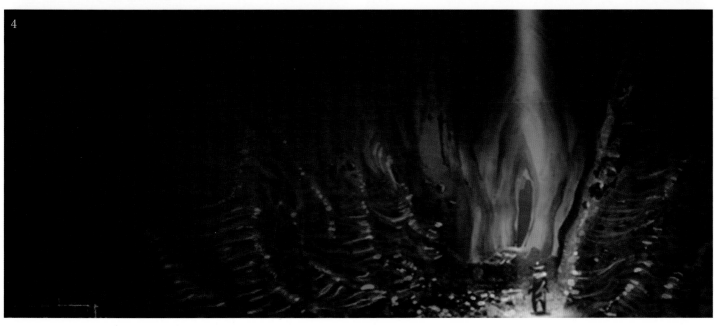

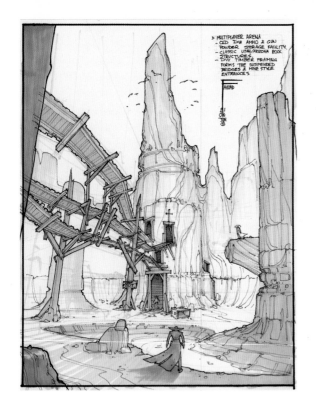

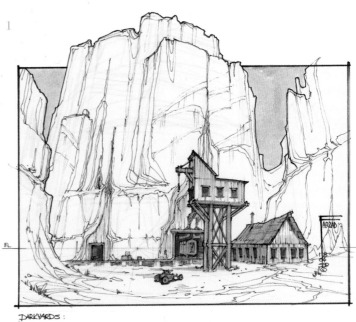

DARKYARDS :

▷ MULTIPLAYER LEVEL: TIMBERFRAMING W/IRON
JOINERY. MORE IRON & STEEL AS YOU MOVE TO THE INT.

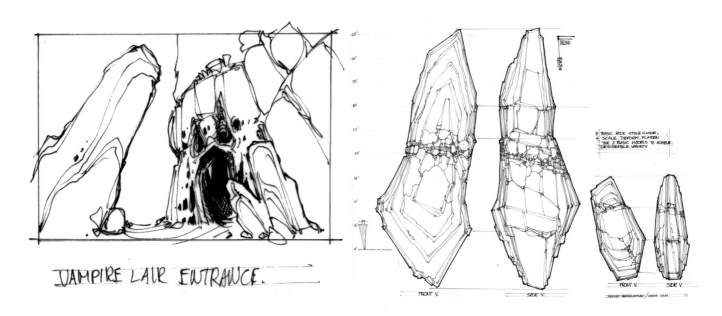

JAMPIRE LAIR ENTRANCE.

MULTIPLAYER

1. DESIGNED BY FARZAD VARAHRAMYAN
2. DESIGNED BY STEVE JUNG / 3. DESIGNED BY SHANE NAKAMURA

In film, you are witness to the camera view the director picks. Interactive game environments, in a lot of genres, are fully explorable by the player, so every aspect of the environment needs to be designed. The player picks the camera view.

Because of this freedom of exploration, you will find hundreds of sketches such as these that define everything from entire environments, buildings, and even boulder shapes to texture treatments.

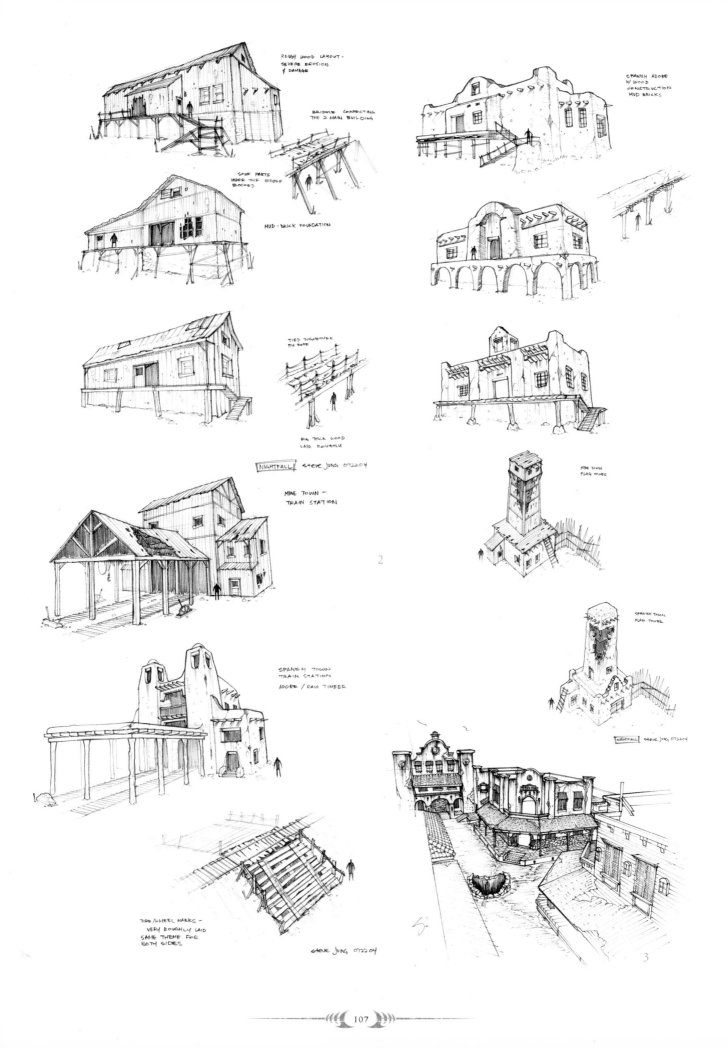

ROUGH WOOD LAYOUT -
SEVERE EROSION
& DAMAGE

SPANISH ADOBE
W/ WOOD
CONSTRUCTION
MUD BRICKS

BRIDGE CONNECTING
THE 2 MAIN BUILDING

SOME PARTS
UNDER THE BRIDGE
BLOCKED

MUD - BRICK FOUNDATION

TIED TOGHETHER
BY ROPE

BIG THICK WOOD
LAID ROUGHLY

NIGHTFALL STEVE JUNG 072204

MINE TOWN -
TRAIN STATION

MINE TOWN
FLAG TOWER

2

SPANISH TOWN
TRAIN STATION
ADOBE / RAW TIMBER

SPANISH TOWN
FLAG TOWER

NIGHTFALL STEVE JUNG 072204

TIRE /WHEEL MARKS -
VERY ROUGHLY LAID
SAME THEME FOR
BOTH SIDES

STEVE JUNG 072204

3

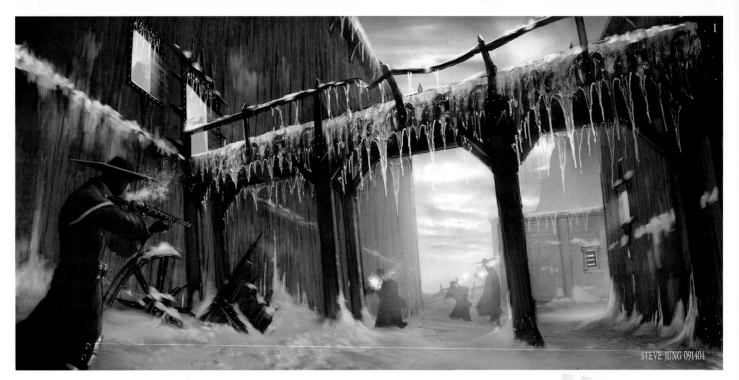

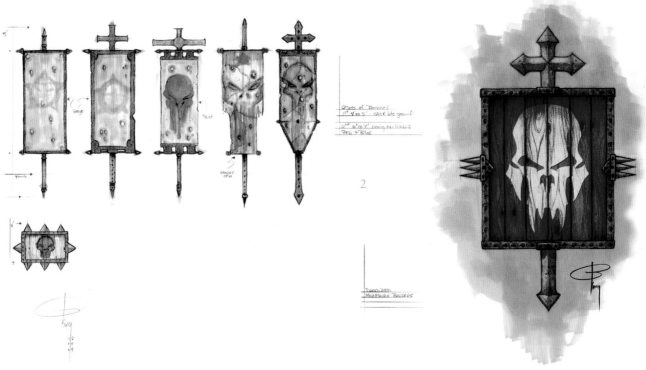

MULTIPLAYER

1 & 3 DESIGNED BY STEVE JUNG / 2. DESIGNED BY BILLY KING

In-game graphics are a very important part of the aid you give the player in navigating through the game. Here, Billy King shows a small portion of the design exploration that graphically helps to define, in this case, multiplayer flags. This graphic language has to look good and be consistent with the art direction, but has to be easily recognizable, easily communicated, and be in a consistent language across the game and in all other graphics associated with the game, such as the user interface, packaging, PR, and advertising. On the opposite page is Steve Jung's vision for what a portion of the secret Darkwatch railroad yards would look like.

3

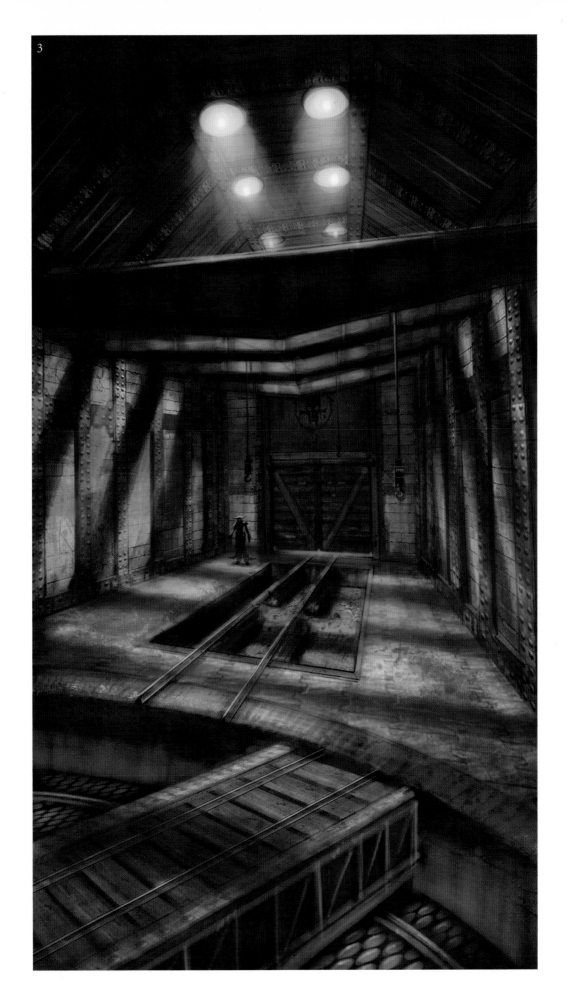

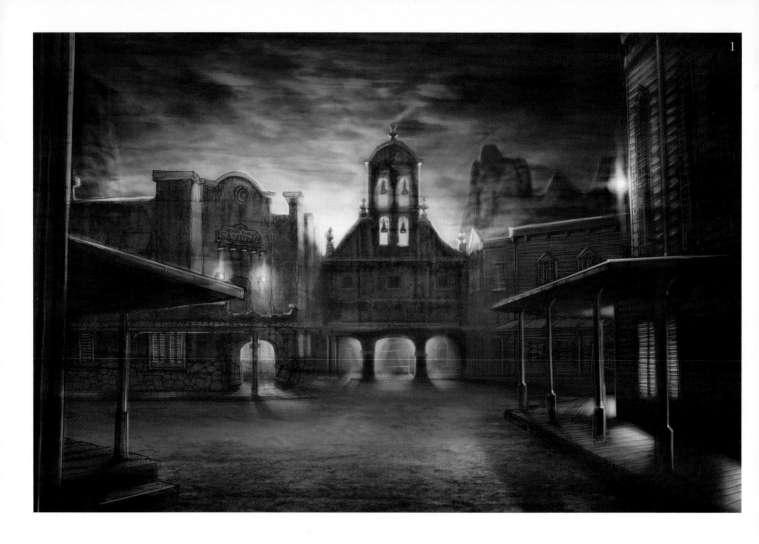

MULTIPLAYER

1. DESIGNED BY SHANE NAKAMURA / 2. DESIGNED BY STEVE JUNG

On the opposite page you see another exercise in creating a graphic and consistent design with the Darkwatch universe for a game device called the Mark of Evil. None of these designs made it into the game, but the exploration was critical in determining that a cross would blend in with all the other crosses in the game and that this object definitely had to stand out on its own more.

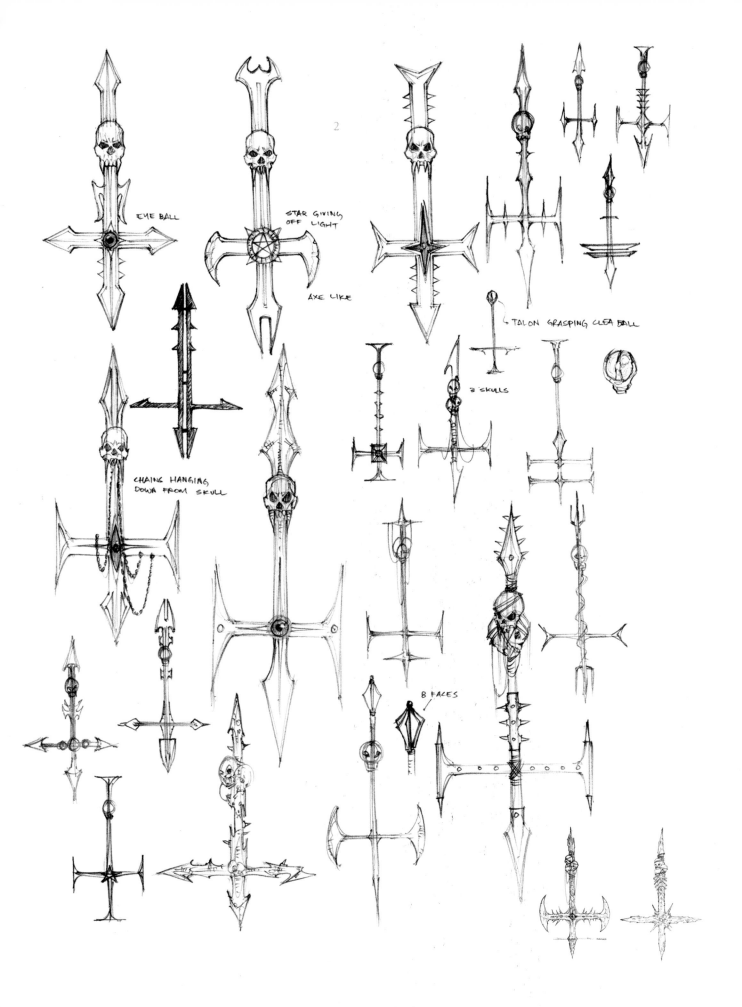

EYE BALL

STAR GIVING
OFF LIGHT

AXE LIKE

TALON GRASPING CLEA BALL

3 SKULLS

CHAINS HANGING
DOWN FROM SKULL

8 FACES

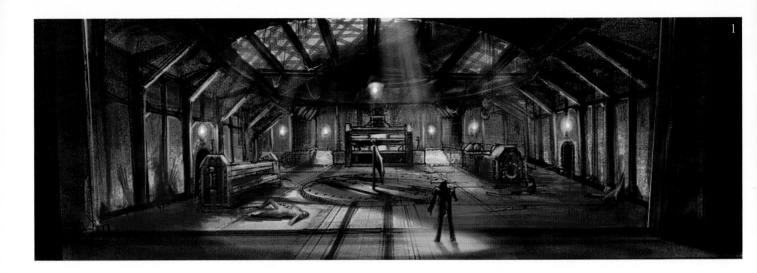

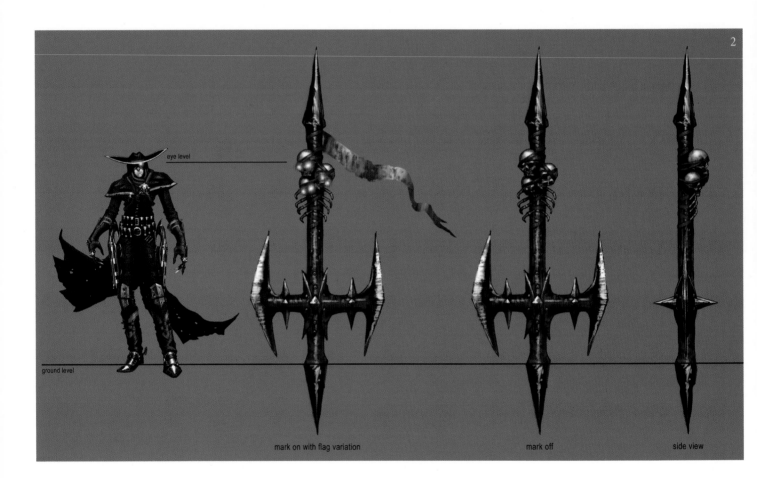

eye level

ground level

mark on with flag variation mark off side view

MULTiPLAYER

1 & 3 DESIGNED BY SHANE NAKAMURA / 2. DESIGNED BY STEVE JUNG

This was the initial design proposed for the cross-shaped Mark of Evil. As mentioned earlier, once in the game, it was hard to spot for something that was critical to spot right away. The final design ended up being a large tree with human corpses embedded in it, with a bright array of lighting FX. Sometimes you just have to try it out and see if it works or not. The important thing is to remain flexible and redirect when needed. On the opposite page, with this environment design, Shane Nakamura tackled the difficult problem of coming up with a vampire architecture DNA for our game. Initially, the environment was designed as an arena where vampires watched other vampires hunt and kill human slaves for their entertainment.

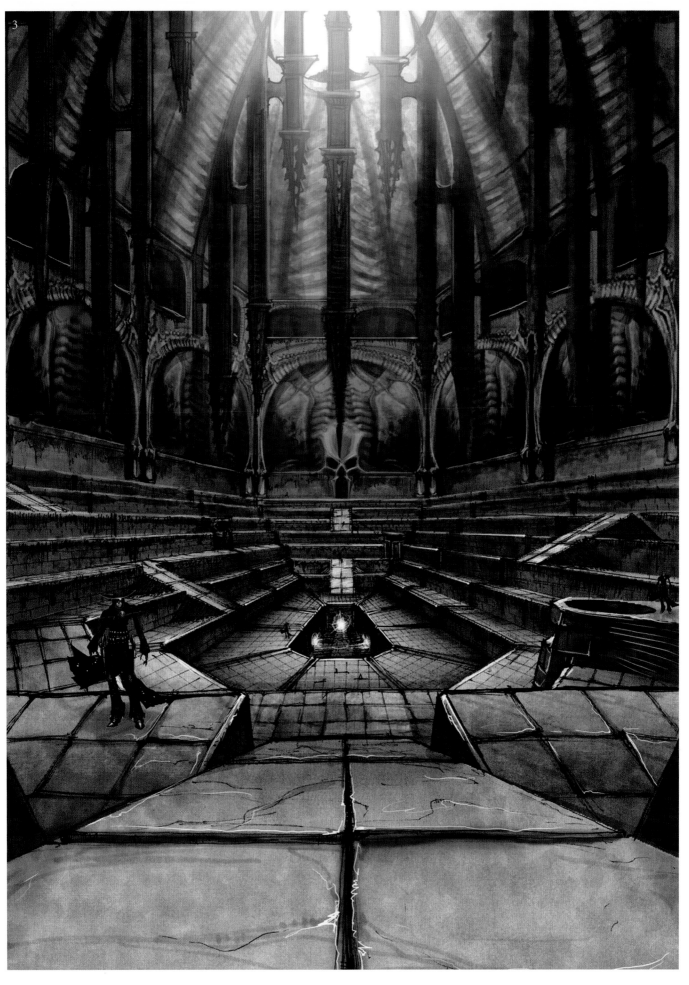

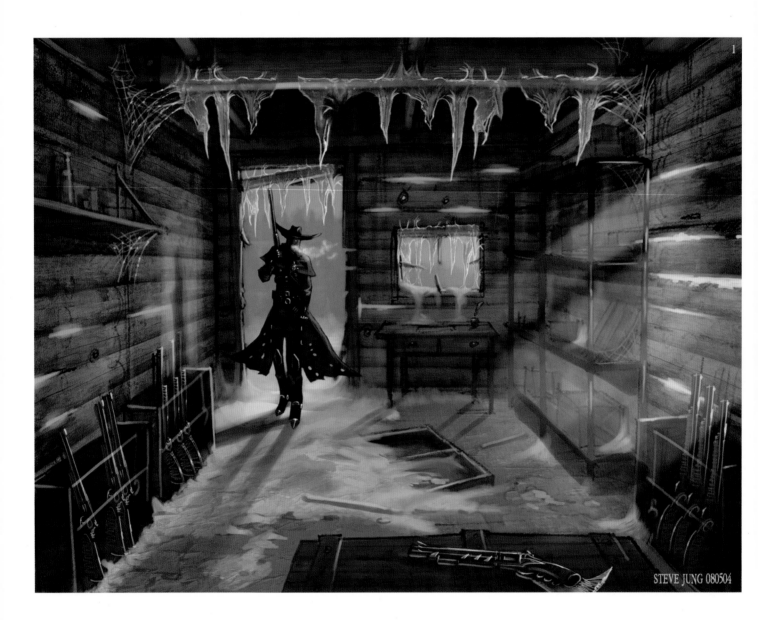

STEVE JUNG 080504

OUTPOST

This was one of those environments, that lent itself naturally to great lighting and mood. The high contrast between the snow, wood, rock, and scenes of violence made it ideal for legible, strong graphic reads.

2

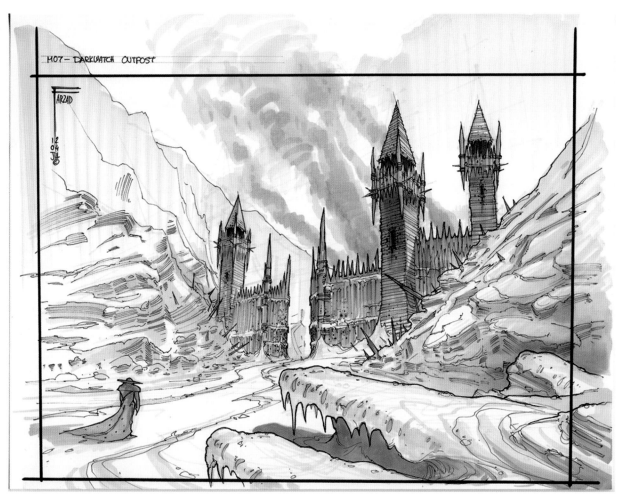

M07- DARKWATCH OUTPOST

3

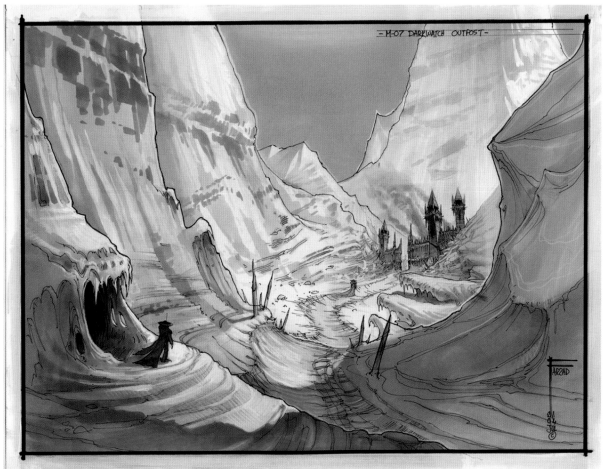

-M-07 DARKWATCH OUTPOST-

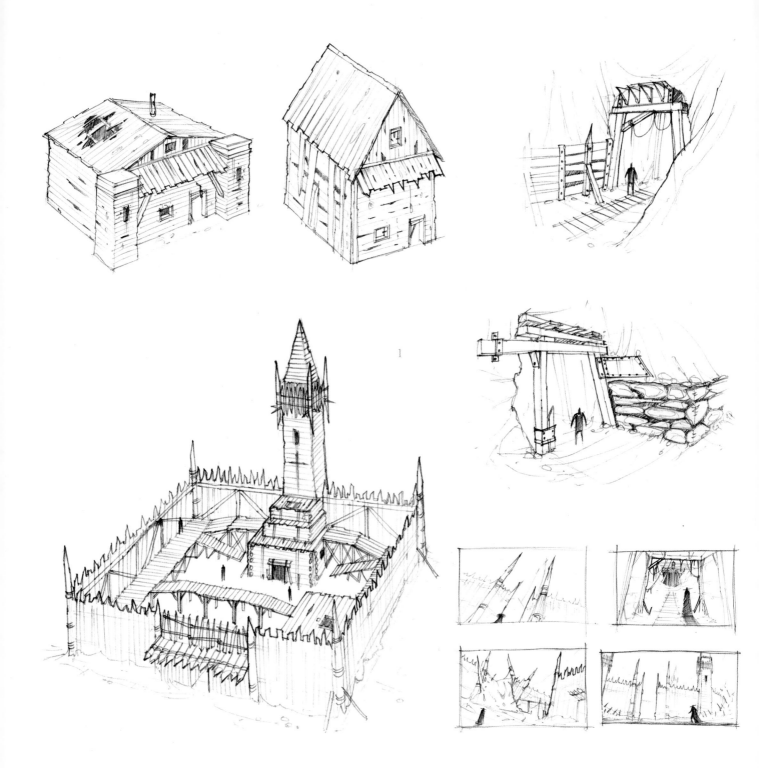

OUTPOST

1 & 2 DESIGNED BY STEVE JUNG / 3. DESIGNED BY FARZAD VARAHRAMYAN

As indicated by the image of the nighttime siege of a fort by undead hordes, we had always hoped to have a large-scale invasion of a Western fortress. Its placement in the snowy mountain passes during the daytime opened up some creative avenues that would bring some variation and a change of scenery from the rest of the Old West we've been redesigning.

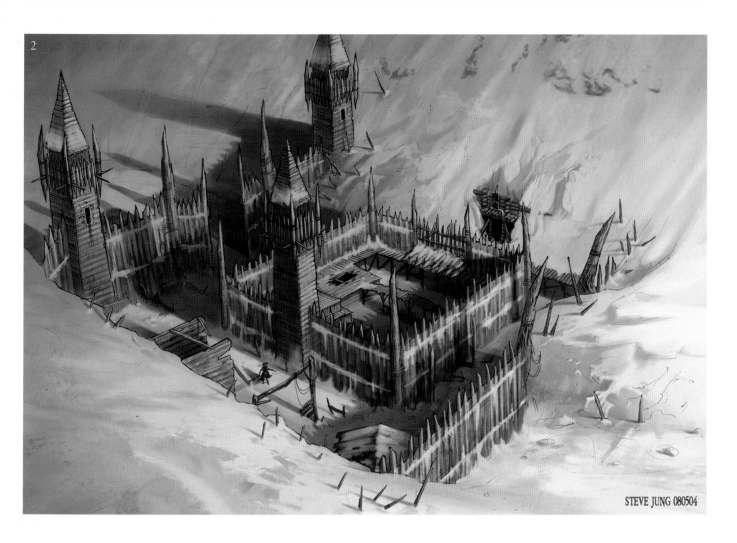

STEVE JUNG 080504

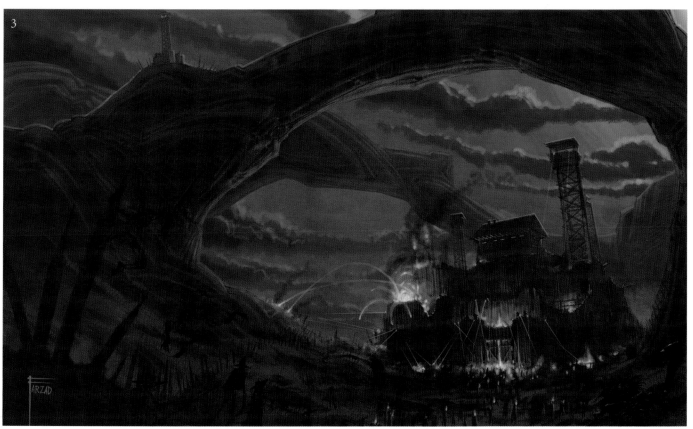

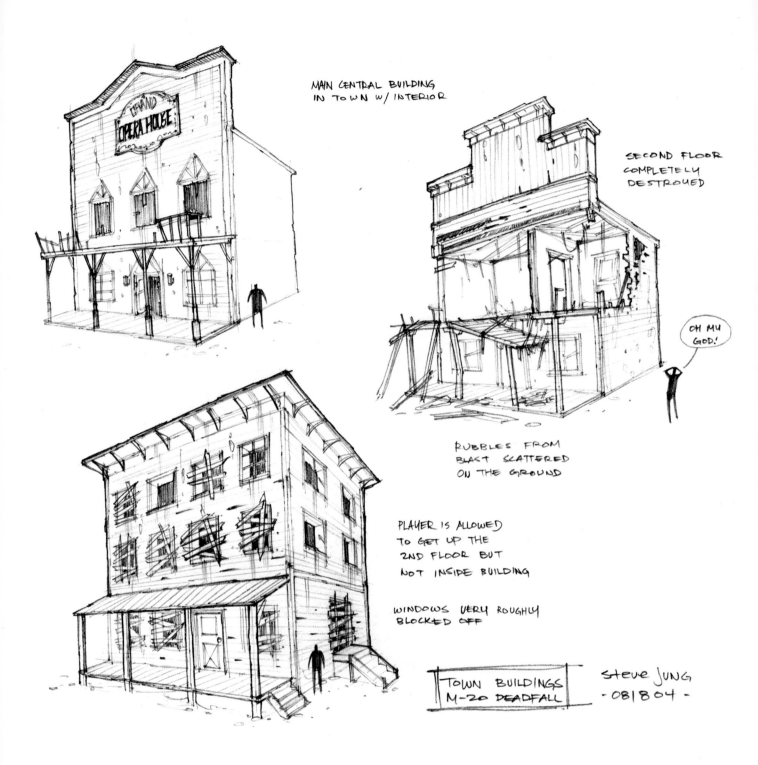

MAIN CENTRAL BUILDING
IN TOWN w/ INTERIOR

SECOND FLOOR
COMPLETELY
DESTROYED

OH MY
GOD!

RUBBLES FROM
BLAST SCATTERED
ON THE GROUND

PLAYER IS ALLOWED
TO GET UP THE
2ND FLOOR BUT
NOT INSIDE BUILDING

WINDOWS VERY ROUGHLY
BLOCKED OFF

TOWN BUILDINGS
M-20 DEADFALL

STEVE JUNG
- 081804 -

DEADFALL

Paul O'Connor, lead game designer, wanted to end the game with one of many bangs. His idea was to have the Darkwatch lay siege to the town of Deadfall, which had been overrun by evil and was gradually sinking into a hellish lava sinkhole. We used imagery from World War II and the eastern front, and images of large railway cannons, barricades in the streets, building-to-building fighting, and other images of devastation.

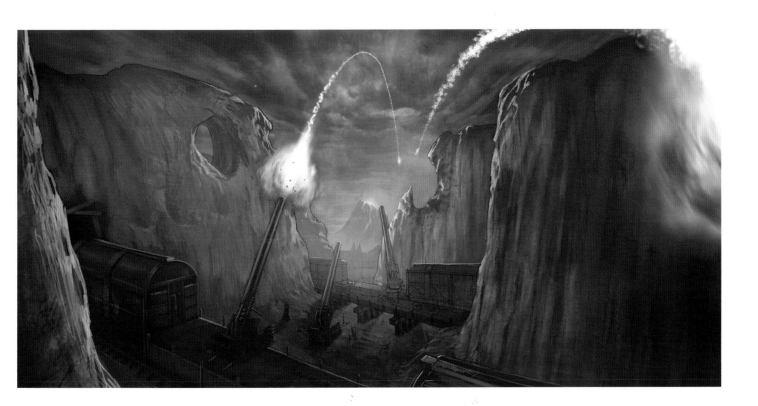

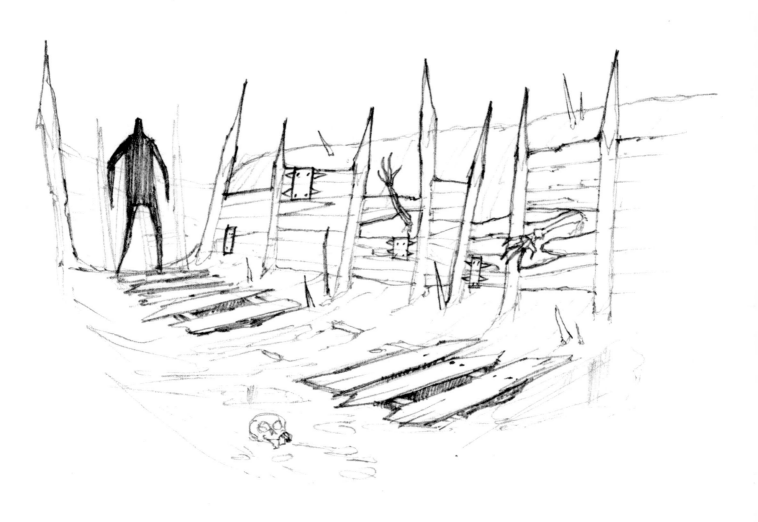

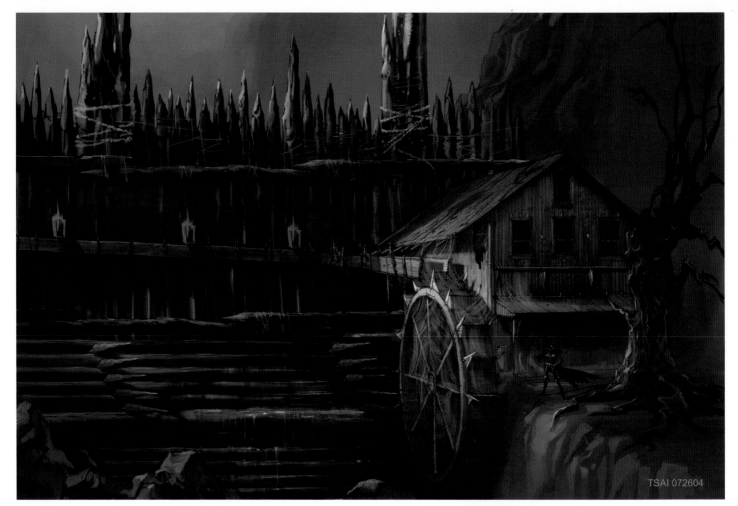

TSAI 072604

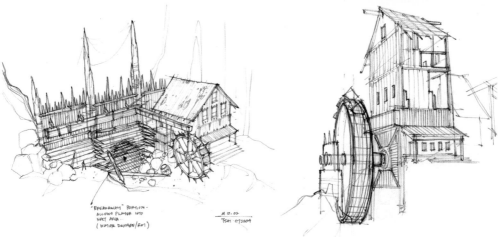

"BREAKAWAY" PORTION -
ALLOWS PLAYER INTO
NEXT AREA
(WATER DAMAGE/ROT)

M 10.02
TSAI 072204

BAPTISM OF FIRE

ALL DESIGNED BY FRANCIS TSAI

Even though its design is colorful, this evil-infested mining camp has a dark and moody feel courtesy of Francis Tsai. If you look carefully, one of the design elements that we use over and over in a variety of ways throughout the game is the simple triangular-shape of spikes.

Even the round shape of the waterwheel got the spikes treatment to give it some edge.

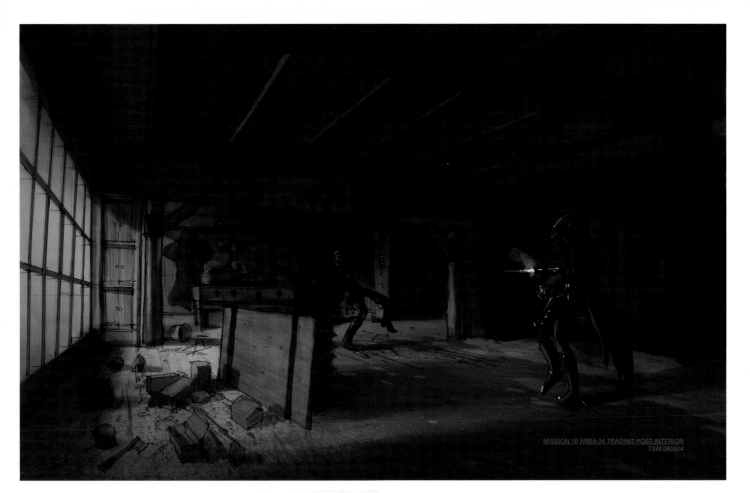

MISSION 10 AREA 04 TRADING POST INTERIOR
TSAI 080504

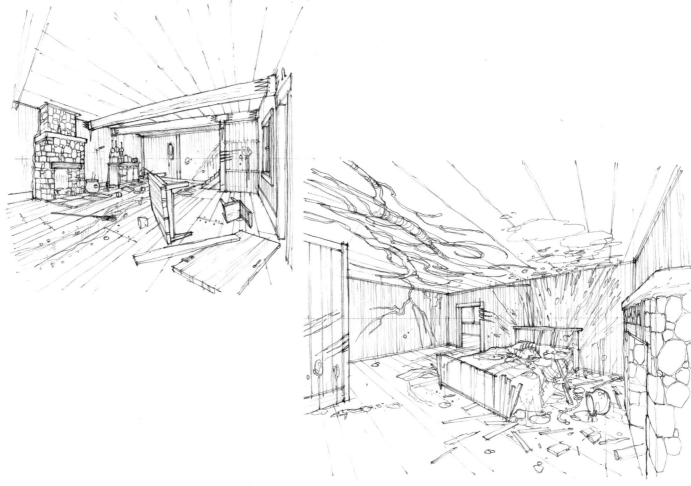

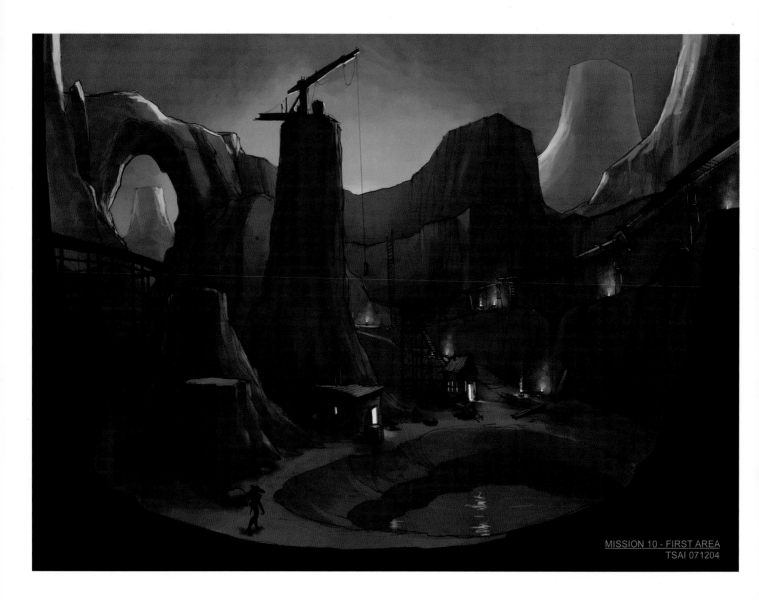

MISSION 10 - FIRST AREA
TSAI 071204

BAPTISM OF FIRE

ALL DESIGNED BY FRANCIS TSAI

Spikes immediately impart a sense of an environment that is unfriendly to humans, especially living ones.

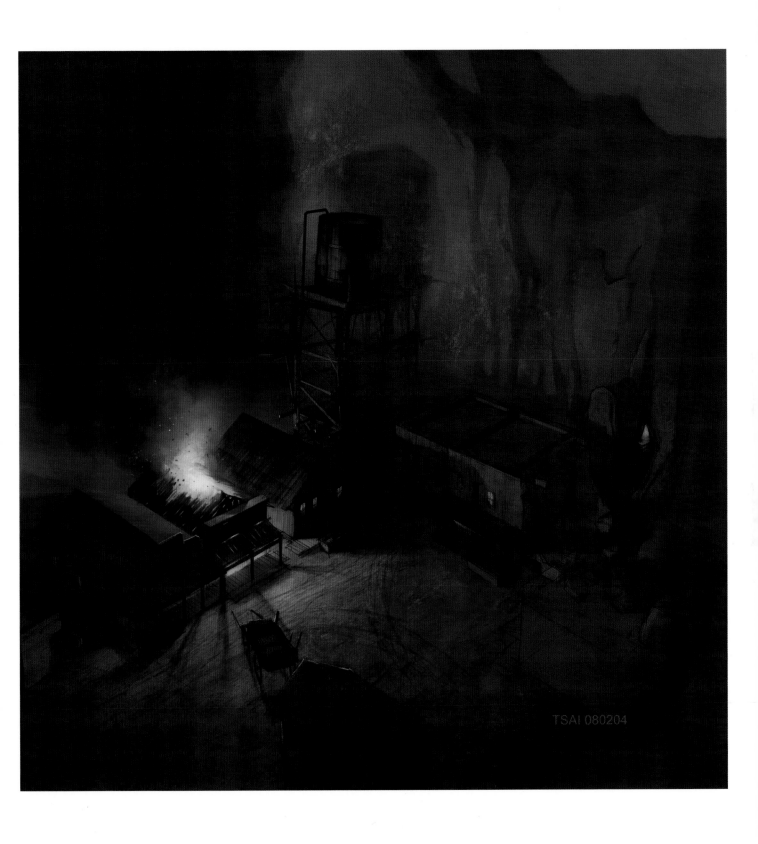

TSAI 080204

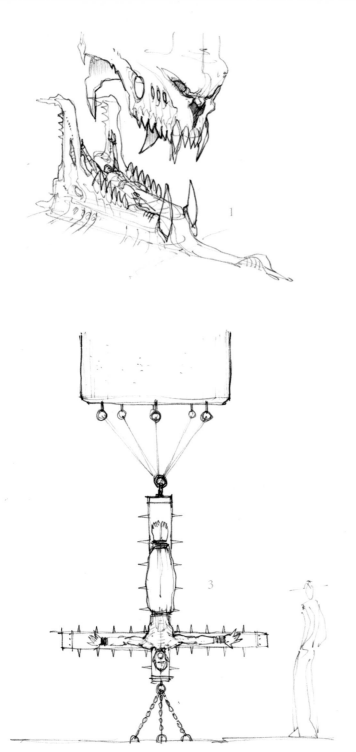

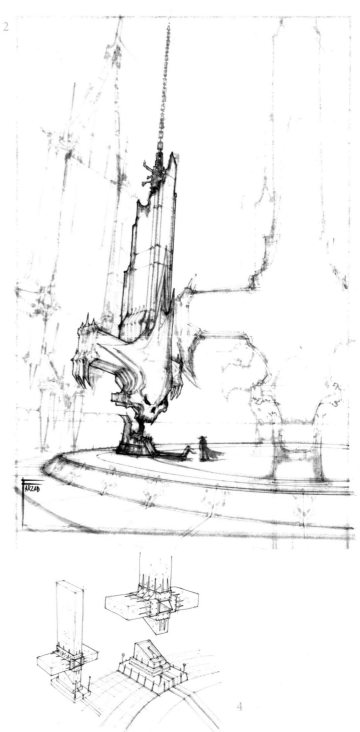

GROUND ZERO

1, 3, 4, 5 & 6 DESIGNED BY FRANCIS TSAI
2. DESIGNED BY FARZAD VARAHRAMYAN

Ground zero is literally that. It was conceptually proposed as the location from which Lazarus would initiate his ultimate plan to take over the world. We settled on a concept that lent itself to the technology available at the time, and also offered the greatest flexibility to the game designers in creating that last battle between good and evil.

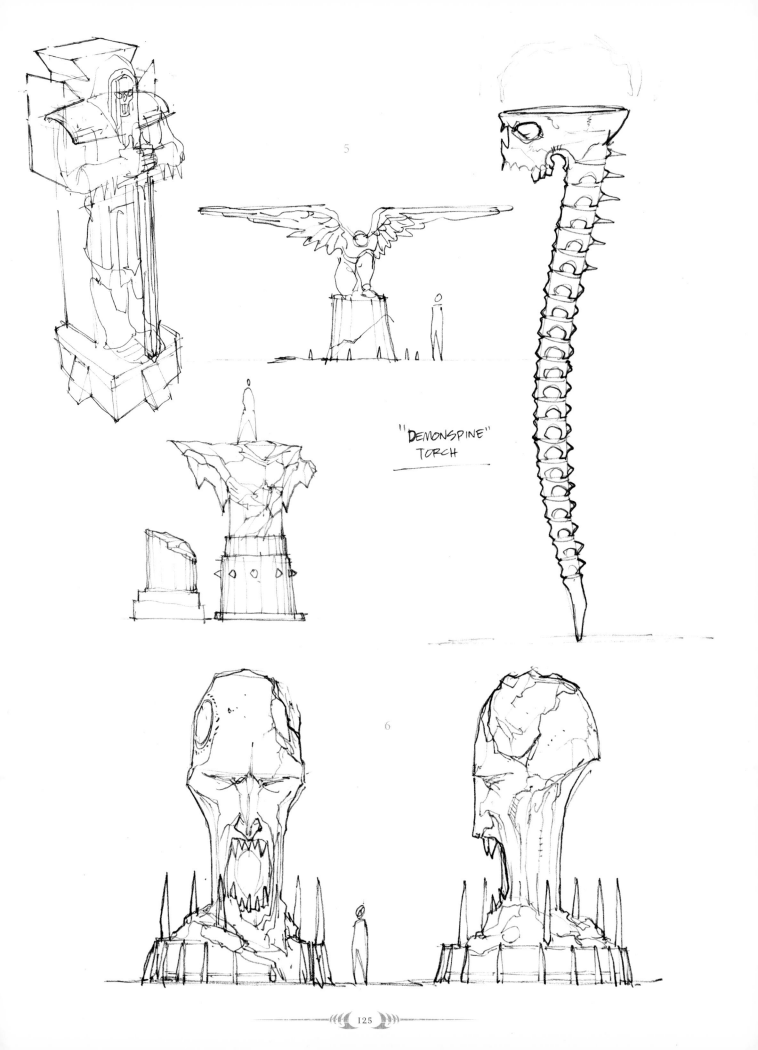

5

"DEMONSPINE"
TORCH

6

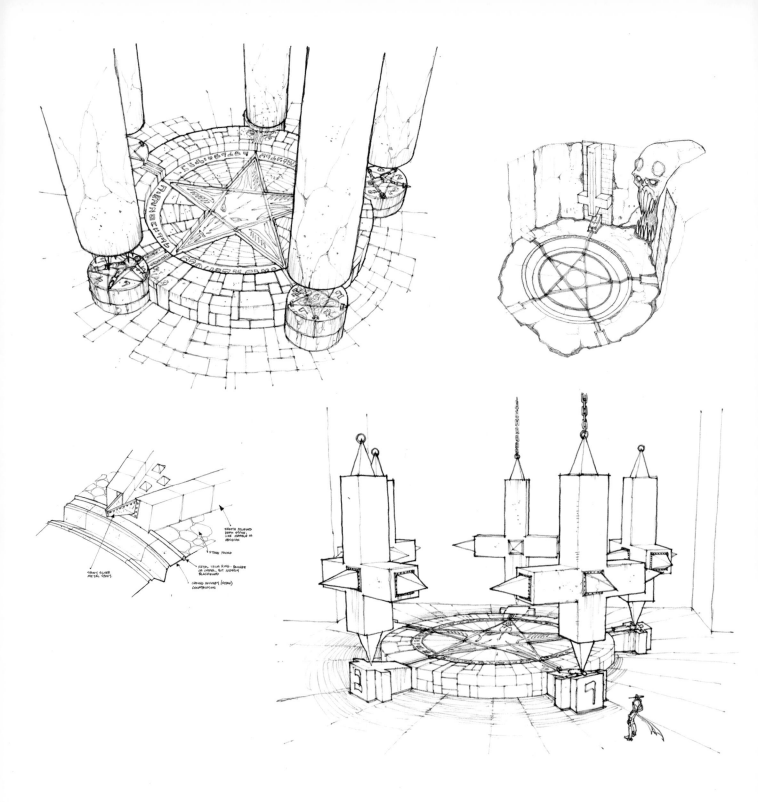

GROUПD ZERO

ALL DESIGNED BY FRANCIS TSAI

Great design is not defined by the amount of freedom one has in a design task, but by the amount of constraints one has to work with to make a great design work. This observation was put to the test on every environment that was designed by the concept team, and then masterfully realized by Ivan Power, senior artist, and his talented team of environment artists.

We decided to make ground zero a vast space but designed it with repeating themes, so fewer maps with more detail could be used, in conjunction with geometry that was dense where it mattered and light where no one would look. Francis and Ivan worked within tight budgets to balance these issues and come up with visual solutions for technical restrictions.

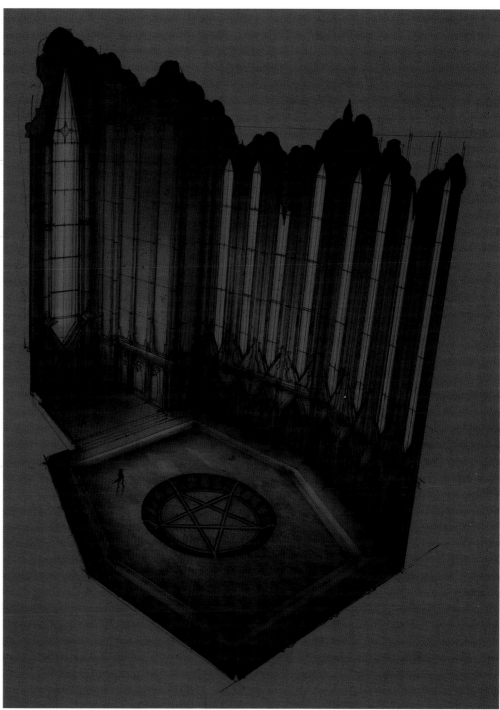

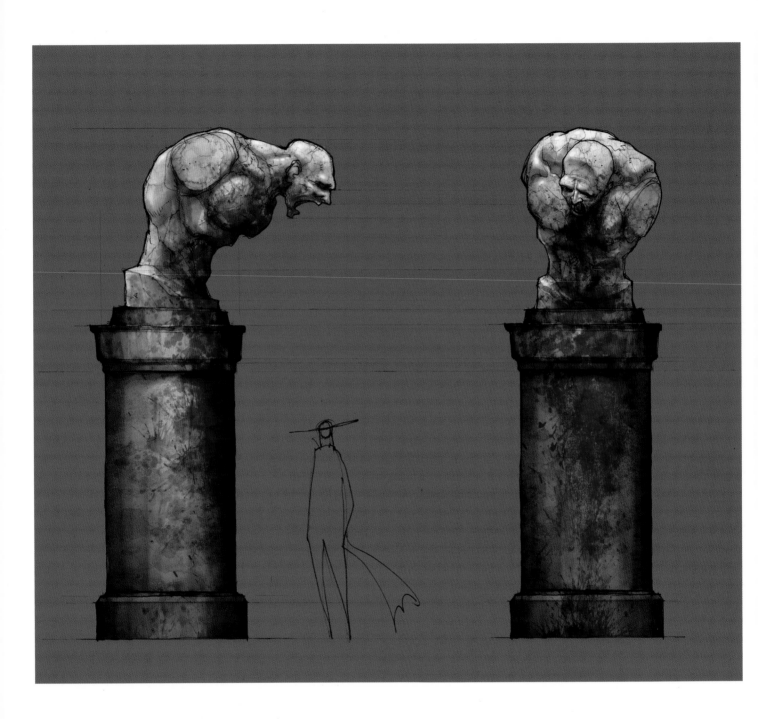

GROUND ZERO

ALL DESIGNED BY FRANCIS TSAI

The core concept we chose to pursue for the visual development of ground zero was, if Lazarus had a cathedral of evil erected in his own image, what would that space be? Francis explored a variety of architectural styles and permutations. The final design was very much referential to Gothic architecture and very appropriate in its dehumanizing scale.

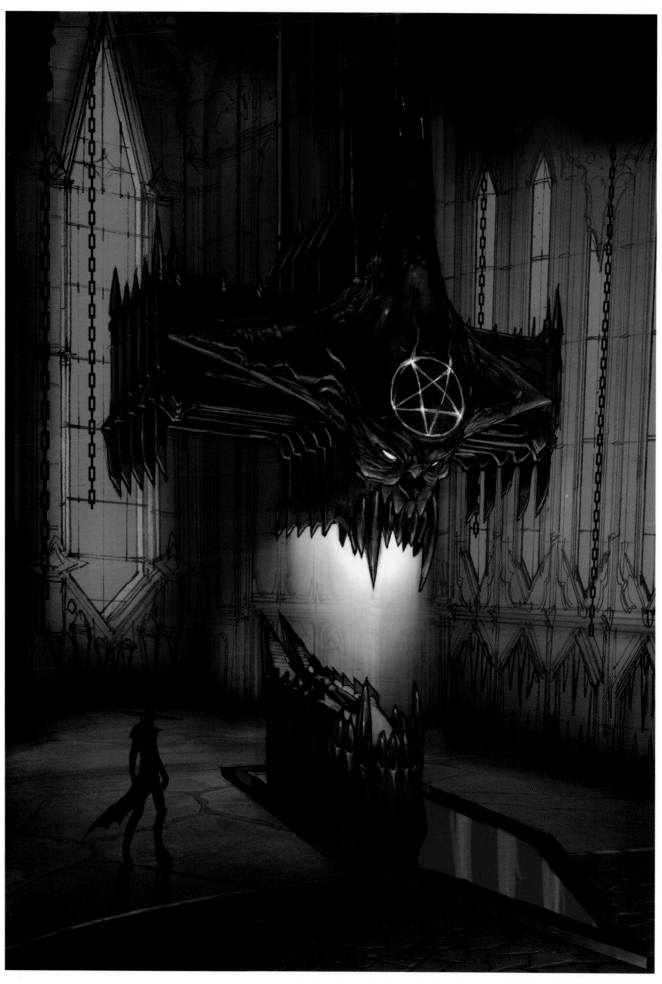

DARKWATCH

DARKWATCH DARKWATCH

DARKWATCH DARKWATCH

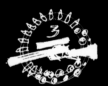

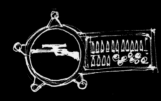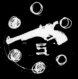

DARKWATCH GRAPHICS

⟪⟪ 4 ⟫⟫

At times it may seem like the Interface may take a second seat, but it's important to stress how critical the interface is. It conveys all the information that is relevant for the player to know. The key is to design an interface that is non-invasive, so the player can retain immersion while still being aware of all the vital information that they will need to survive in the game. Here is a sampling of the design work that went into creating the interface graphics for Darkwatch.

1. DESIGNED BY SHANE NAKAMURA

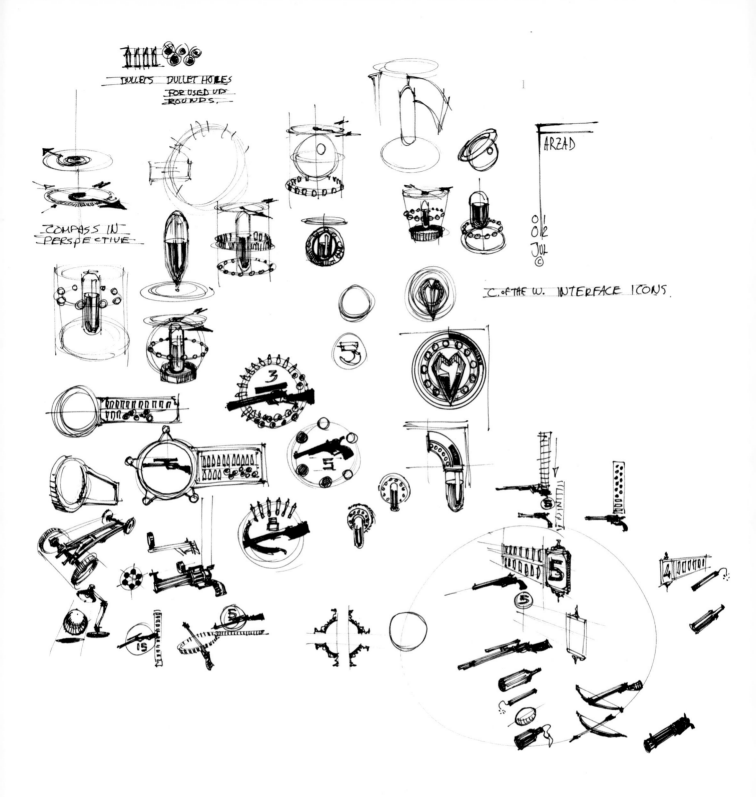

BULLETS BULLET HOLES
FOR USED UP
ROUNDS.

COMPASS IN
PERSPECTIVE

FARZAD

C. OF THE W. INTERFACE ICONS.

USER INTERFACE

1. DESIGNED BY FARZAD VARAHRAMYAN
2. DESIGNED BY JANG C. LEE

The graphics language that is developed for a game is the communication tool that is essential to clearly, quickly, and concisely communicate to the player a range of information, hints, and data that will determine whether the gaming experience will be fun...or not. Everything from the UI, the HUD display, and even the game logo need to communicate well, work together, and fit in the same stylistic world.

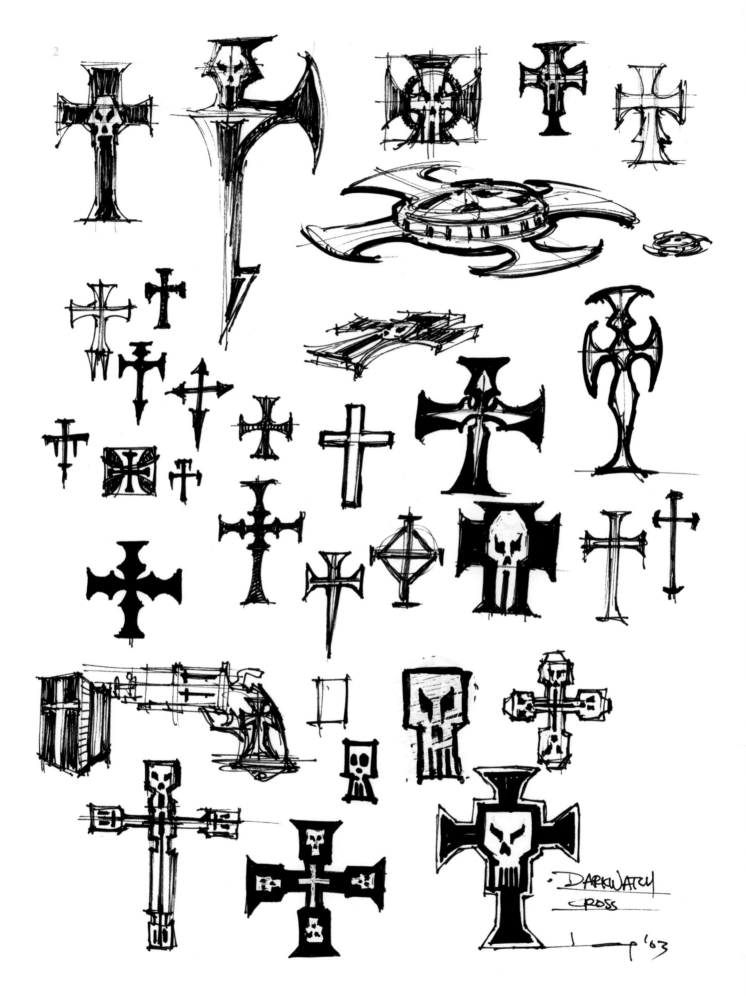

DARKWATCH
CROSS

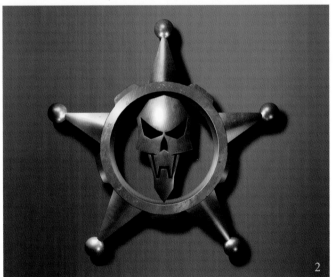

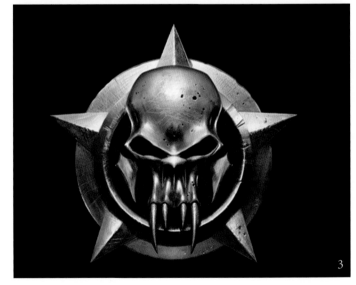

LOGO

1 & 4 DESIGNED BY SHANE NAKAMURA
2. DESIGNED BY EMMANUEL VALDEZ / 3. ILLUSTRATED BY MONGSUB SONG

You can see by following the development and progression of the badge icon and logo text designs that as the theme of the game became refined and darker in nature, so did the visual representation of these graphics.

DARKWATCH™

DARKWATCH

DARKWATCH

DARKWATCH

DARKWATCH

DARKWATCH

DARKWATCH

DARKWATCH

DARKWATCH

a curse of the west
DARKWATCH

DARKWATCH

DARKWATCH

DARKWATCH

DARKWATCH

DARKWATCH

DARKWATCH

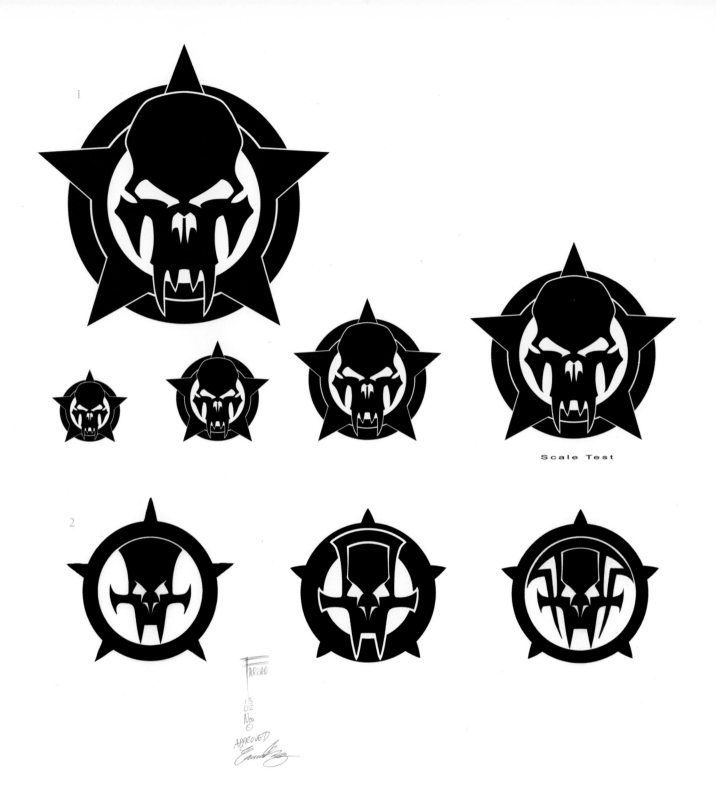

1

2

Scale Test

LOGO

1. ILLUSTRATED BY FARZAD VARAHRAMYAN
2. DESIGNED BY FARZAD VARAHRAMYAN / 3. COMPOSITED BY BILLY KING

Once we settled on the right feel for the logo and badge design, these images were used not only for a variety of game applications but also for marketing and PR purposes. Just remember: Once it's out there, it's out there. So be sure you have done everything in your power to create imagery that is functional, beautiful, and memorable because that is what identifies you and communicates your message to the consumer.

DARKWATCH

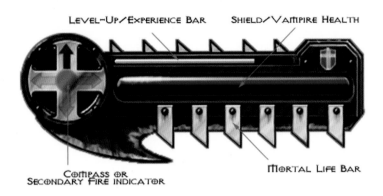

LEVEL-UP/EXPERIENCE BAR SHIELD/VAMPIRE HEALTH

COMPASS OR
SECONDARY FIRE INDICATOR MORTAL LIFE BAR

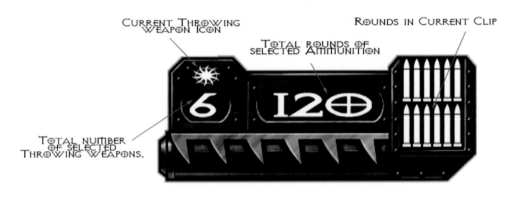

CURRENT THROWING
WEAPON ICON ROUNDS IN CURRENT CLIP

TOTAL ROUNDS OF
SELECTED AMMUNITION

TOTAL NUMBER
OF SELECTED
THROWING WEAPONS.

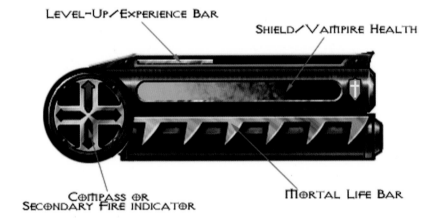

LEVEL-UP/EXPERIENCE BAR

SHIELD/VAMPIRE HEALTH

COMPASS OR
SECONDARY FIRE INDICATOR MORTAL LIFE BAR

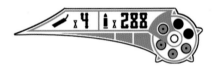

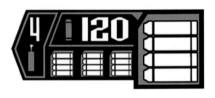

USER INTERFACE

1. DESIGNED BY SHANE NAKAMURA / 2. DESIGNED BY BILLY KING

Shane Nakamura and Billy King had the daunting and difficult task of creating a beautiful yet simple and clear user interface. This task requires you to have a firm understanding of art and graphics, as well as the ability to think technically and work with technical issues that define the UI functionality. Part of the process, once the style is established through some sketches, is to fine-tune and tightly art direct the UI. These Photoshop ren-

derings are a fraction of the images created for the UI. A variety of graphic solutions were pursued to clearly show how many bullets one may have left in a specific weapon. The UI and HUD had the tightest-rendered art direction–more than that of any character, vehicle, or environment.

Vampire Shield

Ghost Brand

1

2

3

Blood Frenzy

Ghost Brand Texture animation

Skull fades out to 50%

and back to 100% slow

Animation of Powerup

- rotate counter clockwise slow
- hover with a slight bounce

Scale

Silver Brand

2

139 is printed at the bottom center

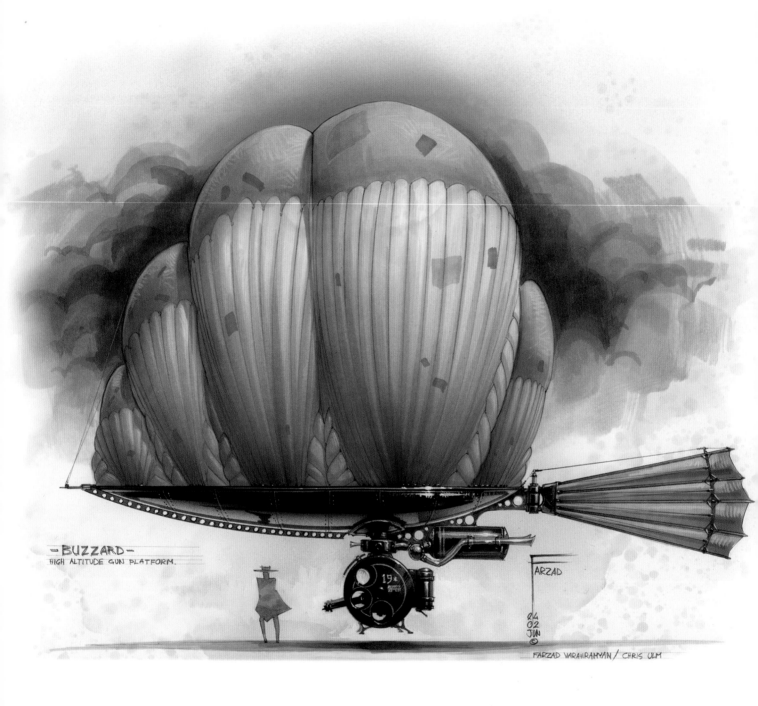

- BUZZARD -
HIGH ALTITUDE GUN PLATFORM.

19

FARZAD

24
02
JAN

FARZAD VARAHRAMYAN / CHRIS ULM

VEHICLES

5

All secret agents must have a plethora of gadgets and vehicles at their disposal to fight against the forces of evil, and the Darkwatch is no different. We sought to not only develop vehicles that were visually appealing, but to also give them a sense of realism. All the vehicles were designed with the ideal in mind that they should appear as if they would work given the technology, materials and design elements of the time...plus a little help from advanced Darkwatch technology. Ultimately, the vehicles had to be fun and contribute to the thrill ride of the player.

BOTH PAGES DESIGNED BY FARZAD VARAHRAMYAN

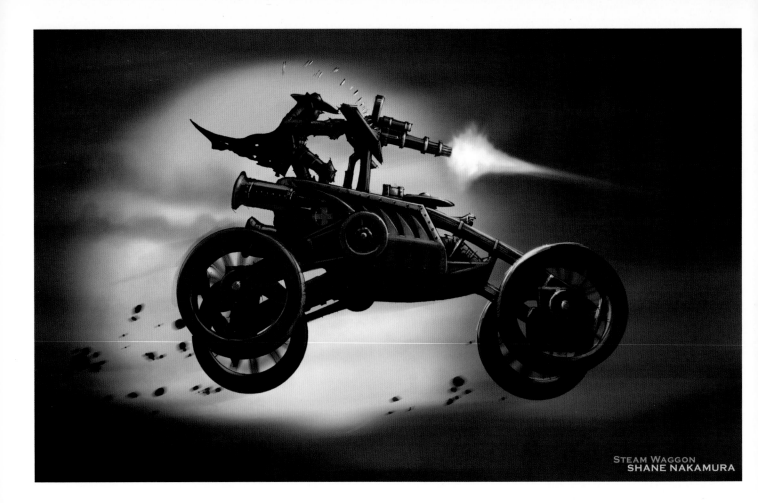

STEAM WAGGON
SHANE NAKAMURA

COYOTE STEAMWAGON

ALL DESIGNED BY SHANE NAKAMURA

The visual DNA document came in handy once again when designing vehicles, specifically the Darkwatch coyote battlewagon. This vehicle was meant to be fast, nearly indestructible, and to dish out lethal punishment to vampires and the undead. We incorporated the advanced Darkwatch steam engine technology, which is actually based on a high-octanelike fuel that is based on various alcohols and ground-up vampire bones. The Darkwatch sensibility for vicious engineering comes through in its use of knifelike support ribbing and bladed front-and-back bumpers that are used for mowing down the undead and their tombstones.

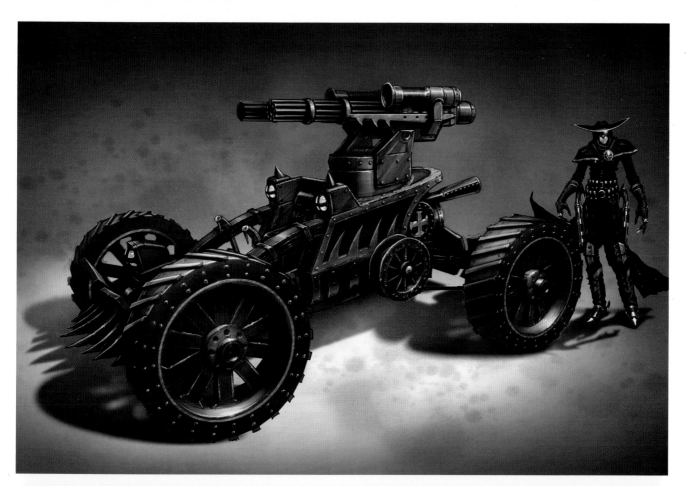

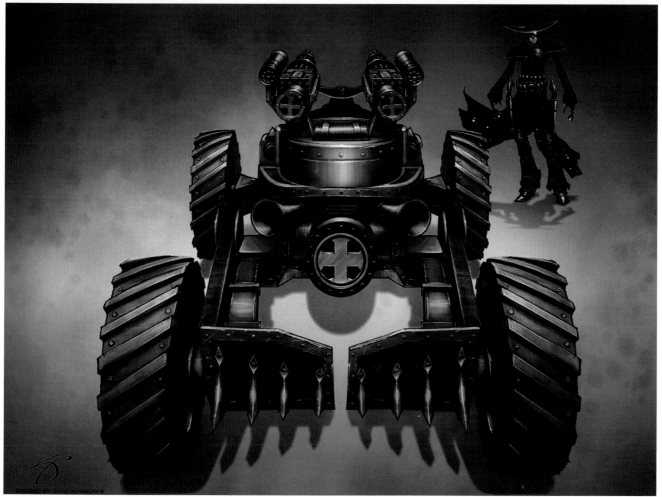

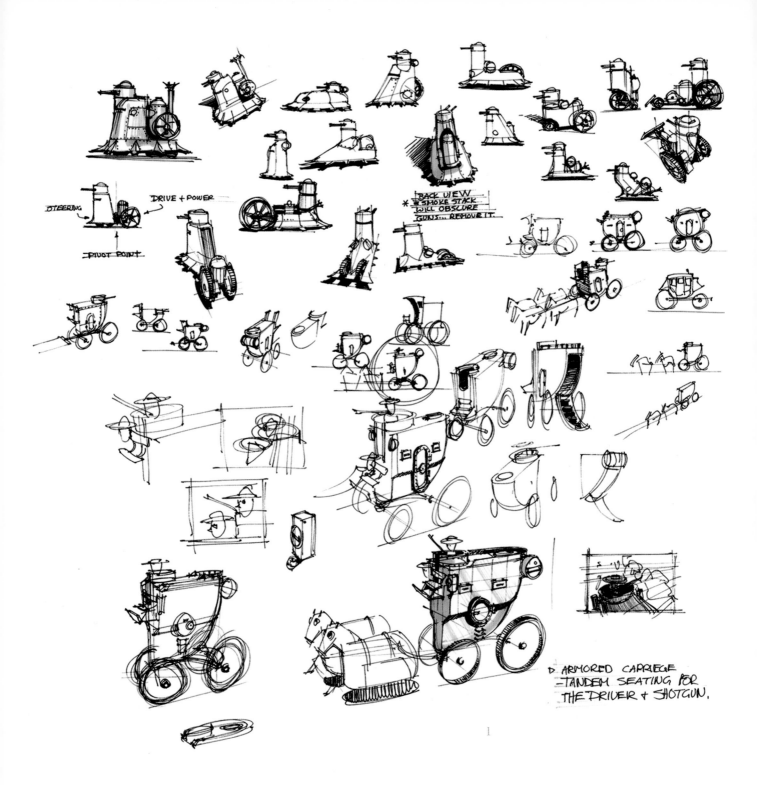

Within the sketches:

STEERING

DRIVE + POWER

PIVOT POINT

BACK VIEW
* SMOKE STACK
WILL OBSCURE
GUNS... REMOVE IT

D. ARMORED CARRIAGE
-TANDEM SEATING FOR
THE DRIVER & SHOTGUN.

1

COYOTE STEAMWAGON

1. DESIGNED BY FARZAD VARAHRAMYAN

2. DESIGNED BY SHANE NAKAMURA

In all design tasks, we start with small thumbnails that focus on the general silhouette, stance, and attitude of the vehicle, without many details. The thumbnails were done at a time when the Darkwatch universe had not yet been defined by the darker and more mature themes it has now. Shane Nakamura's degree in industrial design from Art Center College of Design made him a natural for designing the Darkwatch vehicles. He explored many variations on the coyote that took him from the very large and lumbering to the classical horse-pulled carriage shape to very low, ground-hugging designs. Iteration refined the look and design.

2

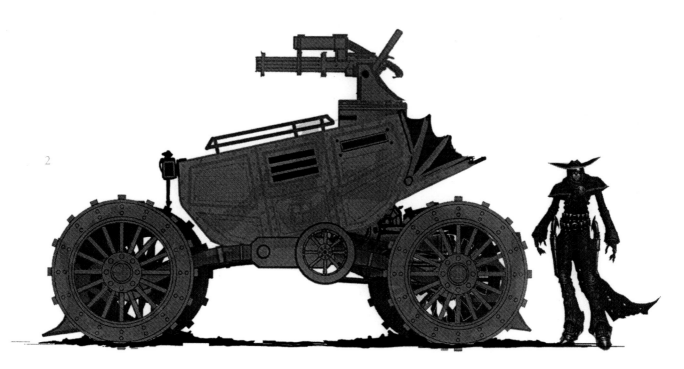

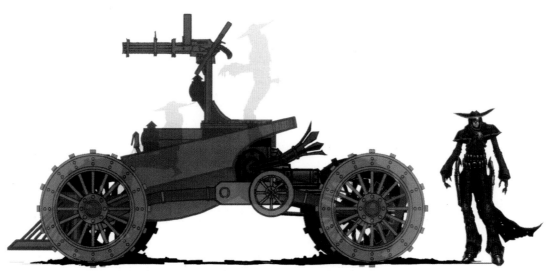

Scale Drawing
[steam wagon]

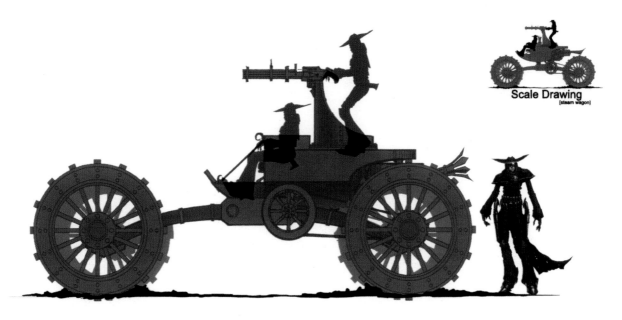

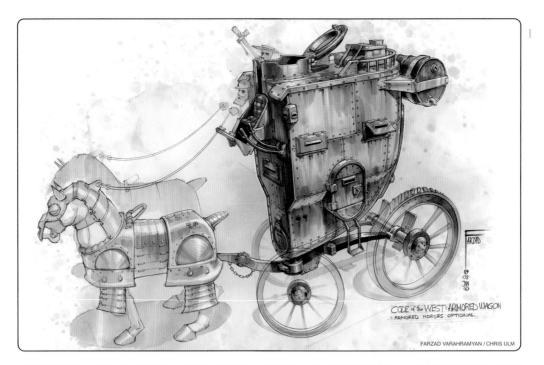

FARZAD VARAHRAMYAN / CHRIS ULM

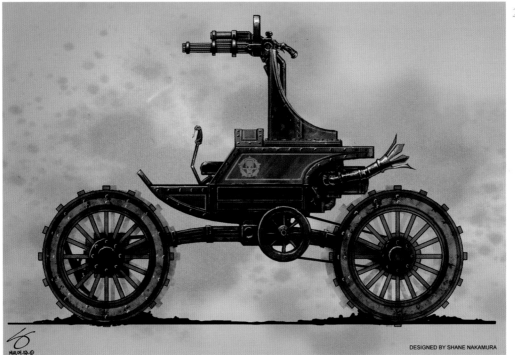

DESIGNED BY SHANE NAKAMURA

COYOTE STEAMWAGON

The horse-drawn armored wagon defines the point in preproduction where we thought the Darkwatch still had to rely on conventional propulsion solutions. However, it became obvious that a fun, high-speed chase with over-the-top firepower and agility would not be possible in a horse-drawn carriage. This is another example of the gameplayers' ability to have a fun game experience driving the process and development of the Darkwatch DNA and technology. The schematic of the coyote is based on our desire to always create machinery, even though it may be fantastical in its design, that looks like it may actually function. Perceived mechanical functionality is an important element that helps make the design "feel" right, and by default it helps it to be animated "feeling" right.

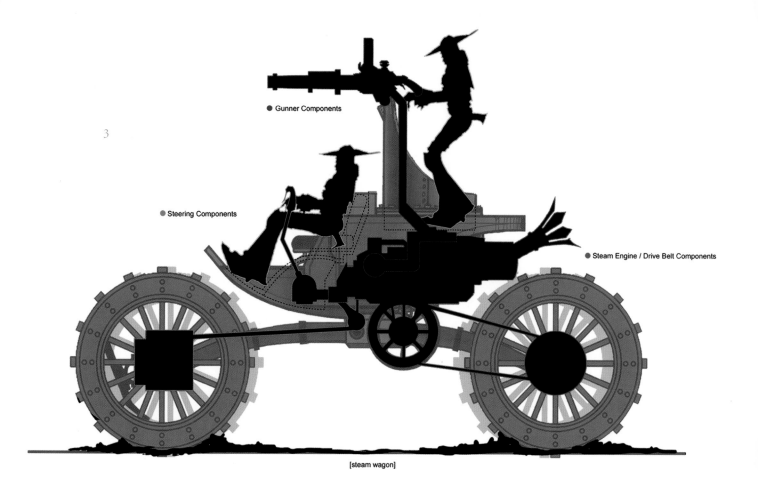

3

● Gunner Components

● Steering Components

● Steam Engine / Drive Belt Components

[steam wagon]

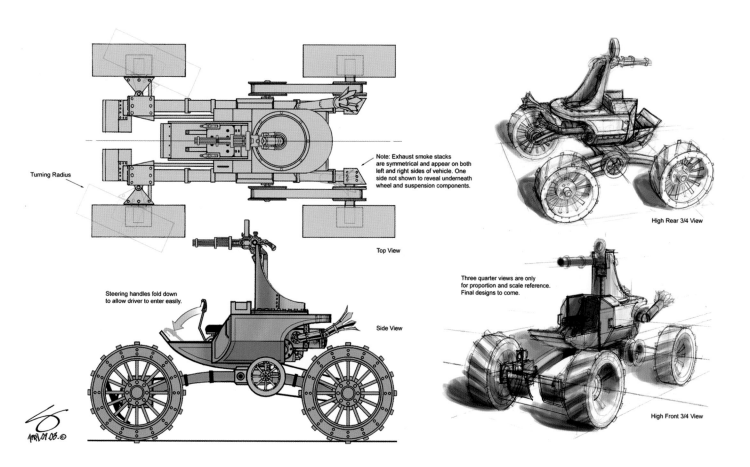

Turning Radius

Note: Exhaust smoke stacks are symmetrical and appear on both left and right sides of vehicle. One side not shown to reveal underneath wheel and suspension components.

Top View

High Rear 3/4 View

Steering handles fold down to allow driver to enter easily.

Side View

Three quarter views are only for proportion and scale reference. Final designs to come.

High Front 3/4 View

APRIL.09.05.©

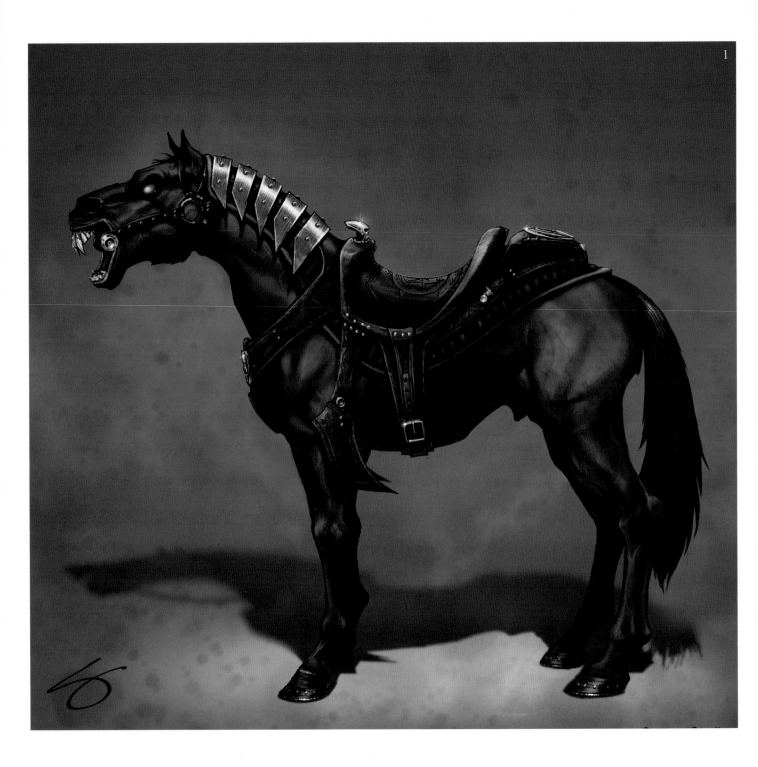

SHADOW

1 & 2 DESIGNED BY SHANE NAKAMURA
3. DESIGNED BY FARZAD VARAHRAMYAN

The final design of Shadow seems to be an obvious one–black, lean, and fast-looking with lethal metal-armor for protection. However, it started out as a big Clydesdale, since we thought it needed to be huge and powerful. This tested with focus groups unfavorably, especially in Europe where this type of horse was considered to be slow, lumbering, and associated with hauling beer or heavy cargo. Lesson? We listen to our audience, try to understand what they mean, and use the good portions of the feedback to help improve our work.

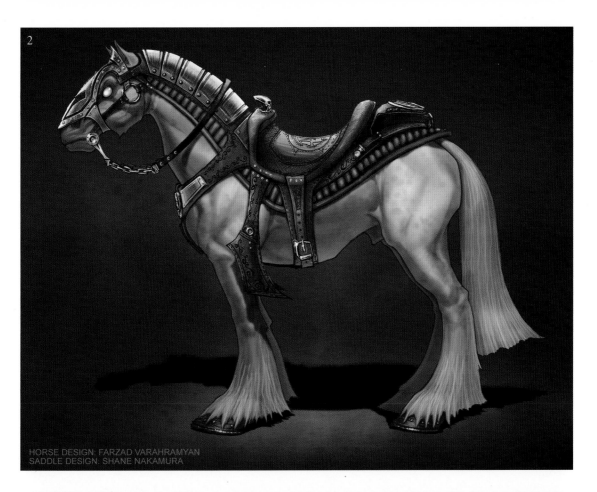

HORSE DESIGN: FARZAD VARAHRAMYAN
SADDLE DESIGN: SHANE NAKAMURA

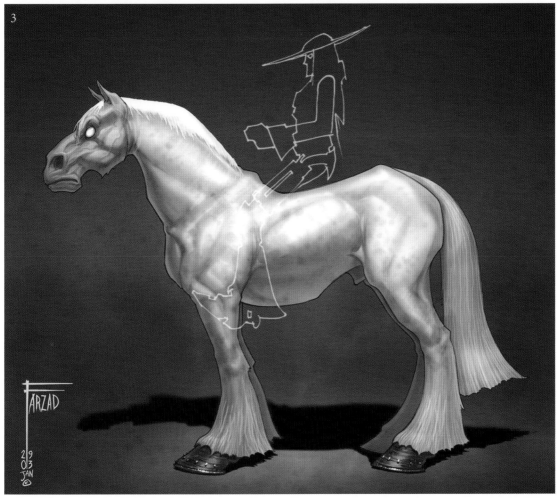

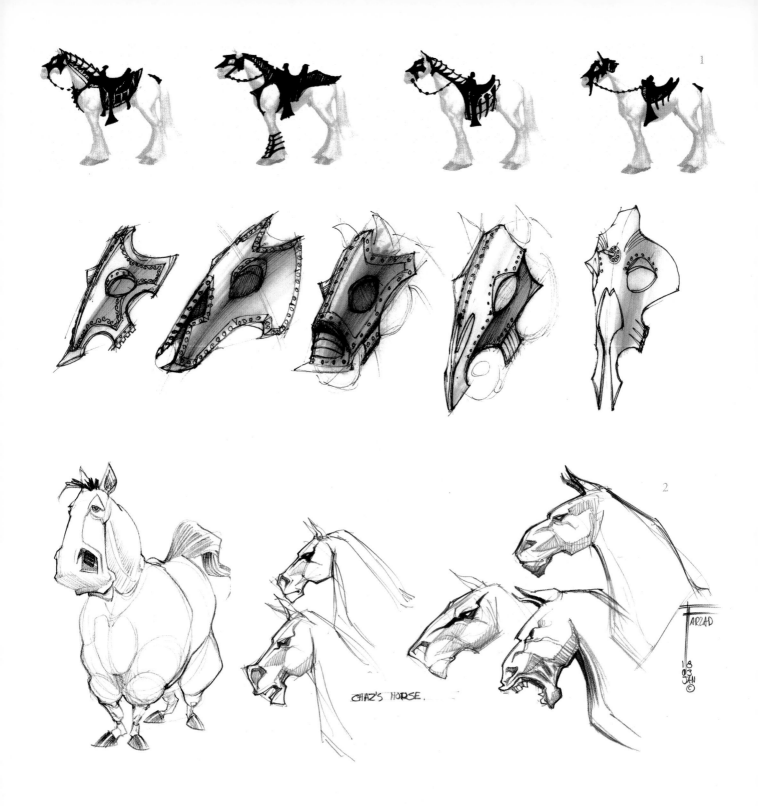

CHAZ'S HORSE.

SHADOW

1 & 3 DESIGNED BY SHANE NAKAMURA
2. DESIGNED BY FARZAD VARAHRAMYAN

Again, initially the vision of the game was less dark. The rotund proportions of the cartoony horse were the defining reason for making the early incarnations of Jericho tall and lanky, with his pelvis where his chest should have been. Later, when designing the more action-oriented Shadow, one of the design cues that Shane used for the saddle and harness were modern-day motorcycle shapes.

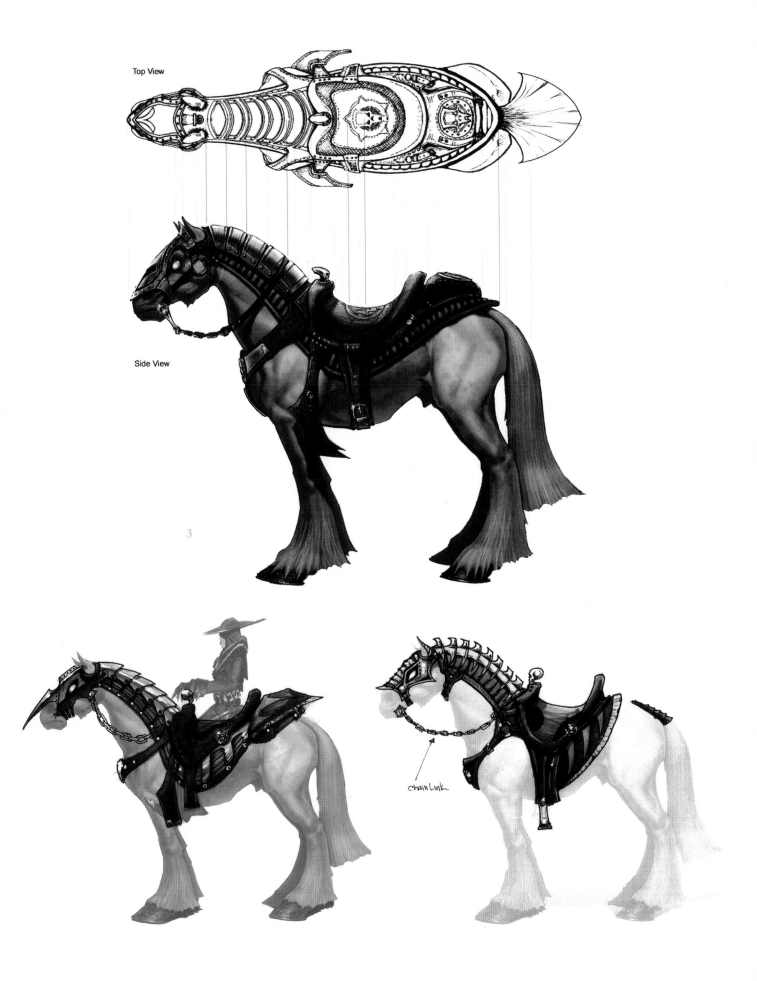

Top View

Side View

3

chain link

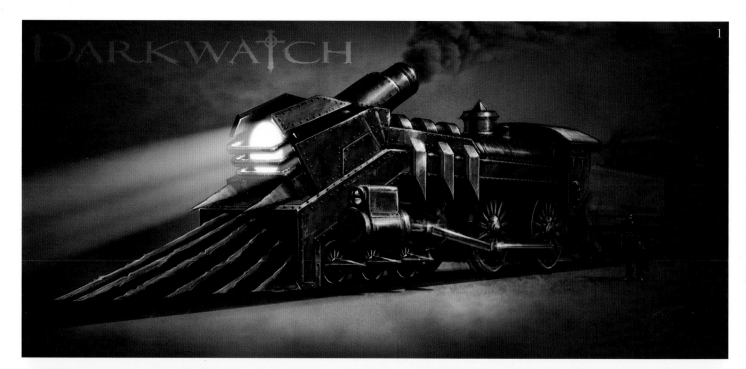

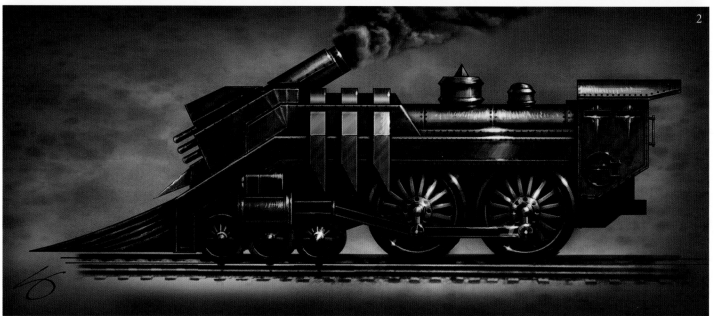

DARKWATCH TRAIN

1, 2 & 3 DESIGNED BY SHANE NAKAMURA
4. DESIGNED BY FRANCIS TSAI

We tried to ground the basic design of the engine on the traditional steam locomotives of the time. Iterations and variations of design cues honed in on sharp, lethal, structural pieces and materials that incorporated the Darkwatch DNA. However, the true feeling of speed and stealth was not achieved until we took our cue from automotive design and simply angled back the smokstack in line with the angle of the lethal cowcatcher. It now felt like it could easily outstrip any locomotive of its time.

3

4

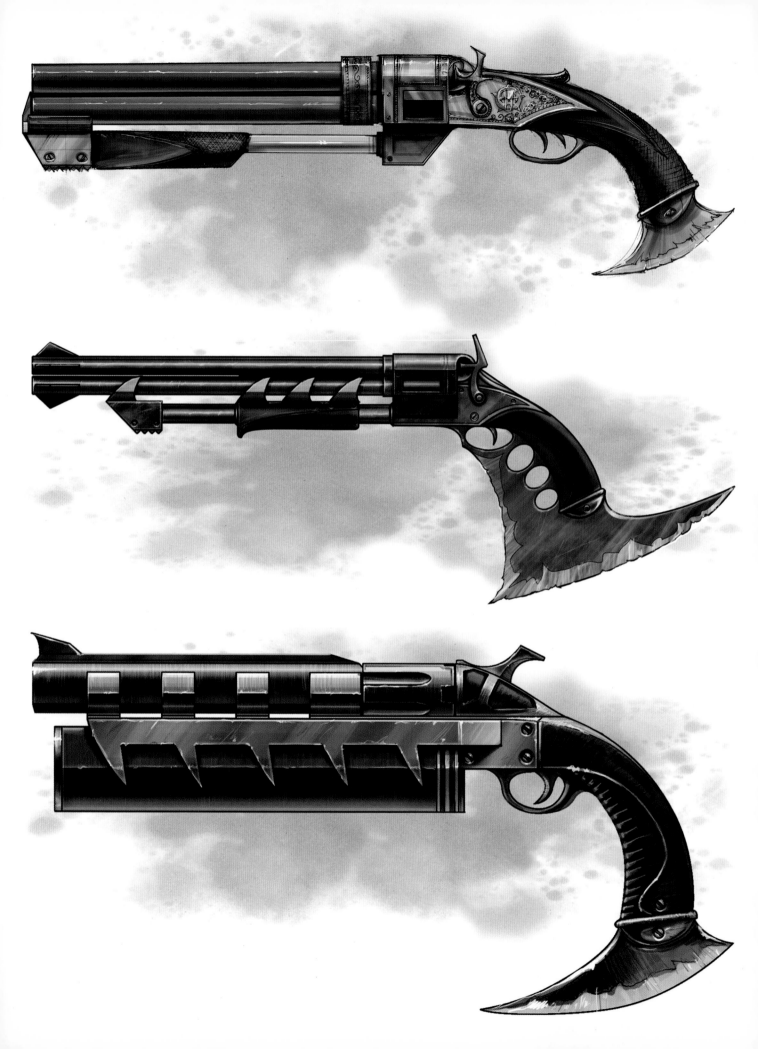

WEAPONS

6

The weapons of the Darkwatch needed to be unique. If a Darkwatch regulator goes up against the legions of the undead, a standard six-shooter or rifle won't cut it. They need fire power and lots of it. Weapons development for Darkwatch was done much like anything else; they had to be fantastical yet believable. Perceived mechanical functionality is sought after in all mechanical designs for the Darkwatch.

Weapons in a first-person shooter are very important. They are the objects you will directly interact with the most. Your survival in the game is deeply linked to your understanding and functionality of the weapon, and because it is right in your face, it also has to look great. Three of the defining visual-design elements that separate all Darkwatch weapons from the ordinary is the cross graphic, the fang motif, and the bladed hilts that turn the weapons into formidable melee weapons.

In a first-person shooter, the weapon is seen 90 percent of the time from that particular view with the weapon in forced perspective. Because of this, as a design approach, each weapon was designed primarily from the player's point of view, first-person, and not just a standard side-view. We found a lot of side-view sketches looked great, but once in first-person view, the most interesting and distinguishing features were usually hidden or most likely created strange read issues.

BOTH PAGES DESIGNED BY SHANE NAKAMURA

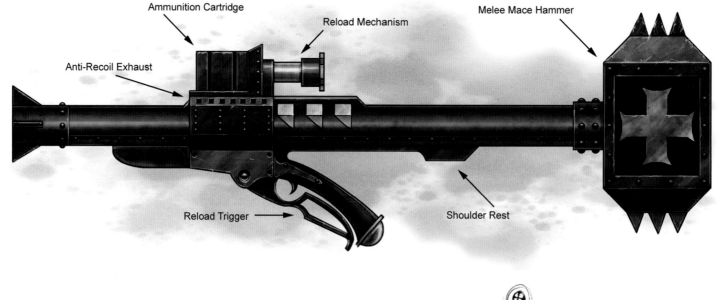

Ammunition Cartridge

Reload Mechanism

Melee Mace Hammer

Anti-Recoil Exhaust

Reload Trigger

Shoulder Rest

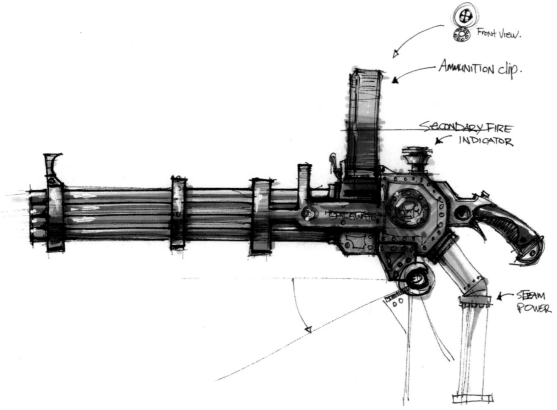

Front View.

Ammunition clip.

Secondary Fire Indicator

Steam Power

RAIL ROCKET

ALL DESIGNED BY SHANE NAKAMURA

In 1809, Darkwatch technicians had to create a mortar weapon that could be handheld. A team of Darkwatch scientists began their task by modifying a naval signal cannon. Eighteen months and nine prototypes later, the mortar hand cannon #10 was successfully tested on a rock formation in the deserts of New Mexico. In 1831, it was officially renamed the rail rocket.

You can see that the early design was based on a steam-power aesthetic, characterized by the adaptation of a steamboat smokestack. We also had to consider the weapon safely clear Jericho's hat. The distinguishing feature on the final design (top) is the battle-proven hammer that defines the weapon's look.

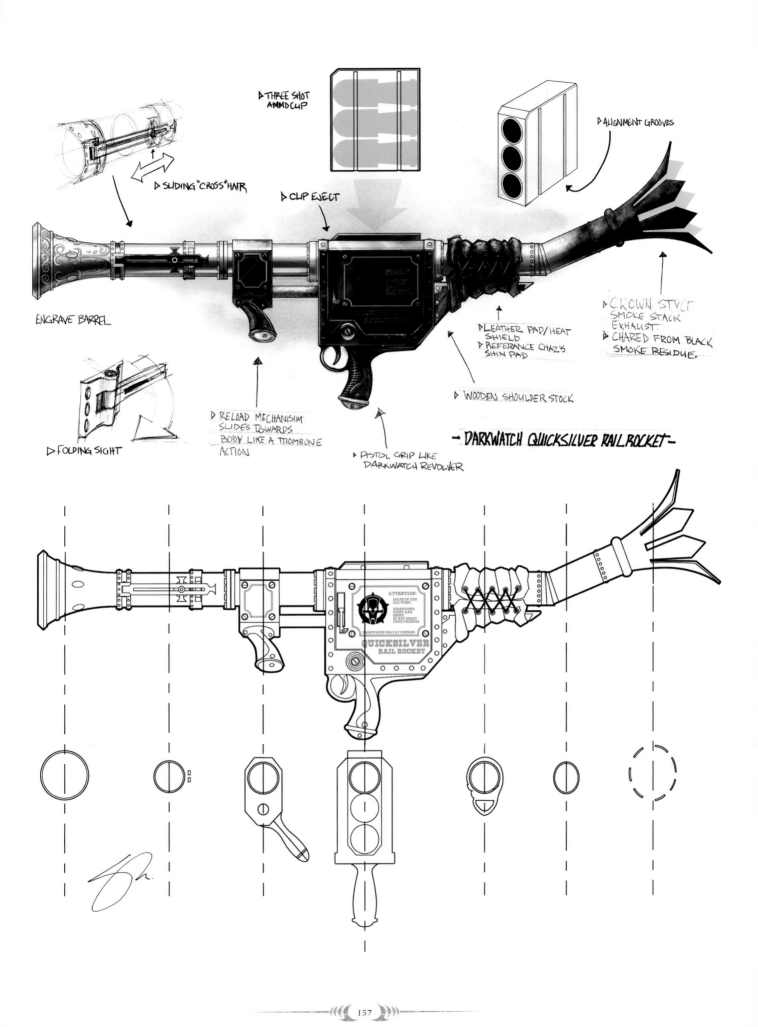

▷ THREE SHOT AMMO CLIP

▷ SLIDING "CROSS" HAIR

▷ CLIP EJECT

▷ ALIGNMENT GROOVES

ENGRAVE BARREL

▷ FOLDING SIGHT

▷ RELOAD MECHANISM. SLIDES TOWARDS BODY LIKE A TROMBONE ACTION

▷ PISTOL GRIP LIKE DARKWATCH REVOLVER

▷ LEATHER PAD/HEAT SHIELD
▷ REFERANCE CHAZ'S SHIN PAD

▷ WOODEN SHOULDER STOCK

▷ CROWN STYLE SMOKE STACK EXHAUST
▷ CHARED FROM BLACK SMOKE RESIDUE.

— DARKWATCH QUICKSILVER RAIL ROCKET —

ATTENTION:
MADE IN THE
OLD WEST.

DIRECTIONS:
POINT AND
SHOOT
DO NOT SHOOT
YOUR FRIENDS

QUICKSILVER
RAIL ROCKET

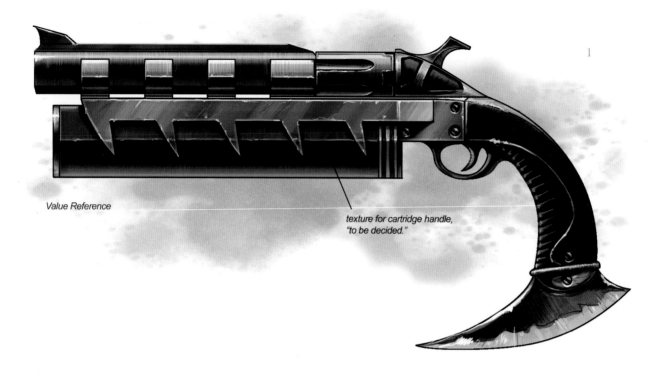

Value Reference

texture for cartridge handle,
"to be decided."

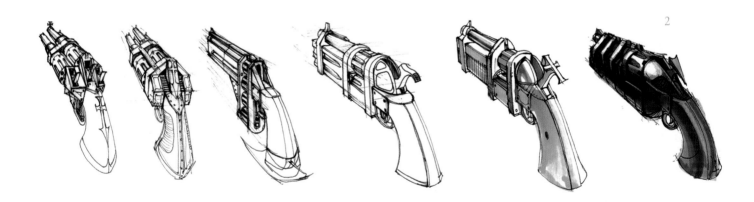

REDEEMER PISTOL

1 & 2 DESIGNED BY SHANE NAKAMURA
3, 4 & 5 DESIGNED BY FARZAD VARAHRAMYAN

The redeemer revolver combined massive firepower with a simple architecture that was resistant to jamming and misfire. The redeemer used modified ejector pins to continuously feed cylinder charges into the weapon's muzzle. Once expended, each cylinder was automatically ejected through the breech to make room for the next cylinder. In this way, a Darkwatch regulator could discharge up to three cylinders, 18 bullets, before replacing the cartridge.

The pistol was the first weapon to be refined into the Darkwatch fang-and-blade aesthetic. This helped establish the DNA for all other weapons. Key, in all weapon designs was the desire to convey a mechanical possibility that the weapon could actually work.

3

MORE STREMLINED
HANDLE

ARZAD

15
02
AUG
©

FARZAD VARAHRAMYAN / CHRIS ULM.

Cross and Fang graphics are
etched into the silver bullet
surface.

Please match reference for
surface shine, and surface
imperfections.

4

Camera Framing

Bullets need to be detailed since they will
be seen up close, and under a slow camera
move (bullet time, no pun intended)

ARZAD

210
02
NOV
©

FARZAD VARAHRAMYAN / CHRIS ULM

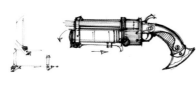

- CHAZ'S DARKWATCH REVOLVER -

5

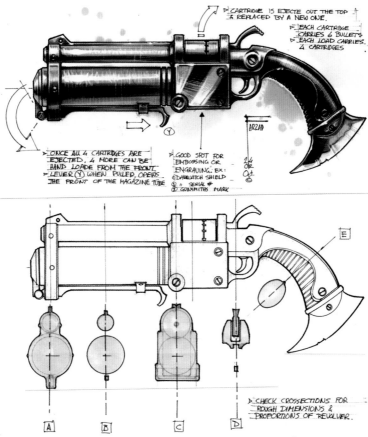

▷ CARTRIDGE IS EJECTE OUT THE TOP
& REPLACED BY A NEW ONE.

▷ EACH CARTRIDGE
CARRIES 6 BULLETS
▷ EACH LOAD CARRIES
4 CARTRIDGES

▷ ONCE ALL 4 CARTRIDGES ARE
EJECTED, 4 MORE CAN BE
HAND LOADED FROM THE FRONT
▷ LEVER (Y) WHEN PULLED, OPENS
THE FRONT OF THE MAGAZINE TUBE

▷ GOOD SPOT FOR
EMBOSSING OR
ENGRAVING. EX:
① DARKWATCH SHIELD
② n SERIAL #
③ GUNSMITHS MARK

ARZAD

24
02
Oct.
©

E

▷ CHECK CROSSECTIONS FOR
ROUGH DIMENSIONS &
PROPORTIONS OF REVOLVER.

A B C D

FARZAD VARAHRAMYAN / CHRIS ULM

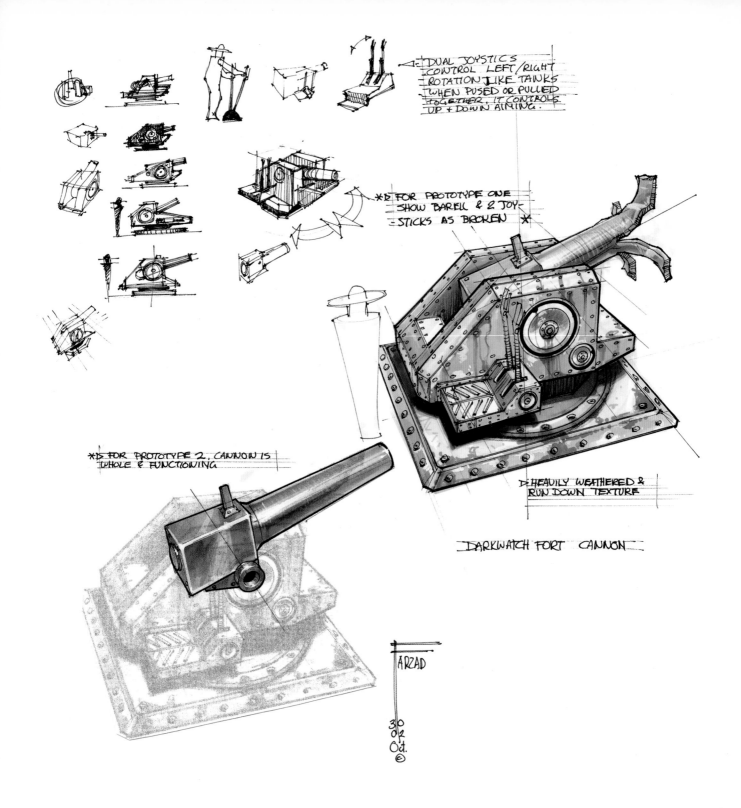

DUAL JOYSTICS
CONTROL LEFT/RIGHT
ROTATION LIKE TANKS
WHEN PUSED OR PULLED
TOGETHER, IT CONTROLS
UP + DOWN AIMING.

*1> FOR PROTOTYPE ONE
SHOW BARELL & 2 JOY-
STICKS AS BROKEN *

*1> FOR PROTOTYPE 2, CANNON IS
WHOLE & FUNCTIONING

1> HEAVILY WEATHERED &
RUN DOWN TEXTURE

DARKWATCH FORT CANNON

FARZAD
30
02
Oct.

CANNON AND AMMO PACK

ALL DESIGNED BY FARZAD VARAHRAMYAN

The cannon and ammo packs were early designs that were eventually dis-
carded due to game-design reasons or to create designs that fit better with
the Darkwatch DNA.

DARKWATCH
AMMO CASE

DARKWATCH AMMO
CASE
CROSS REINFORCE
MENT-LOCK.

*▷ BULLET HOLES
ARE OPTIONAL

▷ CARRIES SPECIAL AMMO FOR
DARKWATCH WEAPONS.
▷ SILVER PLATED CROS IS A BUILT
IN REPELLANT FOR VAMPIRES &
NIGHT CREATURES.
▷ LOCK FLIPS DOWN TO UNLOCK
*▷ LOCK SHIELD CAN GLOW GREEN
OR RED TO INDICATE AMMO & ACCESS

BACK V. FRONT V SIDE V.

FARZAD

23
OCT.
©

FARZAD VARAHRAMYAN / CHRS ULM

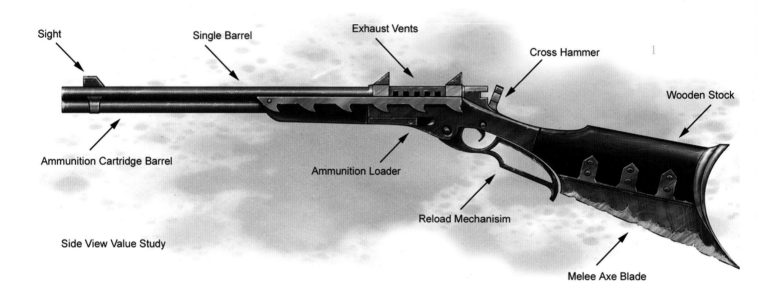

Sight

Single Barrel

Exhaust Vents

Cross Hammer

Wooden Stock

Ammunition Cartridge Barrel

Ammunition Loader

Reload Mechanisim

Side View Value Study

Melee Axe Blade

BLACKFISH CARBINE RIFLE

1. DESIGNED BY SHANE NAKAMURA
2. DESIGNED BY FARZAD VARAHRAMYAN

A derivative of the model 1858 Winfield 2-band musket, the blackfish carbine was a breech-loading repeater that was modified heavily for quick reload and close combat. Winfield's trademark walnut-stock wood was reserved only for the weapon's butt end. This created a heavier total weight but limited recoil and increased bludgeoning power.

The initial rifle was again based more on a Jules Vern/steam-power technology, and although aesthetically pleasing, it did not convey the vicious, over-the-top punishment the Darkwatch DNA demanded. We used the cross graphic as both a design element associated with vampire lore and in this case, also the firing hammer.

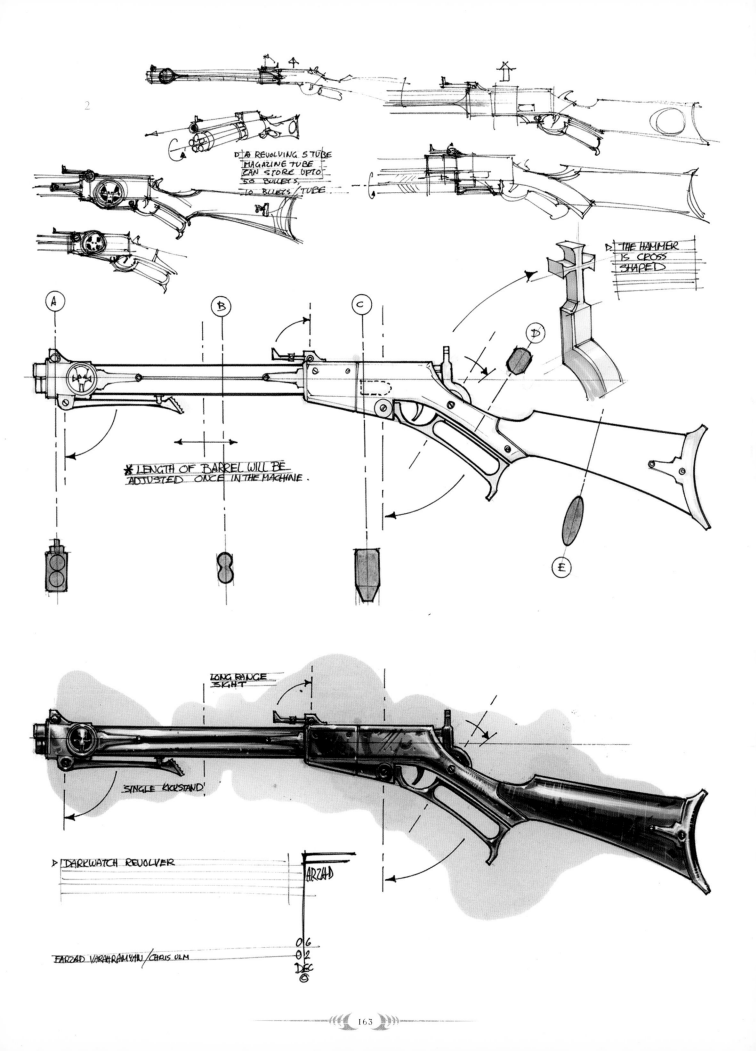

2

▷ A REVOLVING 5 TUBE
MAGAZINE TUBE
CAN STORE UPTO
50 BULLETS,
10 BULLETS/TUBE

▷ THE HAMMER
IS CROSS
SHAPED

A B C D

✱ LENGTH OF BARREL WILL BE
ADJUSTED ONCE IN THE MACHINE.

E

LONG RANGE
SIGHT

SINGLE KICKSTAND

▷ DARKWATCH REVOLVER

FARZAD

FARZAD VARAHRAMYAN / CHRIS OLM

06
02
DEC
©

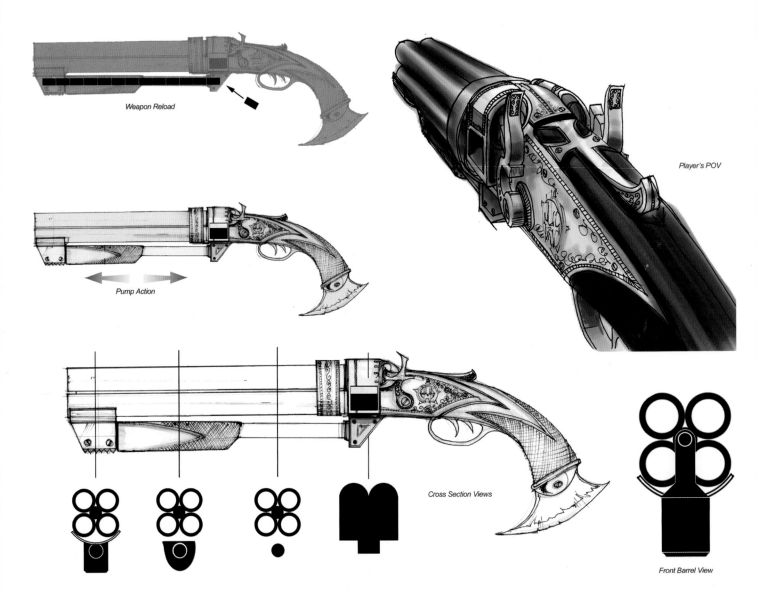

Weapon Reload

Pump Action

Player's POV

Cross Section Views

Front Barrel View

ARGUS SHOTGUN

ALL DESIGNED BY SHANE NAKAMURA

Named for the four-eyed, all-knowing creature of Greek mythology Argus Panoptes, this four-barreled shotgun is a favorite of Darkwatch agents facing an enemy that needs to be completely taken apart.

With all our weapons, we tried to push the implied visual firepower as much as possible, so it would support the over-the-top hit reactions and ragdoll physics that we planned to assign to each weapon's impact on the enemy. One of the distinguishing features on the Argus is the sharp, fang-like hammers that strike the pin.

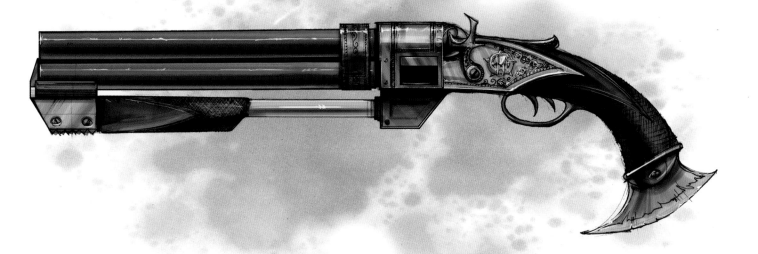

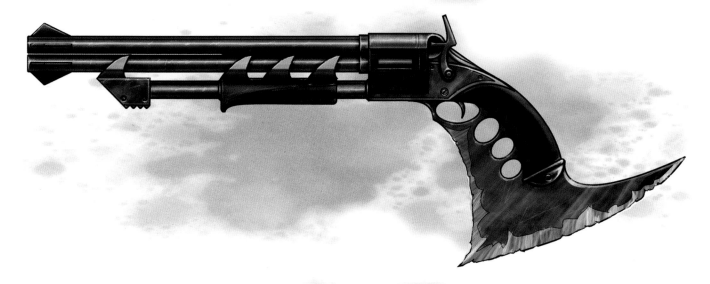

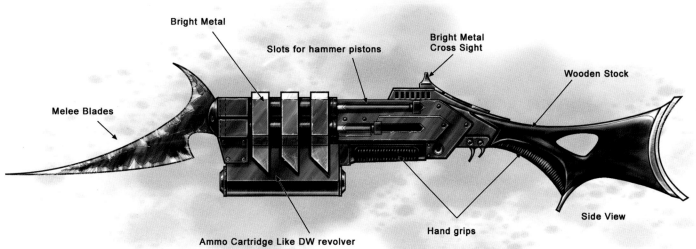

Bright Metal

Slots for hammer pistons

Bright Metal Cross Sight

Wooden Stock

Melee Blades

Ammo Cartridge Like DW revolver

Hand grips

Side View

DARKWATCH Crossbow

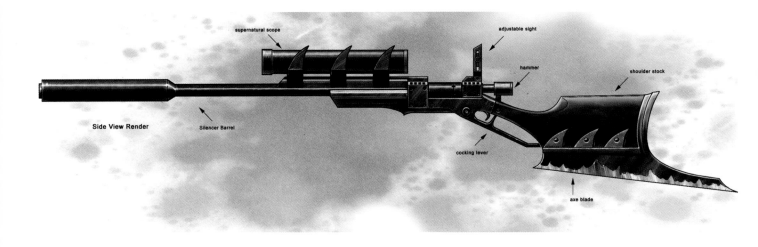

Side View Render

supernatural scope

adjustable sight

hammer

shoulder stock

Silencer Barrel

cocking lever

axe blade

CARSON RANGE RIFLE

ALL DESIGNED BY SHANE NAKAMURA

The Carson range rifle was designed to maximize range at the expense of all else. Its long barrel makes it impossible to conceal and awkward to carry. It has no repeating fire capabilities and bears a fragile five-pound scope, which provides ranged sight.

The sniper rifle also went through some visual fine-tuning. A repeating theme, the cross, finds its way on the weapon as a Maltese cross graphic on the firing hammer.

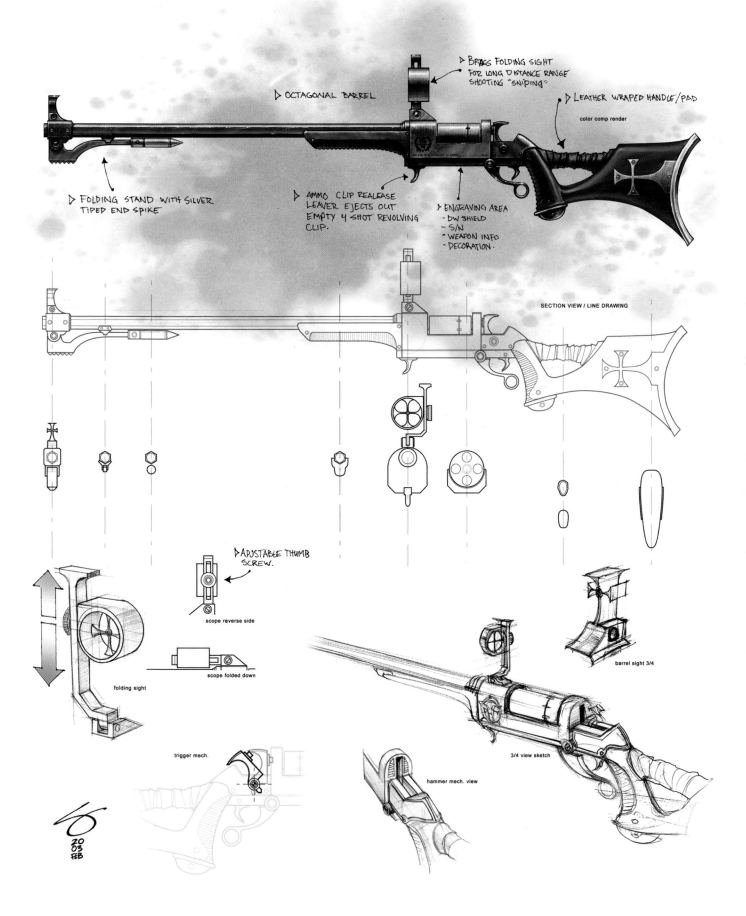

▷ OCTAGONAL BARREL

▷ BRASS FOLDING SIGHT
FOR LONG DISTANCE RANGE
SHOOTING "SNIPING"

▷ LEATHER WRAPED HANDLE/PAD

color comp render

▷ FOLDING STAND WITH SILVER
TIPED END SPIKE

▷ AMMO CLIP REALEASE
LEAVER EJECTS OUT
EMPTY 4 SHOT REVOLVING
CLIP.

▷ ENGRAVING AREA
- DW SHIELD
- S/N
- WEAPON INFO
- DECORATION.

SECTION VIEW / LINE DRAWING

▷ ADJSTABLE THUMB
SCREW.

scope reverse side

scope folded down

folding sight

barrel sight 3/4

trigger mech.

3/4 view sketch

hammer mech. view

20
03
FEB

THE DARKWATCH CONCEPT ART DEPARTMENT

FARZAD VARAHRAMYAN

Creative Visual Director Farzad Varahramyan has always had a passion for drawing and creating new worlds and characters. He received a B.F.A. from the University of Alberta, Canada, and a B.S. with honors from Art Center College of Design, majoring in product design. Farzad's been in the game industry for the last ten years, working as a production designer. He worked closely with Oddworld's Lorne Lanning, developing the visual look of Abe's Oddysee, Abe's Exoddus, and Munch's Oddysee, for which he designed the main character. He has also contributed designs to the films *Jumanji*, and most recently *Alien Vs. Predator*. In 2002, Farzad became cofounder and director of High Moon Studios where he established the concept art department and codeveloped the visual DNA for multiple original IP games. In 2001 and 2003, he received three gold medal awards from New York Festivals for Best Computer Generated Images, and was nominated at the 2002 Game Developers Conference for Excellence in Visual Arts for Munch's Oddysee. Farzad attributes his good fortune in concept art to his teachers and mentors such as Andy Ogden, Richard Pietruska, Norman Schureman, Joe Farrer, Gary Meyer, Warren Manser, Tim Prentice, Lorne Lanning, Steven Olds, Alec Gillis, Tom Woodruff Jr., Chris Ulm, and Paul O'Connor, and the talented artists he works with every day. However, the biggest influences in Farzad's life are his wife Vera, son Maxwell, and daughter Isabella.

FRANCIS TSAI

Senior Concept Artist Francis Tsai has worked in the game industry since 1998 as a conceptual designer and art director. Previously, he worked with several architecture firms in Texas and California where he designed houses, corporate headquarters, streetscapes, and water conservation gardens. Some of his game credits include Myst III: Exile, Star Trek: Hidden Evil, Whacked, Spyhunter 2, and most recently Darkwatch. Francis also works as a freelance illustrator for clients such as Wizards of the Coast, Fantasy Flight Games, Mattel, and Dark Horse Comics. His work is regularly publicized in art annuals and art books such as "Spectrum", "Digital Painting: D'artiste", "Machine Flesh", and "Expose 2" for which he received an award of excellence. He received a masters degree in architecture and an undergraduate degree in physical chemistry from the University of Texas in Austin. Francis is responsible for many key designs in Darkwatch including Lazarus and ground zero, the final climactic boss environment.

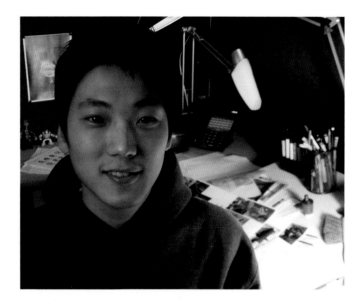

SHANE NAKAMURA

Concept Artist Shane Nakamura graduated with honors from Art Center College of Design in 2001. Shane then went to Presto Studios, where he had interned during college, and was given the chance to art direct the UI and ship his first video game, Whacked! Shane's next video game was Darkwatch, where he worked closely with Farzad Varahramyan in establishing the Darkwatch visual DNA. Shane also holds the patent for the Exoskull, which is protective headgear for use in extreme sports. Shane cites that his biggest accomplishments are his boys and tricking his wife, Nicole, into marrying him. Shane is responsible for all the weapons, vehicles, and UI designs in the game.

STEVE JUNG

Concept Artist Steve Jung was born in South Korea in 1978. After living in Argentina for six years, he moved to the United States in 1991. He didn't start drawing until a freakish accident shattered his left wrist five years ago and he decided to do something with his arm. He graduated from Art Center College of Design in spring 2003, where he majored in illustration with an emphasis on entertainment. His biggest influences are his instructors from Art Center–Vince Robins, Ryan Church, Scott Robertson, Dominique Domingo–and other artists such as Craig Mullins and Rembrandt. Steve is responsible for a lot of Darkwatch's great character designs including Tala and General Cartwright.

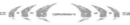

MONGSUB SONG

Associate Concept Artist Mongsub Song was born in Seoul, South Korea. His greatest influence is his father, a well-known and respected Chinese painter, whose studio Mongsub practically grew up in. In 1998 he moved to the United States in order to study art and follow in his father's footsteps. Mongsub graduated from Art Center College of Design in 2004, majoring in illustration and entertainment, and is currently working on Darkwatch II. Mongsub has contributed beautifully lit and mood-setting environment paintings for many of our game environments.

BILLY KING

Associate Concept Artist Billy King grew up in Florida and has worked as a texture and graphic artist in the video game industry for five years. He is mostly self-taught and continues to study art on his own. Billy credits his high school friend Chris Carignan for making him move to California; getting him his first job in the game industry at Solworks, a division of 989 Sports; and for making him learn Photoshop. Billy's game credits include FaceOff 2001, FaceOff 2003, and Darkwatch.

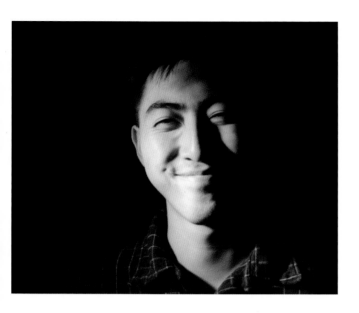

JANG C. LEE

Associate Concept Artist, Jang C. Lee is a graduate of Art Center College of Design, where he majored in illustration. Since graduating he has worked on a variety of projects, including consumer products, video games, film, and animation. Some of his credits include "Baby Blues": Warner Brothers TV Animation; PlaySkool & Glow World: Hasbro Inc.; *Delgo*: Fathom Studios; *The Lord of The Rings: The Battle for Middle Earth*: Electronic Arts; *The Chronicles of Narnia: the Lion, the Witch, and the Wardrobe*: Walt Disney Studios; and Darkwatch. Jang is responsible for designs such as the Banshee and also for setting some our earliest color keys.

SERGIO PAEZ

Storyboard Artist Sergio Paez is a San Francisco native who loves animation and the medium of visual storytelling. His animation credits in the United States and Europe include projects for Lucas Arts, Wildbrain, and Sony, as well as working on Carre Film Group's "The Three Wise Men," and most recently Darkwatch. As an independent filmmaker, Sergio's work has been shown at the Los Angeles International Film Festival, the North Hampton Film Festival, and Microcine Fest in Baltimore among other venues. Sergio Paez attended the Academy of Art College in San Francisco where he studied illustration, animation, and film. Sergio is the closest thing to a Renaissance man we've seen. Sergio was critical for all our linear storytelling moments, including storyboarding and doing the final editing to the original Darkwatch trailer, which introduced Jericho and Darkwatch to the world.

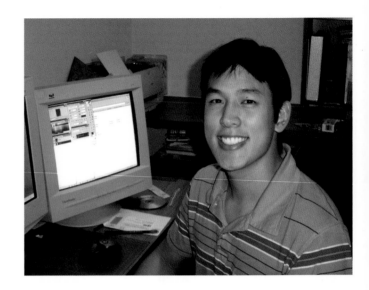

MINDY LEE

Associate Storyboard Artist Mindy Lee was first introduced to the idea of going to art school by her high school art teacher, but did not pursue it because it was considered impractical. Despite some obstacles, she got her first Bachelors Degree in graphic design from San Diego State University, and her second bachelor's from Art Center College of Design. Mindy first learned about Darkwatch during a company-sponsored workshop at Art Center, and shortly after, she joined the project as a freelance artist. Mindy helped Sergio with the large number of cinematic storyboards that were needed, and she continues to refine her skills with well-known and prolific artist John Watkiss.

DANIEL KIT

Production Assistant Daniel Kit graduated from UCSD with a B.A. in ICAM (Interdisciplinary Computing and Arts Major). He began his video game career as a QA analyst for Midway Home Entertainment. After a year and a half, Daniel found his way to the Darkwatch development team, and a month later became a production assistant for the art department. Darkwatch is Dan's first venture into the actual design and development of a game. He continues to climb the ladder with the goal of becoming a 3-D artist.

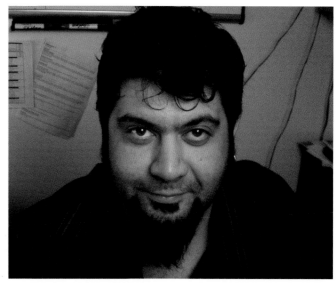

KEVIN GRIFFITH

Production Assistant Kevin Griffith was still in school at the Art Institute of California when he started working in the Darkwatch art department. Kevin's goals were to get real production experience and find out what true concept art was all about. His daily one-hour commute each way was a testament to his dedication and great work ethic. His interests are movies, video games, concept art, and entrepreneurship. Since graduating, he has been working on starting up a digital FX studio, Seraphim Twitch, with some of his cograduates. We expect great things from Kevin.

AARON HABIBIPOUR

Associate Producer Aaron Habibipour worked in graphic design and web development for many years, designing front-end interfaces and print collateral. He started his art education at Art Center College of Design as a film major, and attended the Art Institute of Pittsburgh for 3-D Design. His passion for art lead him back to his roots, and in 2001, he pursued a career as a freelance illustrator. This eventually led him to video games where he has worked as a storyboard and concept artist on a variety of projects. His credits include art director and associate producer for Iron Phoenix, which had him stationed in China for two months. Aaron eventually became a member of the Darkwatch team, producing the concept art team and the in-game cinematics, marketing, as well as handling web art assets, the Heavy Metal Darkwatch Prequel: Innocence, as well as the art book you are reading right now.

CREW LIST

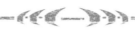

ORIGINAL DARKWATCH CONCEPT CREATED BY

Chris Ulm
Farzad Varahramyan
Emmanuel Valdez
Paul O'Connor

STORY AND SCRIPT BY

Paul O'Connor and Chris Ulm

DIRECTORS

Software Director
Clinton Keith (Connecticut)

Design Director
Chris Ulm (California)

Creative Director
Emmanuel Valdez (California)

Creative Visual Director
Farzad Varahramyan (Canada)

DEVELOPMENT TEAM

Executive Producer
Brian Johnson (California)

Senior Producer
Steve "Sargie" Sargent (England)

Producer
Chuck Cuevas (California)

Associate Producers
Donte "Dipshoot" Knippel (California)
Josh "Han Cholo" Heenan (California)

ART

Lead Artist
Sean Miller (New York)

Senior Artists
Ivan Power (California)
Andrea Cordella (Italy)

Technical Artists
Randy Stebbing (Utah)
Marc Mackin (Texas)

Artists
Alvin Chung (California)
Yves Courtier (France)
Jim Busike (California)
Wesley Cann (Canada)
Ivan Kaplow (New York)

Go Woon Choi (South Korea)
Dave Wilkins (South Carolina)
Richard Zagala (California)
Gi Ung Kim (Korea)
David Mershon (Illinois)
Isabelle Chen (Taiwan)
Shayne Hudson (Massachusetts)
RJ Biglang-awa Jr. (California)
Matthew Lim (New Jersey)
Terrence Keller (New York)

Art Wrangler
Marvin Najor (California)

ANIMATION

Senior Animators
Sean Letts (Canada)
Mike Brown (Colorado)

Animators
Jason Diaz (Florida)
Mauricio Hoffman (Mexico)
Darrell Robinson (California)
Tim Webb (Washington)
Jin Jang (South Korea)
David Tully (California)

Additional Animation
Sandra B. Christensen (California)
Eli Enigenburg (California)

CONCEPT

Senior Concept Artist
Francis Tsai (Texas)

Concept Artists
Shane Nakamura (California)
Steve Jung (California)

Associate Concept Artists
Mongsub Song (Korea)
Billy King (Florida)
Jang C. Lee (Korea)

Storyboard Artists
Sergio Paez (California)
Mindy Lee (Hong Kong)

Producer
Aaron Habibipour (Virginia)

Production Assistants
Daniel Kit (Illinois)
Kevin Griffith (California)

DESIGN

Lead Designer
Paul O'Connor (California)

Senior Designer:
Characters and Mechanics
Brent Disbrow (Canada)

Senior Designer: Levels
Matt Tieger (Pennsylvania)

Senior Designer: Cooperative Play
Jeff Ross (New York)

Senior Designer: Multiplayer
Chad Steingraber (California)

Designers
Rory McGuire (California)
Matt Krystek (California)
Jared Ellott (New York)
Stephen Riesenberger (California)
Tony Dormanesh (California)
Scott LaGrasta (California)
Tony Huynh (California)

Senior Technical Designer
Scott Blinn (New Hampshire)

Technical Designers
Sean Levatino (New York)
Adam Poulos (New York)

Additional Design
Shane Walker (Oklahoma)

PROGRAMMING

Lead Programmer
Stephane Etienne (France)

Senior Programmers
Mike Acton (California)
Mark Botta (California)
Jamie Briant (Scotland)
Sean Houghton (Oregon)
Tyson Jensen (Montana)
Noel Llopis (Spain)
Alastair Patrick (Scotland)
Philip (North Carolina)
Tom Plunket (Vermont)
Gary Scillian (Washington D.C.)
Eric Yiskis (California)
Andrew Zaferakis (New York)

Programmers
Marc-Antoine Argenton (France)
Phil Chu (Massachusetts)
Mark De George (New Jersey)
Rory Driscoll (England)
Lei Hu (China)
Christian Gyrling (Sweden)
Cedric Lallain (France)
Charles Nicholson (New York)

Joel Pritchett (Oregon)
Jim Tilander (Sweden)

Engine and Tools Director
Dave Wagner (Ohio)

Tools Programmers
Nathan Blomberg (Wisconsin)
Lucy Boyd-Wilson (England)
Scott Carter (California)
Eric Eldrenkamp (California)
Frederic My (France)

AUDIO

Audio Manager and Cinematic Rerecording Mixer
Gene Semel (North Carolina)

Sound Design
Robert Burns (New Hampshire)
Rodney Gates (Arizona)

Audio Programmers
Paul Skibitzke (California)
Christian Sakanai (Colorado)

Original Music Composed and Performed by Mike Reagan
Asdru Sierra of Ozomatli

"The Good, the Bad and the Ugly (Theme)" by Ennio Morricone
© 1966 Renewed 1994
Eureka Edizioni Musicali, S.A.S.
Rights for the World Excluding Italy Assigned to EMI Catalogue Partnership
All Rights for EMI Catalogue Partnership Controlled and Administered by EMI UNART Catalogue INC.
All Rights Reserved. International Copyright Secured. Used by Permission.

Cinematic Music Editorial
Jeremy Raub

Cinematic Foley
Monkeyland Audio

Additional Sound Design
Jason Schmid
Earbash Audio, Inc.

MOTION CAPTURE

JR Salazar (California)
Sarah Back (Washington)

Talent
Sarah Back

Mike Brown
Colin Follenweider
Billy King
Sean Miller
Darrell Robinson
Mami Sato
Aaron Toney
Emmanuel Valdez
Vanessa Vander Pluym
Kerry Wong

VIDEO SERVICES

Senior A/V Specialist
Dave Cravens (Minnesota)
Ron Austin (Pennsylvania)
Ly Ha (Florida)

MARKETING

Steve Fowler (California)
Richard Iggo (England)
InJoon Hwang (South Korea)
Sandi McCleary (California)
Jim Chadwick (New York)

PR

Meelad Sadat (Iran)
Alex Armour (California)

GAME MANUAL AND DOCUMENTATION

Senior Technical Writer
Robert Bacon (California)

INFORMATION TECHNOLOGY

Sr. IT Manager
Dan Mulkiewicz (California)

SERVER TEAM

Systems Administrator
Bryan Dibella (California)

Network Administrator
Richard Westberg (California)
Database Administrator
Junko Takasawa (Japan)

DESKTOP TEAM

Desktop Support Supervisor
Ross Deynata (California)

Senior Systems Technician
Steve "Estaban" Rottman (California)

Systems Technician
Frank Galang (California)

Systems Technician
Spencer Weise (Texas)

BRAIN ZOO STUDIOS

Executive Producer
Mohammed Davoudian

Producer
Karen Dixon

Technical Director/Lead Animator
David Hickey

CGI Artists
David Bailey
Eric Ehemann
Paul Schoeni
Tom Narey
Mike Ryan
Mike Arrana
Kevin Clarke
Daniel Herrera
Frances Ko
Chris Hung
Hyon "Mario" Kim

QUALITY ASSURANCE

QA Manager
Jon Williams (England)

QA Supervisor
Eric Narvaez (California)

Lead Product Analyst
Jeffrey Lamug Tamayo (Philippines)

Senior Product Analysts
Aaron Hartman (Vermont)
Product Analysts : Project Leads
Erwin "Seismic ErGasm" Gasmin
(Philippines)

Kevin Pimentel (Connecticut)

Technical Standards Analysts
Rich Phim (Cambodia)
Paul Gardner (California)
Kenneth Reyna (Mexico)
Sammie Prescott Jr. (California)
Stan Shambaugh (California)
Joe Price (California)
Jay Torcedo (California)
Michael J. Brown (California)

QA Darkwatch Team
Anna Pacheco (California)
Arthur Fernandez (Guam)
Brian 'Negative 1' Robertson (California)
Daryl Jennings (California)
Drew Jennings (California)
Gedrey Wild (Hawaii)
Jason Copeland (California)
Jeffrey Dequina (California)
Jose Lopez (California)
Joshua Krolak (California)
Justin Wood (California)
Kumiko Yuasa (Japan)
Mark Benavente (California)
Mark MacBride (California)
Mark Ratley (California)
Michael Taylor (California)
Michael A. Willette (California)
Michael Williamson (Australia)
Miles Trumble (California)
Morgan Warner (West Virginia)
Neil Carter (Japan)
Nick Lutz (California)
Oreon Lothamer (Oregon)
Preston Whitaker (California)
Robert Zepeda (California)
Ryan Thompson (California)
Victor Araujo (California)
Vinh Ha (California)
Wesley Bunn (California)
Willis Wong (California)

BLACK POWDER MEDIA

VO Director
Art Currim
Casting
Brigitte Burdine

Coordinator
Michelle Tomlinson

Engineers
Eric Thompson & Chris Navarro
VO CAST

Cassidy : Jennifer Hale
Tala : Rose McGowan
Cartwright : Michael Bell
Lazarus : Keith Szarabajka
Darkwatch Agent 1/Townie 1 : Chris Smith
Darkwatch Agent 2/Townie 2 :
Fred Tatascore
Female Townie : Kari Wahlgren

RenderWare is a registered trademark.
Portions of this software are Copyright
1998-2004 Criterion Software Ltd. and its
licensors.

Middleware Physics System provided by
Havok.com™; © Copyright 1999-2002
Havok.com Inc. (and its licensors).
All Rights Reserved.
See www.havok.com for details.

Multiplayer Connectivity by Quazal

SPECIAL THANKS
John Rowe, Hajime Satomi, Yoshiharu
Suzuki, Rick Olafsson, Umberto Bossi, Jackie
Corley, Kevin Anderson, Carol Angell, Max
Elliot, Paul Lackey, Dina Mastbaum, Chad
Bishop, Jason Weber, Lori Miller, Seiki Saito,
Koichi Sawada, Mimi Rigby, Amy Bersch,
Tami Hathaway, Nana Ishizuka, Lani Minella,
the family and friends of the Darkwatch
development team

other titles by design studio press:

ISBN 0-9726676-9-5 hardcover

ISBN 0-9726676-0-1 paperback

ISBN 0-9726676-7-9 paperback

ISBN 0-9726676-3-6 hardcover
ISBN 0-9726676-2-8 paperback

ISBN 0-972-6676-8-7 hardcover
ISBN 0-972-6676-4-4 paperback

ISBN 0-9726676-6-0 hardcover
ISBN 0-9726676-5-2 paperback

To order additional copies of this book and to view the other books we offer, please visit:
http://www.designstudiopress.com.

For volume purchases and resale inquiries please e-mail:
info@designstudiopress.com.

Or you can write to:
Design Studio Press
8577 Higuera Street
Culver City, CA 90232

tel 310.836.3116
fax 310.836.1136